REVISED AND EXPANDED

BURNE HOGARTH

DYNAMIC ANATOMY

WATSON-GUPTILL PUBLICATIONS

Berkeley

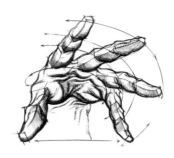

To my sons
Michael Robin Hogarth, Richard Paul Hogarth,
and Ross David Hogarth

Copyright © 2003 by Burne Hogarth Dynamic Media Holdings, LLC
Copyright © 1958 by Burne Hogarth

All rights reserved.
Published in the United States by Watson-Guptill Publications, an imprint of the Crown Publishing Group, a division of Penguin Random House LLC, New York.
www.crownpublishing.com
www.watsonguptill.com

WATSON-GUPTILL is a registered trademark, and the WG and Horse designs are registered trademarks of Penguin Random House LLC.

BURNE HOGARTH® is a registered trademark of Burne Hogarth Dynamic Media Holdings, LLC, All Rights Reserved.

This revised and expanded edition first published in 2003 by Watson-Guptill Publications, Crown Publishing Group, a division of Random House Inc., New York
First edition (hardcover) 1958
First paperback edition 1990

Library of congress control number: 2003102368

Trade Paperback ISBN: 978-0-8230-1552-8

Printed in China

Cover design by Kris Hammeras-Hogarth
Interior design by Cindy Goldstein, Eric Baker Design Associates

19 18 17 16 15 14

First Revised Edition

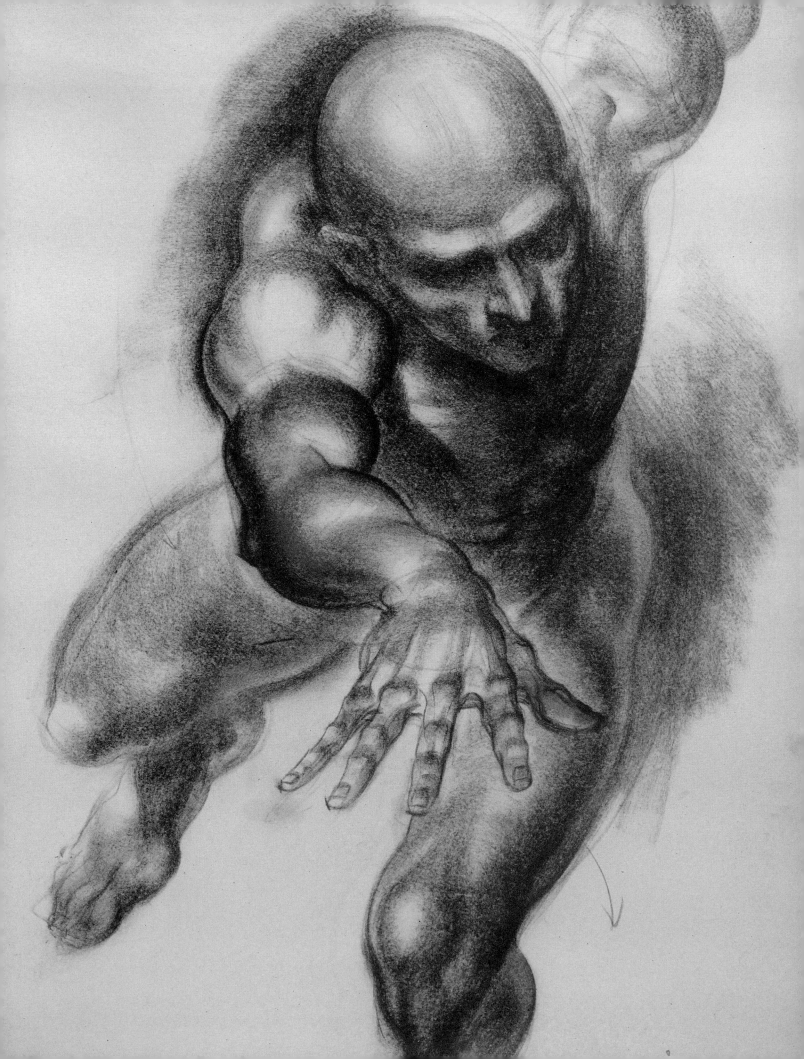

FOREWORD

I WAS INTRODUCED TO THE WORLD of Burne Hogarth in 1977, when I was sixteen. I had decided to take the potential career path of being a comic book artist and was consuming literally thousands of comic books, trying to teach myself how to do superhero-type drawings. Up to that point, all I had done was doodle incessantly in the corners of my homework pages and during science classes.

As I studied the work of some of the influential comic book artists of the time, one thing became apparent: I lacked the technical knowledge of how the human body actually worked, let alone how to move a character within the page. Clearly I needed to acquire that knowledge if I hoped to create work samples worthy of sending to the comic book companies in search of a job.

One day I went to a bookstore and happened to come across a copy of Burne Hogarth's *Dynamic Anatomy*. It provided my skill level in drawing with a jump-start, teaching me how the human body was constructed through information laid out in fairly simple terms that made sense to a sixteen-year-old artist. Once I started putting the building blocks of the human body together and became familiar with how to construct male and female figures from any given angle, I then had to conquer the next level: I had to learn where the muscles and bones went, how to establish correct proportions, and how to make the figure relate convincingly to the surrounding space. Hogarth's book showed me how to foreshorten and how to twist and turn the human form, transforming my work into what he called "dynamic." During the years Hogarth drew the comic strip *Tarzan*, he often depicted the scantily clad hero swinging from vine to vine in the jungle, and his mastery of the human figure in motion obviously evolved through his own work in comics, his studies, and through decades of teaching.

When eventually I broke into the comic book business, I continued to come back to the lessons I had learned from studying Hogarth's book. Now that I have enjoyed some success in the field, people often ask who my comic book influences were. I give them a handful of names of current and pioneering artists, but always credit Burne Hogarth as the one who most directly taught me how to actually move iconic figures on a page and how to stage them in melodramatic fashion. It's terrific for me to be able to sit back now and watch as a whole new generation of budding artists becomes exposed to the same teachings that so richly rewarded me. I hope all of you who read this book find the information it contains as valuable and inspiring as I did. I wish you good luck, and would like to thank Mr. Hogarth for his legacy.

TODD MCFARLANE

Spawn *creator and former* Spider-Man *artist*

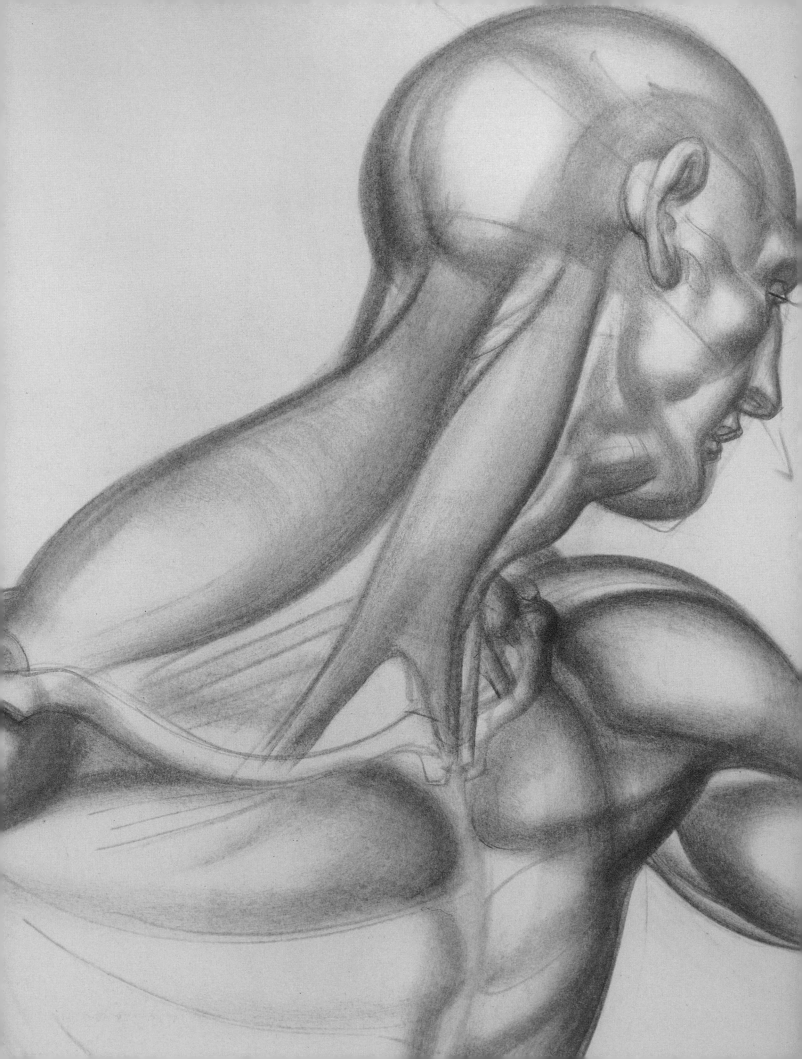

PREFACE

THE BOOK YOU ARE ABOUT TO READ is concerned with the artistic anatomy of human form, not medical anatomy. It proposes to deal with anatomical form and structure for the understanding of the figure in foreshortening and depth of space, for corrective discipline in drawing and, perhaps, to add new information to the interrelationship of its masses and its movement.

Traditionally, the major emphasis of anatomy texts for artists has been to reveal and explain muscular dissection and skeletal structure from the position of the laboratory medical anatomist. A finely integrated and voluminous literature already exists dealing with the myology and osteology of the figure, including, in some examples, the types of joints and their articular surfaces, the deep ligaments and membranes attaching the bones, and cross-sections through the body at various points describing veins, arteries, nerves, and organs, as well as muscle and bone. These are scholarly and studious projections in the Vesalian tradition, and have served to keep the Renaissance heritage of the figure alive in art. As such, they have informed new art students of the need to know more than the caprices of fads and styles, and the successful imitation of current mannerisms.

Rather than repeat the fine body of work already accomplished, this book will take for granted the existence of skeletal structure and deep myological descriptions in other literature, and respectfully advises the reader to consult them for such purposes. Here, we shall attempt to work out solutions to some of the problems that evolve out of anatomical structure, but the stress will be on the relationships of masses in figure movement and how these affect surface form and visual observation in drawing. We shall be seeking insights into the enchantment of the living figure, not the dissected one.

There is an interesting corollary to this approach. Historical evidence has it that when Andreas Vesalius began his monumental work on anatomy, *De humani corporis fabrica*, some four hundred years ago, he approached the great Venetian master Titian to produce the large number of plates required for the volume. The unrivaled artistry of these anatomical descriptions, executed by Titian and some of his students, has never been equaled in similar works. Now an intriguing problem comes up. Vesalius obviously knew a great deal more than Titian about internal medical anatomy. Vesalius, hailed as the Reformer of Anatomy, was in the process of making *new discoveries* in anatomical structure that Titian could not have learned beforehand. How did it happen that Titian, a master in art, knew *better than Vesalius* the visual description and correct delineation of anatomical human form? Titian was able to master artistic form in spite of his incomplete knowledge of medical structure. Clearly, it would seem a thorough knowledge of internal

ACKNOWLEDGMENTS

I CANNOT HELP THINKING as this volume goes to press that the creation of a book has many labors in it besides the author's. It would be difficult to report on the problems encountered from its first vision to its final revision. To do so would reward the reader with its burdens rather than its pleasures. However, a special debt of gratitude must be mentioned here to those persons and organizations who have contributed substantially to its completion.

I extend my warmest thanks and sincere appreciation to Miss Elsa Lichtenstein of Barnes & Noble, who first saw its possibilities and proclaimed them fulsomely; to Mr. Norman Kent, editor of *American Artist* magazine, who cleared the track and green-lighted the way; to Mr. Edward M. Allen, editor of Watson-Guptill Publications, a gentleman of rare charm and patience whose generous understanding encouraged and guided it from beginning to end; to William Gray, José Llorente, Diedrich Toborg, and Marvin Hissman for their unstinting assistance in consultation, photography, and production; to Emilio Squeglio of *American Artist* magazine for the major contribution and guidance in design, layout, and typography; to my wife, Constance, who, as her name implies, with enduring forbearance made the typewriter and the manuscript a significant part of her many household chores.

Further, I wish to express sincere appreciation to those museums and organizations that gave generous assistance and permission for the use of artworks from their collections: to the New York Academy of Medicine for the use of the Vesalian prints, which it published in conjunction with the University of Munich in the special edition of 1934, from the original 1543 wood blocks, under the title *Andreae Vesalii Bruxellensis Icones Anatomicae;* to the Museum of Modern Art for permission to reproduce from its collection the works of Boccioni, Braque, Kandinsky, Klee, Léger, Matisse, Picasso, Rodin, and Tchelitchew; to the Metropolitan Museum of Art for permission to reproduce from its collections the works of antiquity and the intervening eras, including the examples of Pollock and Pereira; to the American Museum of Natural History for permission to reproduce the examples of Paleolithic and primitive art; and to the Delius Gallery of New York.

Finally, I wish to extend sincerest thanks to the School of Visual Arts in New York City, in whose encouraging and experimental atmosphere many of the ideas in this book were explored, and to the school's faculty and students, who asked provocative questions in response to the increasing student demand for an answer to the relevant and proper study of anatomy in the light of past traditions and contemporary idioms of art.

BURNE HOGARTH
1958

ACKNOWLEDGMENTS FOR THE REVISED

AND EXPANDED EDITION

As *Dynamic Drawing* nears its fiftieth year in print, we are proud to see the publication of a revised and expanded edition of Burne Hogarth's award-winning classic. This first title in the dynamic drawing series now appears with newly discovered artwork from the Hogarth archives that adds and restores illustrations in their original, breathtaking colors.

On behalf of the Hogarth family and Burne Hogarth Dynamic Media Worldwide LLC, we would like to acknowledge several people, without whom this project would not have been possible.

First and foremost we would like to thank our friend and legal adviser, David B. Smallman, Esq. His concerted efforts and dedication to the legacy of Burne Hogarth created the opportunity for this book to reach fruition.

We thank Todd McFarlane—a brilliant artist in his own right—for his generous and thoughtful foreword to this edition of *Dynamic Anatomy,* which introduces the book to a new generation of artists.

We also express our gratitude to Burne Hogarth's longstanding publisher, Watson-Guptill, for bringing about a new edition of this timeless work. Finally, we each thank family members Stephanie, Pam, Kris, and Brady Todd Hogarth for their love, support, and insights, all of which kept us on track during the past several years.

We hope this revised and expanded edition inspires students and artists around the world. Enjoy!

MICHAEL HOGARTH

RICHARD HOGARTH

ROSS HOGARTH

Spring 2003

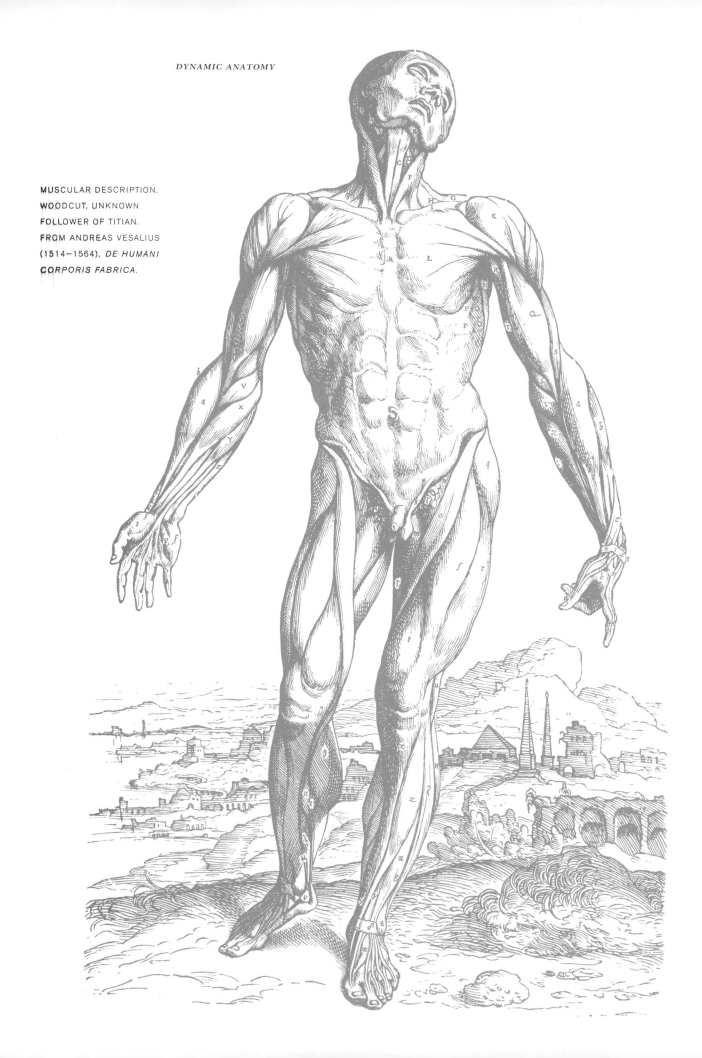

MUSCULAR DESCRIPTION.
WOODCUT, UNKNOWN
FOLLOWER OF TITIAN.
FROM ANDREAS VESALIUS
(1514–1564), *DE HUMANI
CORPORIS FABRICA.*

I.

THE DUALISM
OF ART
AND SCIENCE

THE YEAR IS 1538. In the town of Padua, hardly twenty miles from the great seaport of Venice, a young man is about to deliver a lecture. It is late in the year and a brisk wind is blowing. A large concourse of students and observers has gathered to watch him. His subject is anatomy and they are here to see a dissection. A smile flits across his intense face. He is new here and already his demonstrations have received wide acclaim and respect.

The excited murmur of voices quiets as he steps down from his chair high on a dais before the semicircular bank of benches in the hall. He moves confidently toward a long center table with its array of instruments. A year earlier he had created a stir among his colleagues by arrogantly rejecting the help of "demonstrators" and "ostensors" in the practice of dissection. To him, the practice of dissection is art, and the anatomical discovery of man as the living reflection of God is worthy of the highest personal dedication.

His dark eyes fix on the subject before him. It is a cadaver, the corpse of a criminal, and it has not been very well preserved. It is held in a standing position with a pulley rope looped around the back of the head, supported from a beam at the ceiling. He reaches for a knife. His high forehead with its tight curls gleams in the sallow light as he bends forward. His hand is sure. He has done this many times before. From his earliest days in his father's house in Brussels, to his student days in Louvain and at the University of Paris, he has done this. Now, as Professor of Surgery appointed by the Senate of Venice to the University of Padua the year before, he is about to perform another dissection.

But this time it is different. The young Professor of Surgery is engaged in a search. It is a time of knowledge, enlightenment, and invention. It is a time of voyaging and discovery. And this time he has embarked on a voyage of discovery all his own.

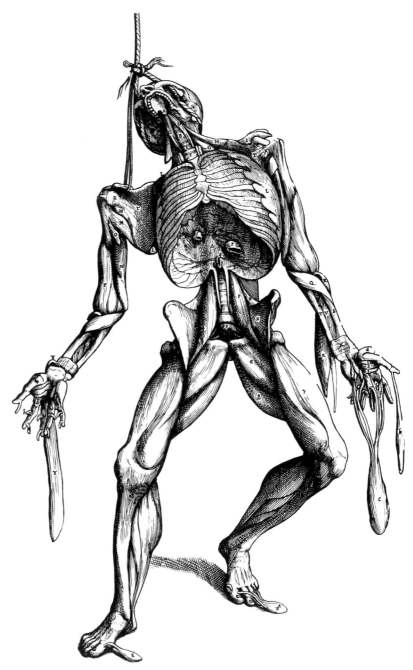

DISSECTED FIGURE.
WOODCUT. UNKNOWN
FOLLOWER OF TITIAN.
FROM ANDREAS VESALIUS
(1514–1564),
*DE HUMANI
CORPORIS FABRICA.*

He is fully conscious of his purpose. He knows well the importance of his task. In his mind's eye parade the great figures of classical antiquity—Hippocrates, Aristotle, Herophilus, Galen—those exalted men whose observations have laid the basis for his undertaking. Earlier in the year he had published with instantaneous success his fugitive sheets, the *Tabulae sex*. Now he is afire with an idea. With his keen eye, sharp knife, and steady hand he will cut through the veil of time and mystic belief and lay open the matrix of man. Below the layers of skin and tissue he will observe and record the structure of human form.

Knife in hand, he reaches out and makes a swift longitudinal incision from rib cage to pubis in the body of the cadaver.

The young man, Professor of Surgery at Padua, is but twenty-four years old. His name is Andreas Wesel, but in the Latinate convention of that day, we know him as Andreas Vesalius. In four years' time, his work will be done. In four years' time, he will have produced some seven works in text and graphic illustration published under the title *De humani corporis fabrica—The Structure of the Human Body.* He will be twenty-eight years old, but he will have swept away for all time the obscurantism of almost two thousand years of philosophical inertia. He will be called the Reformer of Anatomy, and he will take his place in history as ushering in the modern scientific era of medical and physiological discovery.

DISSECTION INSTRUMENTS. WOODCUT. UNKNOWN FOLLOWER OF TITIAN. FROM ANDREAS VESALIUS (1514–1564), *DE HUMANI CORPORIS FABRICA.*

A brisk wind blew in Padua that day. But another wind was blowing—the wind of humanism and new science, the Renaissance—blowing across the length and breadth of Europe. In that era a three-pronged assault would be launched against the bastions of scholastic conservatism and academic rigidity. The Platonic-Aristotelian construct of the universe would be rent by Francis Bacon's description of scientific logic and empirical method in the *Novum organum;* the geostatic cosmology would be torn asunder and made heliocentric in Nicholas Copernicus' *De revolutionibus orbium coelestium;* myth and speculation would be forever dispelled in human anatomy in Andreas Vesalius' *De humani corporis fabrica.* Macrocosm

and microcosm—the deterministic mover of the universe superimposed on the predestined behavior of man—held together in a fixed logic of idealist dogma, would come crashing down. Renaissance thought, from that day to this, would introduce a new advance in the rational powers of man, and new light would be shed on the phenomenology of natural causation. The Augean stables of the mind would be ready for the Tiber.

———————————————

The scientific revolution of the sixteenth century was an intellectual breakthrough of such magnitude as to compare with the greatest achievements in human history. Not since the rise of Greek civilization had its like occurred. Renaissance humanism had signalized the end of the Middle Ages, and the hierarchy of social formalism was crumbling. The emancipation of the individual from feudal servility presaged the dawn of democratic institutions. The age of science had begun and the early outlines of modern man had appeared on the stage of history.

Profound as the breakthrough was in medicine, mathematics, physics, astronomy, and natural science, the achievement in art was equally spectacular and dramatic. The Renaissance inaugurated an entirely new concept in expressive form. It was not so much a change in subject matter as it was a working out of new solutions to older problems. The themes were scriptural still, but the stress, the emphasis of its approach, was the portrayal of religious ideas as *episodes in human history*. God as man and man as humanity were extolled as the aim of art. The impact focused on the deeply felt human experiences of the times, and revealed the personal significance of faith. In this sense, the new art ceased to be withdrawn, austere, symbolic, essentially decorative in character. Instead, it became an innately human, warmly imagistic, pictorial art. It served a moral purpose through education and reason, rather than through fear and obedience. Scientific discovery, breakdown of feudal barriers in social structure, and the increased importance of the individual persona led to the profound metamorphosis in Renaissance art.

Fundamental to this change was the naturalistic representation of the human figure, the primacy of anatomical man. From this premise, concepts of form, space, and design structure in the two-dimensional flat surface of the picture were subjected to the rationale of scientific method and analysis. Thus, the investigation in medical anatomy and physiology through human dissection led to a powerful insight in artistic anatomy and the rectitude of human form; the mathematics of navigation and exploration, contributing a geometry of space instead of planes, touched off the development of visual perspective in the control and measurement of the third dimension; the new heliocentric astronomy

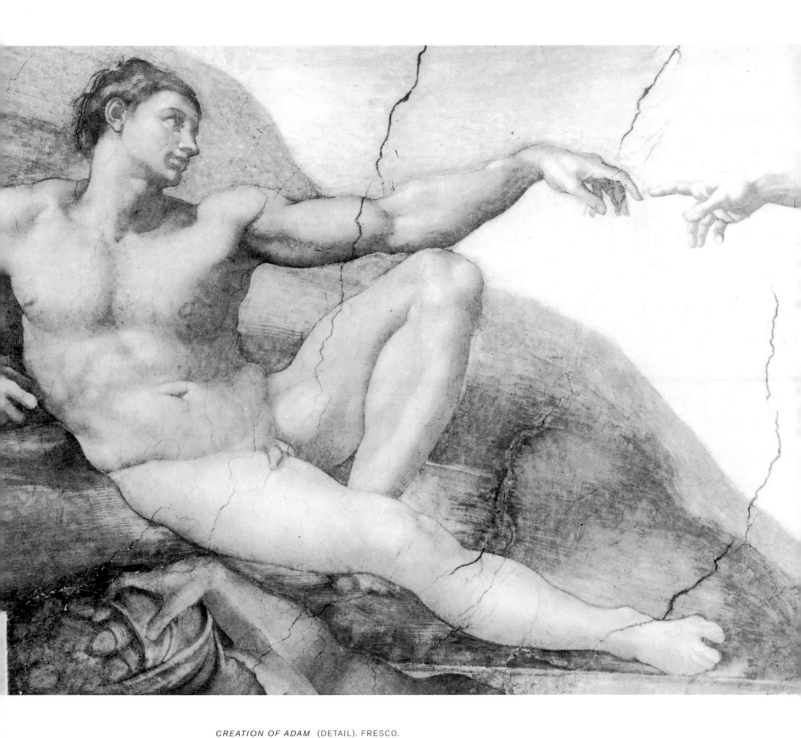

CREATION OF ADAM (DETAIL). FRESCO.
MICHELANGELO (1475–1564).
ITALIAN. SISTINE CHAPEL CEILING,
VATICAN, ROME.

projected motion of the body and dynamic foreshortening of the figure in deep space; celestial mechanics, theories of the interaction of mass, space, and energy in physics, provided weight and solidity of form, and shot through diagonal tensions and thrusts in design structure; the gravitational field of the planetary system put the ground plane into the picture (objectively analyzed for the first time in history); interest in natural science produced an awareness of botanical form, correct description of animals, and atmospheric recession in landscape and environment.

The revolution in art, concurrent with the revolution in science, was directed toward one overriding aim. The artists of the Renaissance gave visual expression to reason and nature in the birth of human form. Elemental man, his surge and drive, his passion and repose, pulsed and beat in the supernova of the intellect, the transcendent mirror of the age. What made the sixteenth century so remarkable was its departure from the stultified application of static conventions. Its essential idea was an expanding aesthetic, concentrated on the observation of man's continuity with the unity of nature. Thus, very shortly, the dynamics of their concepts led them from one discovery to another in their penetration of human experience. Empirical science and natural process became an ongoing philosophical principle of art.

According to the new criteria, the strictures in earlier Gothic art were held up for close scrutiny and revaluation. The austere iconography dissolved in a proliferation of concrete experiences and physical realities. The human figure was the first to change. Slowly the individual emerged. Cimabue, Giotto, Masaccio felt him—his suffering, his ecstasy, his terror. Anatomy galvanized the wooden forms to life; nerve and sinew writhed with energy; the man of hope, of tumultuous passion and grandeur surged on the scene. The *Creation of Adam* in Michelangelo's Sistine fresco is the appropriate analogue of the time. The seasons, the weather, the time of day; youth and age, manhood and womanhood, birth and death; the growth of things, the cycle of life began to appear in art. Leonardo, Raphael, Giorgione, Titian, Tintoretto saw the mysteries of nature, atmosphere and light, serenity and tenderness, poignancy and pathos. In the West, the moral principles and ethical values in personal behavior prevailed in the van Eycks, van der Weyden, Bosch, Dürer, Grünewald, Brueghel, and El Greco.

The seventeenth century, pressing closely on, took a new leap into the future of the individual in art. A quickening process of scientific research, transitions in society, and new philosophical concepts brought forth the human portrait, individual man in his ordinary environment and specific locale. The baroque era, projecting the great age of portraiture and the landscape in art, realized in visual terms the discoveries of Galileo,

Kepler, Descartes, and Newton on the mechanics of motion and universal gravitation, geometry of motion, optics, and the spectrum of light. In the philosophy of Hobbes, Descartes, and Spinoza it sustained and exemplified the importance of relative human intelligence, basing universal law on science. Coincidental with these, the solo instrument, the aria, the recitative proclaimed the individual consciousness in music. In its portrayal of human warmth, baroque art synthesized the pulse of anatomical man with Harvey's discovery of the circulation of the blood.

The baroque was an art of realism, the realism of human personality, the insight into the character of man. In its genre, its grace, its elegance, it had the essential "human touch." In its air and space were the flashes of the daily lives, the activity, the work. But its tour de force was its play and counterplay of light. In its chiaroscuro was revealed the human drama, the moods, the lightning and thunder of the emotions of its people, the living people. In Velázquez, in Rubens were the courtly, the refined, the ease and grace, the joy of life. In Vermeer and de Hooch, the gesture, the tilt of head, the eyes in greeting—in response, in reflection, in repose. In Hals, the laughter of men and women, the cry of children. In Rembrandt, the poor, the lame, the bent, the bemused; the stertorous sounds, the cough, the suspended breath of trailing wonder and doubt; the sustained, pervasive sense of time, the unutterable poignancy of life. And always the landscape—the fields, the clouds, the sky; the locale of house and garden; the things of work and rest.

The dualism of art and science, from its inception in the Renaissance, had created a cyclical system of broadening aesthetic dimensions. As the boundaries in scientific and human activity widened, so did the boundaries of artistic endeavor. The process of intersection and correlation in religious, social, and human affairs had been an accepted premise in the progress of art for more than two hundred years. Now a stasis began to set in, an imperceptible slowing of the process. With the rise of powerful monarchies in the conflict and consolidation of power, the dualism of art and science began to show a cleavage. What has been called the rococo period in art of the eighteenth century was, in effect, a crisis in the relationship of art to the progress of the individual in his time—a concept that the baroque era profoundly fulfilled in its awareness of human worth. In Francis Bacon's words summarizing the aspirations of the preceding periods, the works of the Renaissance and the baroque eras stand revealed: "On the observation of nature we shall build a system for the general amelioration of mankind."

Toward the end of the seventeenth century scientific pursuit had begun to shift from an act of faith in the improvement of mankind to an increase in scope as an activity

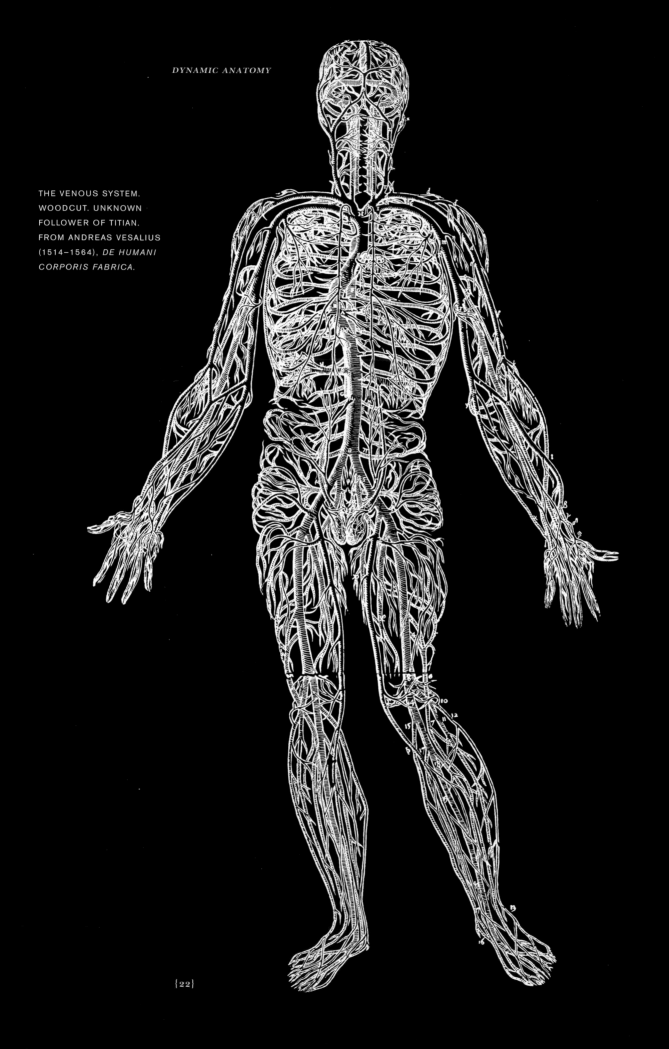

THE VENOUS SYSTEM.
WOODCUT. UNKNOWN
FOLLOWER OF TITIAN.
FROM ANDREAS VESALIUS
(1514–1564), *DE HUMANI
CORPORIS FABRICA.*

of enterprise and a utility in commerce. Leibniz, philosopher, mathematician, and adviser to Frederick I of Prussia, extolled this view with decisive clarity; the role of science is necessary as an instrument of policy in the perpetuation of the state. The dualism of art and science in the early eighteenth century was in tension and transition. Concepts of the figure developed generally along three broad lines of expression. The art of the nobility and aristocracy presented a mixture of thinly disguised, taut contradictions. As spatial volume and recession of planes moved deeper, thematic concepts declined into the superficial, the shallow, and the banal. Color and brushwork intensified and became more vivid, while form became fugitive and insubstantial. Rococo art in the aristocratic mode had become a plaything of princes, a decor of palaces, a reflection of opulence. It had become an art of adornment, of miniatures, of preciosity in intimate decoration. It had become an extension of effete and courtly refinement, of mythical-classic concoctions, of fool-the-eye pictures and hallucinosis of vision.

It was in the middle class, in the growing commercial power of the bourgeois, where the firm note was struck. Here, the aristocratic leadership yielded to the burgeoning prestige of middle-class taste and patronage. In portrait, landscape, and still life were presented the substantial new class and its ways. Because it was a section of society mainly concerned with mercantile interests, the themes of home, surroundings, and family interest—landscape and still life—gained in importance as subjects of art. Aristocratic efflorescence waned in the sensuous fulminations of Van Dyck, Fragonard, Watteau, Boucher, Tiepolo, and Gainsborough. It surrendered to the less spectacular, more vital products of Constable, Hogarth, Romney, Raeburn, Chardin, and Turner. In America, the broad stream of social movement influenced the orderly art of Copley, Stuart, West, and Trumbull.

But the dislocations of life in the eighteenth century brought out a third movement in art, a line of argument, as it were, of satirical criticism and savage social commentary. Investigations of science in new fields in physiology, embryology, and microscopy, as well as observations of phenomena in human affairs, led to liberalism, free thought, and social examination in caustic art and literature. Art became both literary in subject matter and naturalistic in treatment, in Greuze and Longhi. But emotionalized exaggeration and caricature of the figure was its end product, and its most energetic expositor was William Hogarth.

The end of the era gave rise to a series of social shocks that had deep repercussions on the development of art. Scientific invention produced the Industrial Revolution; social invention produced the American Democracy and the French Republic; artistic

invention produced the pictorial reportage of immediate human events and advanced the movement toward modern realism and political cartooning. Goya, like the towering, brooding Colossus of his etching, turning to look backward at the past, was about to move into the future of a new age with the thunderous intensity of a new concept of theme, form, and style. At the apex of his powers, Goya crossed the bridge of a new century, a new age in society, and a new art. The link had been forged; the eighteenth century rushed into the nineteenth; and a conscious symbolism of subjective emotionality and distortion showed itself in the human figure.

It was left to the Napoleonic era to fix irreversibly the lines of demarcation between the earlier leanings of the genre realist baroque and the aristocratic rococo baroque into two antagonistic movements; the academic respectability of Napoleonic-classicist art and the genre libertarianism of romantic-realist art. The tendency to concentrate on subject matter and argument of viewpoint in thematic material gave both movements the characteristic of immediacy in the portrayal of events. As such, personalized adventure and melodrama became an important feature of art, and in this they were the forerunners of modern magazine illustration. The two movements were notably marked by the recurring thrusts and counterthrusts of their diverse positions throughout the Napoleonic era. Essentially, it was a contest for the opinions of men; the drive toward egalitarian nationalism against conservative authoritarianism. On the one hand were Goya, Géricault, Delacroix, Daumier, Forain; on the other, Gros, David, Meissonier, Ingres.

The principle of art and science as a dual relationship had been undergoing an estrangement. Now, a dislocation was evident. The fracture between art and science was the reflection of a deepening dichotomy within the general field of science itself. Scientific pursuits had become largely an activity of commercial enterprise, sanctioned and supported through the benevolent authority of the state (Leibniz's view realized); academies of science, especially in the physical and normative sciences, were the proper official bodies through which the leading figures pursued their endeavors and received official recognition and commendation; refinement of observations, verification, and quantification in proof of earlier accepted theories were the dominant, recognized lines of inquiry in the controlled academies. However, new scientific inquiries and discoveries in the humanist-Baconian tradition, as well as investigations leading to the emerging human and social sciences, had no official sanction or status, and were viewed with suspicion and hostility. Findings in the progress of the individual were frequently not considered science at all. They were bitterly fought in academic circles. Briefly, we may observe the acrimony directed against such familiar figures as Darwin, Huxley, Pasteur, and Freud.

An almost identical correlation emerged in cultural and artistic circles. Toward the latter half of the nineteenth century, the academy of art, with its proud reliance on state sanction, arrogantly rejected those artists (in France especially) who did not adhere to the well-defined strictures of neoclassicist concepts in thematic material, technique, manner, form, and style. Critical romanticism, stringent realism, and commonplace impressionism were held up to ridicule and disfavor as extolling the crude, the vulgar, the gauche in art. The rebellion against the academy was precisely in those areas of greatest academic divergence from the humanist-Baconian traditions in art, in revealing the human condition of the times. Academic denial, lack of patronage, and public disaffection led to poverty, disorientation, and alienation among the artists of the period. Extremes of personal rebellion, bohemianism, escapism, and mental breakdown wracked their lives. Toward the end of the century, the Prussian invasion of France, the downfall of the decadent monarchy of Louis Napoleon, and the crisis in the emergence of the Third Republic brought the artist and his art to a turning point in history.

In the onrushing tempo of the industrial age and the weltering disorder in personal life, the artist seized upon two exponents of the importance of the individual as an answer to his social rejection and moral anguish. The late nineteenth century posed the riddle of man's existence in a historical frame of reference. Is man free or determined? In the eighteenth century, the artist believed man to be free to think, to reason, to determine his own existence in nature. Now, in the nineteenth century, this belief was challenged head-on in the confluence of shocks and crises. The alienated artist saw himself as a unit of life in a mechanistic, determined, materialistic world. His answer was to seize upon two concepts of the individual: Bergson's philosophy of vitalism, asserting the life force in the individual to be a positive, conscious act of will in governing his present existence; and Freud's psychological investigations into the character structure and personality behavior of the individual, revealed in conscious and subconscious states of being. He saw an answer to the dilemma in his personal existence and artistic creation. In assuming the principles of Bergson and Freud, he constructed a self-contained, introverted, esoteric world. In the anguish of his soul and the torment of his psyche, he created a spiritual-psychological unity, an intuitional-emotional autonomy.

Goya, the progenitor of the modern movement, had reaffirmed the humanist objective to the harsh realities of life in symbolic form, expressive line, and emotional power. But the impact of the intervening years had left their mark on the progeny of the protean Goya. Postimpressionism, fauvism, cubism, expressionism, seeking refuge from the responsibilities imposed by the technological complexities of the twentieth century,

withdrew into a subjective world of egostatic calm, intellectual repose, voluntaristic excitement, and psychoneurotic release. The long road of achievement in art, of communication to men, resolved through the unity of art and science, had come to the edge of a precipice. The dualism was finally ruptured. The crevasse of despair opened up a gulf of conflicting states of experience, of frustration and anxiety, introspection and empathy, conscious and unconscious strivings, disjunctive, half-realized momentary appearances and esoteric symbols of experiences. Anatomical form, the ground plane, principles of reason, spatial structure, control of depth—the world of art presented through empirical perception and objective criteria—were at a point of no return. The primal form in art, the figure of man had become a prisoner of the ego, held incommunicado in a nongravitational space void. The artist had rejected science in art.

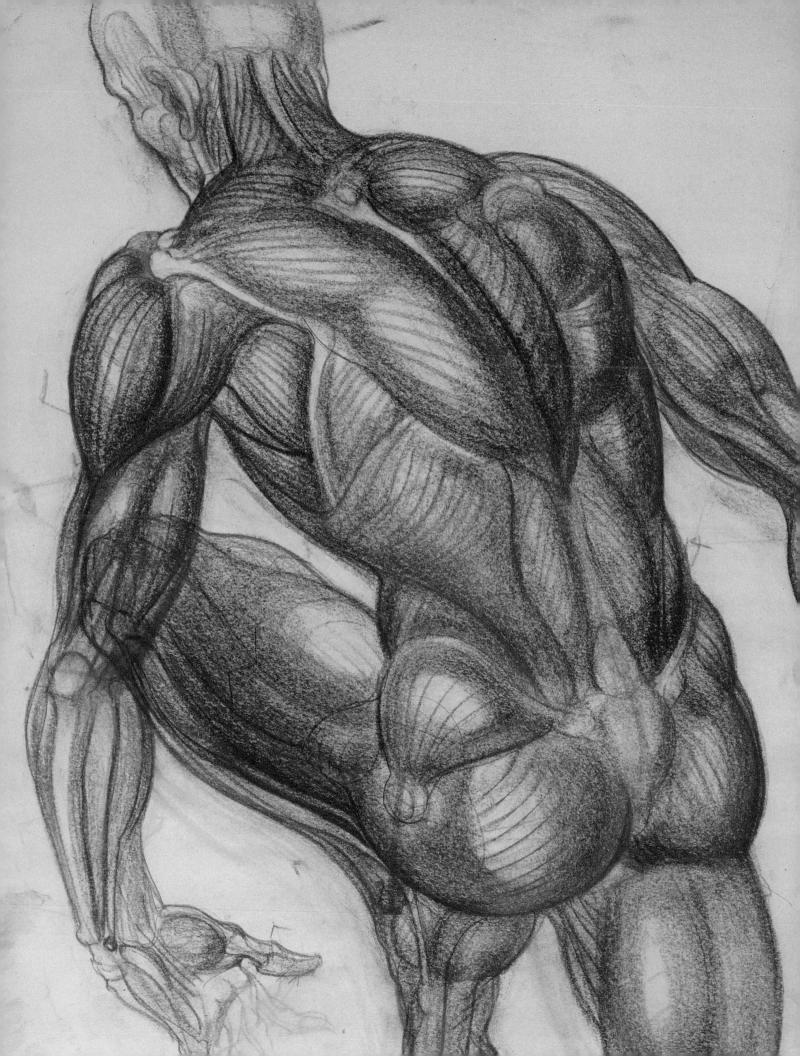

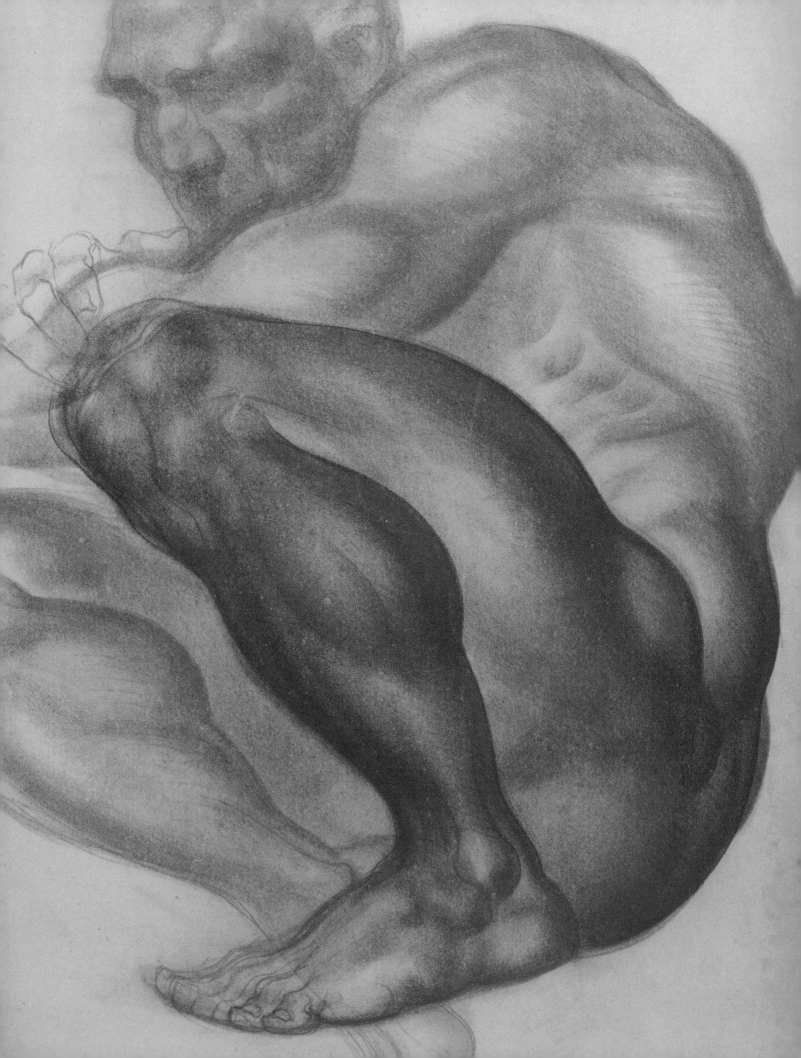

II.

AT TEN O'CLOCK IN THE MORNING, on any day of the week except legal holidays, the typical art museum anywhere in the country is open for visitors. The entrance hall usually leads the average aficionado of art through a series of galleries in orderly progression from one imposing collection to another, presenting the visual history of civilization, the drama of the human mind. As far back as man could reason, his works are there: evidence of the Neolithic, the dawn of civilizations, the antique remains of dynastic power, the classical traditions, the intervening lines of humanist development, the Renaissance and baroque flowering, to the most recent acquisitions of modern and contemporary art; they are all there, more or less, in periodic array. As he progresses leisurely through the halls, the visitor is led through a process of transitions in the ages of man. He is hardly aware of the changes, yet their impact, gradual and moving, is not lost on him. He correlates the concrete visions of the past into a stirring processional of events.

As he reaches the modern age, his eye is delighted with the radiance, the luminosity, and joy of impressionism. Yet he is vaguely disturbed by its unmannerly sketchy appearance, its random spontaneity, its lack of finish, its seeming amateurishness. Then, as he crosses the threshold to the new art, to postimpressionism and beyond, deep into cubism, expressionism, abstraction, and surrealism—their derivations and deviations— the alarm bells begin to ring in his head, the sirens and the fireworks go off, and our aficionado of art—who is not a snob, by the way—is left in a morass of helpless confusion and dismay. The even tenor of his mood is disrupted in the colorific visual violence, the aesthetic assault from the walls. The simple progression is gone; the contact with life is demolished in a pyrotechnic profusion of unrecognizable fulminations.

In the art of the past, there seemed to be no line of visual expression our visitor to the museum could not follow. No matter how far back, even to Paleolithic cave art, he could trace the thread, the primitive urge, the historic need, the humankind. At times, the line stretched thin and tenuous; at others, strong and firm. But always it was there for him to see, a long unbroken line of human succession, linking a vast reach of time, twenty thousand years of change. Now in his own time, in the day when the visitor and modern man have arrived at a new age of invention and discovery, recognizing the demand of every human need and the promised fulfillment of every human dream, the historic line of art communication in human understanding, imperative now more than ever before, has broken down. The new art that thundered down at our receptive visitor to the museum is filled with an eclectic diversity of forms—biomorphic, kinemorphic, psychomorphic, mechanomorphic—all of them intensely personal, subjective expressions of inner states of being. The figure in art, the highest expression of man's visual creative powers, the subject of twenty thousand years of painstaking search, has been reduced to a number, a cipher, an esoteric symbol, a kinesthetic impulse driven by a primitive-emotional urge. Today, anatomical man, for all artistic purposes, is dead.

Art, in the mid-twentieth century, is in a period of critical transition. We are seeing today an extraordinary concentration of effort and energy in the visual arts never before experienced at any time in history. Never has there been so widespread an interest, never have so many individuals participated actively in its creation. Never have we had so much contact with art of all kinds—art from the dim reaches of time, art from across the oceans, art of primitive peoples; art from the past great eras to the modern era; fine art, commercial art, industrial art, technical art, experimental art, psychological art, leisure art, amateur art. It would appear we are seeing a great new Renaissance in visual art, for in the volume of art creation we are witnessing a cultural phenomenon of the first magnitude.

In the frontiers of knowledge and culture, art may be said to be in its heyday of exploration. The exploratory fervor of the sixteenth century, using new logic, new mathematics, new science, opened the unknown areas of the world to commerce and physical contact of peoples and brought out a treasure of artworks to the Western world, which only now, in the twentieth century, is being experienced by artists in our time. Like the riches of the East in an earlier day, this influx of art is beginning to be seen, felt, and assimilated. The day of global exploration is accomplished. Now has begun the day of cultural exploration, some five hundred years later. Yet never has there been so much confusion in the arts as there is today.

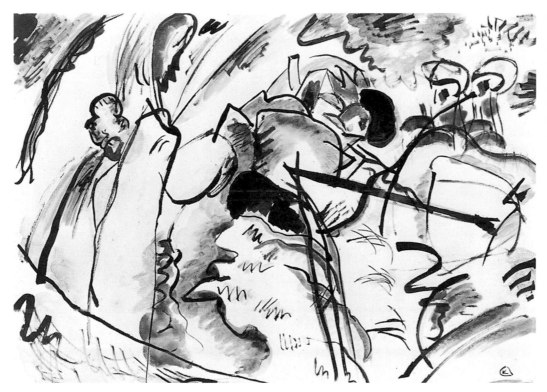

STUDY FOR *PAINTING WITH WHITE FORM*.
INK. WASSILY KANDINSKY (1866–1944). RUSSIAN.
COLLECTION MUSEUM OF MODERN ART,
NEW YORK
(KATHERINE S. DREIER BEQUEST).

The twentieth-century artist appears to be in a state of conflict and disorder. He has a world of art to explore, yet he shows no purpose, no goals. He seems to have lost his sense of direction as he ranges across the uncharted art frontiers. He has rejected the compass; he has thrust aside standards, criteria, definitions; he has renounced science as a tool in the discovery and development of art. He has rejected the human need to relate, to communicate the results of discovery.

If we recognize it is the mission of science to define with clarity and precision the workings of the universe, to relate with order and harmony the new concepts of time, space, and energy into new and better ways of life, we reach the conclusion that science is the most powerful instrumentality in the progress of man. To the artist, however, science is considered an invasion, a hindrance, a stricture upon his free and personal interpretation of the world. He sees the scientist as an intellectual instrument—precise, logical, mathematical, mechanical. He sees himself as a sensitive organ of feeling, emotion, inspiration, and intuition. As a result, the artist rejects science and scientific thinking in the projection of art. Art to be pure, he reasons, must be devoid of science; feeling is not precise; emotion is not mechanical; inspiration is not logical; intuition is not measurable—the artist is no scientist. Attempting to distinguish the work of art from other works of life as a

refinement of cultural endeavor, distinct and separate from the ordinary and commonplace necessities, the artist has in effect said that science prods and pushes with the workaday things to build a better mousetrap, while he, the emotionally endowed aesthete, represents the inspirational work, the filtered aesthetic reflex of society, the fine arts. It is a neat trick of turning the tables; the bohemian wastrel and garret outcast, through intellectual legerdemain and bootstrap levitation, has become an individual of a pure kind. In this state, he rises above plebeian strivings to a position of sophisticated recognition and social grandeur, and from this remote pinnacle surveys the marketplace mediocrity below.

How devastating and destructive a view this is can be gauged by the fact that in every other area of modern life, in every field of endeavor, science merges easily, compatibly, productively—except in the visual arts. Only here is the view held—by artists of all idioms, indeed, the whole of contemporary society—that science and art do not mix, that they are mutually contradictious, irreconcilable. Yet this is a distortion of the truth, a delusion, a self-imposed deception, a retreat from life.

The dislocation of art and science has never been so apparent as it is today, almost a hundred years from the time it first revealed a disturbance in the continuity of art communication. The impressionist rebellion, the last flower of the humanist spirit of the Renaissance, still exhibiting its attachment to scientific precepts in its spectral light and its recorded observations of the momentary life of the people, their work, recreation, and leisure, was too weak a movement to triumph over the entrenched authority of the regressive French Academy. When it withered and died after twenty years of frustration and social exile, the deep space of the picture plane became a barren shell; the landscape closed down into a two-dimensional decorative pattern of shapes; the vibrant pulsating figure, the human analogue, shrank and hardened into an artifact, a constructed intellectual object; the artist's emotional power and insight in human affairs subsided into symbolic outcroppings of tenuous moments of excitation, apprehension, or despair.

In their seizure upon the "immediate" and the "personal," the followers after the impressionists disengaged themselves from every known principle of spatial structure and design. They withdrew from earlier concepts of form, value, color, and image. They worked toward the total rejection of the Academy. In their hatred of the "academic," they extirpated the *scientific legacy of art,* carefully nurtured and marshaled over fifty centuries of historic development, and erased it in a short span of fifty years. In their need to rebel against the "academic," they rebelled against science. They proclaimed the distinction of the "fine arts" and gave it to society as a new description, uniquely different from academic art or the utilitarian commercial art. They presented to the entire contemporary

generation of society and the artists who followed the doctrine that "art" was above scientific discipline, above definitions and criteria. The need to communicate in art, to be responsible for the exchange of art experience into human experience, was considered to be an anachronistic demand of aggressive academic vulgarity, and was held beneath contempt. The rebellion against the "sterile," the "mechanical," the "academic"—truly a human cry of anguish—had become a distortion and a delusion. The fine artist had turned his back on reality. He became an incoherent high priest of good taste, an absolute arbiter of egocentric mirror-image art, a melancholy, involuted microcosm turned in upon itself to an inevitable dead end.

Yet the impulse to art is unquestionably the impulse to life. The art process and the life process are an indissoluble entity. The components of one are the components of the other. They may be uneven, but never alien; they may be out of joint, but never out of union. The need to create, to synthesize experience, is a primal force in art. Because it is the

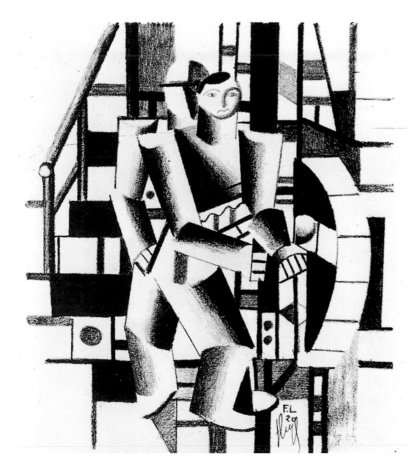

TWO MEN.
LITHOGRAPH.
FERNAND LÉGER
(1881–1955).
FRENCH. COLLECTION
MUSEUM OF MODERN ART,
NEW YORK (GIFT OF
EDGAR KAUFMANN JR.).

distilled essence of perception and experience, art needs its adherence to life. But the work of art of today needs, more than ever before, the energizing transfusion of *commonly shared experiences*. It needs a *conscious agreement* with the cross-fertilizing, wider empirical objective.

Artists of today stand at the crossroads of immense opportunities and possibilities. What they have discarded earlier in the scientific discipline of art as academic, inhibitory, and repressive of free expression they now substitute, strangely, with *new* science! In their search for a new basis of art without restraints, they lay hold on the world's storehouse of art, which they now have at their command. They feel the impact of new scientific fields and attempt to resolve these in visual terms. Virtually the entire gamut of human and social discovery, scientific and technical advances have found their place in the free interplay of the design structure. Never in the entire history of art have so many variations of art expression occurred in a single given era. The range of concepts and movements is truly enormous; even as this is being written, new ones are being born. The listing of a few at random is to indicate the multiplicity of reactions to the technical-scientific-analytical age.

Thus, starting with impressionism, we have: pointillism, neoimpressionism, postimpressionism, fauvism, cubism (analytical and synthetic), expressionism (three schools, perhaps more), Orphism, surrealism, abstraction, dadaism, futurism, nonobjectivism, neoplasticism, constructivism, purism, Bauhaus, primitivism, social realism, dynamism, abstract expressionism, abstract surrealism, mobiles, stabiles—and on and on, et cetera. The list seems endless. In these definitions can be seen some of the descriptive leads to the larger environment of the age, where the art form has attempted to embrace psychology and psychoanalysis, natural history, biology, chemistry, physics, kinetics, mechanics, engineering, archaeology, anthropology, microscopy, telescopy, etc. In the fission and fusion of two-dimensional space, the artist uses science pragmatically, experientially, without whole concepts. Nevertheless, it forms the basis of his art. But it is not a complete art. For, in the practice of it, the artist simultaneously rejects the existence and influence of any scientific rigor, control, criterion, or standard. His art, perforce, without objective direction, releases a welter of exquisitely personal, eclectic minutiae.

If we quickly scan the art horizon and examine the amazing output of art today, we find endless experiments in textures; inconclusive shapes, masses, forms; positive and negative space; tensions of line and mass; contrasts in color; line variations; eclectic working together of art old and new; cell structure; automatic writing—endless, precious, purist variations, powerless to come to grips with itself, to proclaim any

direction or value judgment for others. The figure in art—always the touchstone of the art of any era—has become the visual admission of the artist's failure to cope with the ethical-moral, social-human needs of our time. It is a symbol of dislocation and depersonalization; the ideograph of the alienated man, insecure, lonely, without fiber; the portrait of the artist, the autograph of the author.

Probably the most disturbing phenomenon in the art of the current century, a result of the dislocation in the dualism of art and science, is the profoundly pervasive indifference of the whole contemporary generation of artists to formulate a clear-cut definition of art itself. The obscurantism, the evasive arguments and denials, the lack of any direct, forthright statement, is evidence of a deep-going crisis in art. With the exception of a few scholars, nowhere in the field of art has there appeared a challenging assertion to say what art is in our time.

In the social arena of modern living, the most engaging diversion is the extensive practice of generalized and personal analysis. Because we live in a technical-scientific-analytical age of calculating machines and statistical truths, we respond to the powerful pressures of analytical behavior—to define, to clarify, to identify. It is a great game of analysis; dissection and decortication of the underlying mechanisms in every segment of the social structure, from psychoanalysis to social surgery. We practice the analytical game everywhere except in the fine arts. Here, in the arts, the emotional fog rolls in, intellectual inertia overtakes us, and the cultural swamp remains undefined, unexplored. Words like *style* and *taste* have no clear meaning except, perhaps, in commercial usage. And the special caste terminology—*feeling, intuition, inspiration, perception, creativity*—are ritualistic ceremonial expressions of artists, undefiled by simple definitions except in the laboratories of clinical psychologists.

The special word *art* is a sacred temple, a mysterious inner sanctum of artistic pursuit, where magical intellectual powers interact with primordial outpourings of the irrational subconscious. Paraphrasing Thucydides, who has put it abruptly: When common, everyday words lose their definitions and meanings, there is a *general crisis* in a given field. To go further, when art terminology has lost its power to convey sense, idea, or meaning of art expression, then the artist, the art field, the whole cultural endeavor, is conflicted, confused, and disordered; it becomes a chaotic wasteland, a lost continent of the culture.

The net result has been to let loose a carnival of art dilettantism and chi-chi art sophistication concealed behind an imposing front of synthetic rhetoric, aesthetic lyricism, and emotional bathos. The state of art today is such that it can now be performed by tyros and amateurs with virtually no study, preparation, or training. In galleries and exhibitions,

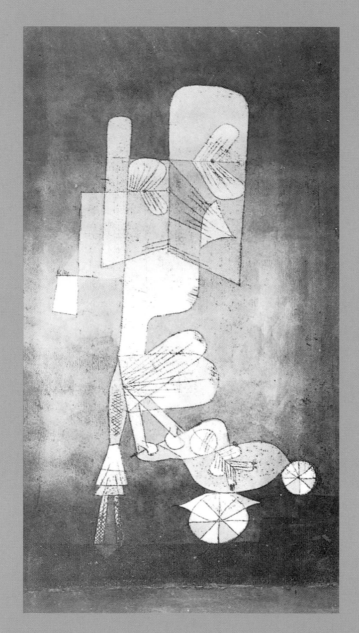

*GIRL WITH
DOLL CARRIAGE.*
PAUL KLEE
(1879–1940). SWISS.
COLLECTION MUSEUM
OF MODERN ART.

the amateur aesthete can now compete on equal terms with the seasoned, knowledgeable master with such facility that hardly anyone, frequently not even art connoisseurs and critics, can tell good art from bad art, amateur art from professional art. When the quest for brevity and simplicity has been reduced to infantile primitivism, we have lost the validity of concepts; when the creative urge to reveal life has been distorted into a wayward surge of undirected energy, we have lost control of direction and experimentation; when the search for clarity and order has been diverted to piecing out a meaningless jargon of amateur misbehavior, we have lost our artistic heritage; when the need for definitions, standards, and criteria has been seduced by vacuous emotional mumblings, we have seen the perversion of the philosophy of art and aesthetics. When the artist has surrendered his status, his authority, his principles, his professionalism, then the amateur has taken over, and the jungle is upon us.

The problem of the amateur in art is really the problem of the artist in society. To say that the amateur has invaded the arts, and that the fine arts are becoming an amateur art, is to say that the artist has defaulted in his obligation to the social environment. But this view alone does not face the issue squarely, for it would force the conclusion that the artist alone is responsible for the neglect and deterioration of art. To say that the artist has rejected the norms of living, has removed himself from society, has turned away from reality to promote his inner personal image of life and art-for-art's-sake isolationism, is to say the exile prefers the desert, the suicide enjoys cutting his veins, the tortured man relishes his anguished cries for help. In truth, these are but the pathetic attempts of the withered, truncated man to become a whole man. The issue at hand is really a dual problem; it is not only the artist's inbreeding and involution—it is also society's forced estrangement and neglect of the artist. If there is a crisis in art, a disintegration of its moral fiber, a decay of its historical precepts and philosophical virtues, it is because society *first* has disavowed and disabled it as an intellectual resource, a cultural necessity, a social and educative force. It has refused its permission to be integrated with the technological, scientific advances in our time, except as a utilitarian, commercial, ancillary art. To engage a solution on this basis needs a moral reawakening of society and a conceptual reworking of art.

The reestablishment of self-control in the artist and social respect for art devolves on creating again a new dualism of art and science in the twentieth century. The obscure terminology must be clarified and attached to commonly shared associations; personal values must be defined according to generalized experience; the personal subjective purpose must be widened to embrace the broader social goal. The immediate and urgent necessity, the first order of the day, is to redefine the old word *art*. The clichés, the

nonsense, must be stripped off. Art must have a new interpretation, infused with new meanings and values, in order to find its equal place with other positive cultural pursuits in our time. It must mean as much to the population as medicine, surgery, bacteriology—or physics, engineering, architecture—or steak, mashed potatoes, apple pie. It must be executed so ably and understood so well that it will stand strong and firm as a skyscraper does when it is done well—or it will collapse in ruins when it is not. Art must be refined into a critical intellectual tool to meet these challenges. New cutting edges must be given to the old "saw," fine-honed and sharp, diamond-hard and tough, to stand up under the friction and abrasion of life. To be "art," it should be made responsible for communication of its ideas and concepts; it should reflect the life and times of the artist, his integrity, his ethics, his democratic ideals in the progress of man; it should show his developed skill and judgment in projecting significant, expressive form; it should reveal invention and originality in transmitting the aesthetic experience; and, above all, it should arise out of the environment, the social-human-scientific culture base as the controlling factor in its creation.

This does not mean that strictures or rigid conventions must be placed on the artist; nor does it say that experimentation or freedom in personal expression should be curtailed or abrogated; nor does it propose that there is only one way of seeing the world around us, one outlook, one style or method of approach. It does not ask the artist to obey or be subservient to any fixed rule, regulation, dogma, or tradition. It does not set up absolutes of authority, or impose conditioned reflexes of conformism. However, it does ask the artist to respect and rely on the positive norms, values, and traditions that still operate and still function in the study and preparation of the artist, that still apply in the cultural background of modern art creation. These should be seen as the educative resource, the imperative precondition for the survival and growth of art.

Socrates, we are told, attempting to probe into the nature of law, speaks of the laws of men as a response to the social pressures that arise out of human conditions in the natural environment. And therefore, he argues with penetrating insight, to understand the nature of law we must first understand the law of nature. The liberating principle of art lies precisely here, in the Socratic approach to the conjoined relationship of two mutually attracted, interacting forces—man and nature, nature and man. This *synergistic principle*, if we can refer to it as such, argues for a relationship of ideas, in Toynbee's words, in a context of challenge and response, response and challenge. It seizes upon diverse attitudes of thought, probing for intrinsic attributes of contraction and expansion, refinement and extension; it enlarges the field of intellectual vision, and refines the area of critical judgment; it tends to limit subjective bias and mental myopia.

If we apply the principle to one of the central problems of art, the presence of the amateur in the fine arts, we might uncover these provocative correlations: To understand the amateur of art, we must first understand the art of the amateur; to recognize the professional of art, we must recognize the art of the professional; to explain the presence of the amateur in professional art, we must explain the presence of the professional in amateur art. Suddenly, the critical questions rise to the surface: In how many ways is professional art an amateur art? Can professional art be easily imitated by the amateur? The way is open for other challenging assertions. For instance, that much-abused old habit, skill: To discover the skill in art, let us first discover the art in skill. Or: To ask where the old traditions are in modern art, we must first ask where the modern is in the old art. This is not a mere game of idea inversions or word juggling. If it were, the new statement of ideas in reverse would not be so sticky with uneasy, astringent meanings that quickly leap to mind. Nor is this a conclusive demonstration posed as an answer to the problems of art. It is an exercise of reason, an analytical approach in the examination of hitherto unassailable notions. It might be seen as the first incision in cliché and slogan surgery to arrest the deterioration in art.

A new dualism of art and science, if we can agree on the premise as indispensable to art today (as it was in the Renaissance), must again seek to introduce commonly understood criteria and standards. We must reestablish certain major links with the past as historical background, consistent with art progress today. We must incorporate the old traditions that are *still* viable, *still alive* today. But which are the living traditions and how can we be sure? Let us apply the synergistic principle and make an incision.

Our civilization is predominantly an advanced technical age of science. It developed its abundant greatness from earlier civilizations and beginnings. Now, a question: Where do the earlier civilizations appear in the modern age of science? We must first ask, where does the modern age of science appear in earlier civilizations? The answer seems clear: in those civilizations that have made *scientific* contributions. The reason we search out the older civilizations, and attach their findings to ours, is a *scientific reason*. This is true historically for our humanist-democratic institutions as well. Therefore, the answer to the older traditions in modern art lies in the context of the larger framework; those old art traditions that tend to live on have survived for a *humanist-democratic scientific reason*.

Where modern art has precisely been interested in the art of the world's cultures, across the seas and in the past, is the human reason, the scientific reason. But it has done this willy-nilly, capriciously, driven by impulse rather than direction. It has chosen,

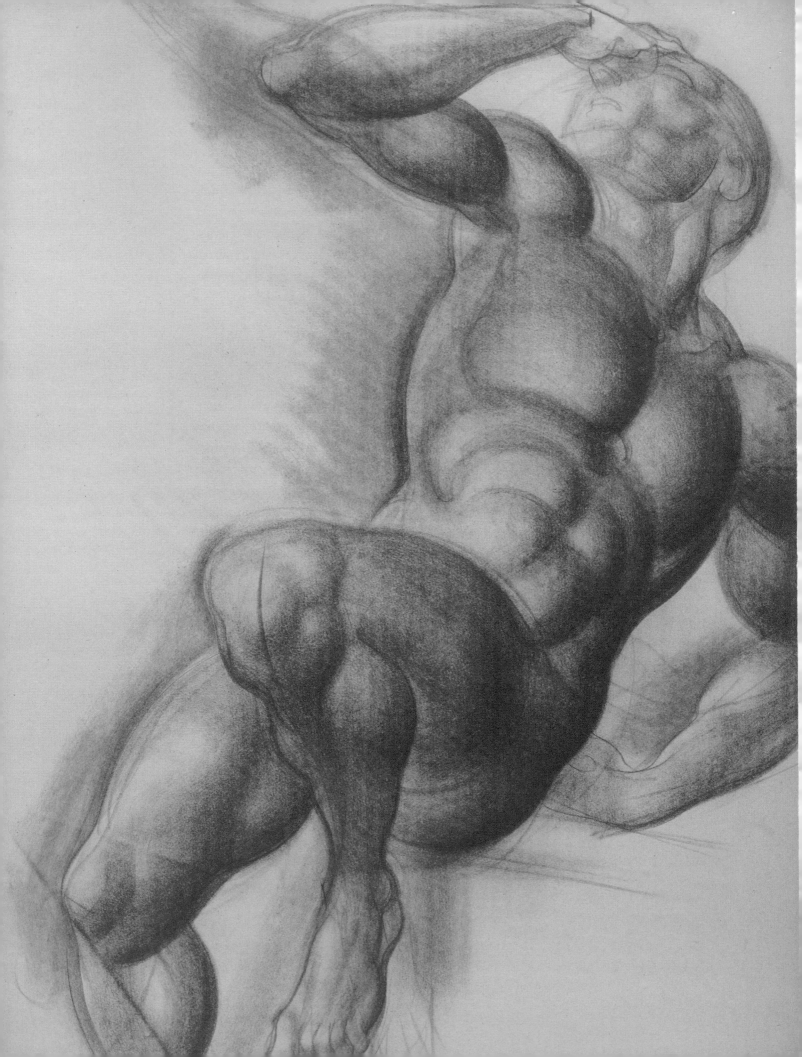

III.

OVERVIEW
THE FIGURE
IN ART
HISTORICALLY
DEVELOPED

WHATEVER MAY BE SAID of the historical development of art generally, the human figure presents the deepest insight into the social-cultural concepts of art, from aboriginal tribal culture to the most advanced civilizations, past or present. If art can be seen as the refined endeavor of human aspirations, the figure in art is its most important expressive concentration. The inherent problem in its artistic invention, whatever its cultural source, is the attempt by the artist to resolve his physical experience and aesthetic perception into a meaningful, significant visual form. But the limitations of his social-cultural viewpoint interpose a mental screen between the countless physical experiences and his capacity to absorb them. Thus, the artist's perceptions are refined into a condensed aesthetic form—the art style of his social environment. To speak of a style in the narrow sense of the individual artist is to discover personal mannerisms and techniques in the application of tools and media to surfaces and materials in an individualized, expressive way. Attributes of this kind are easily distinguished and are firmly imbedded in personal works of art as much as the autograph or signature of the artist is part of the art. To enlarge the field of definition, however, to embrace generations of artists in a sociological framework of culture, that is, a given era in art, is to speak of the general art style of the time. If the analogy of the personal signature or handwriting holds for the individual artist, then the basic language construction, generalized expressions, idioms, and colloquialisms could be said to belong to all the people of his period as well as to the artist. Thus, to explain the art style of an era, an overview is taken of the historical matrix of the period, the major events and their impacts on living process and thought process, and their general influences on artists. These are broadly chiseled, in bas-relief, as it were, to present the procession of the human figure in limited, significant, visual conceptions of art.

SURVIVAL MAN: THE FIGURE OF NECESSITY

PERIOD Upper Paleolithic Age (Old Stone Age), in Western Europe; Aurignacian Period (CIRCA 20,000 B.C.–10,000 B.C.)

BACKGROUND The figure of Paleolithic man is one of stern necessity, of hardship and privation in a primitive, antagonistic environment. The figure he painted on the walls of his cave or carved on artifacts of use were mostly animals—more important to him than human figures. They are figures that arise out of the immediate and pressing need to surmount the daily attrition of want, scarcity, and hunger. Because early man lived a life of personal privation, he created concretely real, objectively important figures of animals, his figures of necessity for survival. Figures of himself were small, nonpersonalized, and unimportant. To him, his cave animals were dimensionally real, as real as Paleolithic man saw them in physical existence. They are not idea, spirit, or soul, but extended living embodiment in actual reality.

POLYCHROME BISON (DETAIL FROM A CAVE PAINTING). ALTAMIRA, SPAIN. COURTESY OF THE AMERICAN MUSEUM OF NATURAL HISTORY.

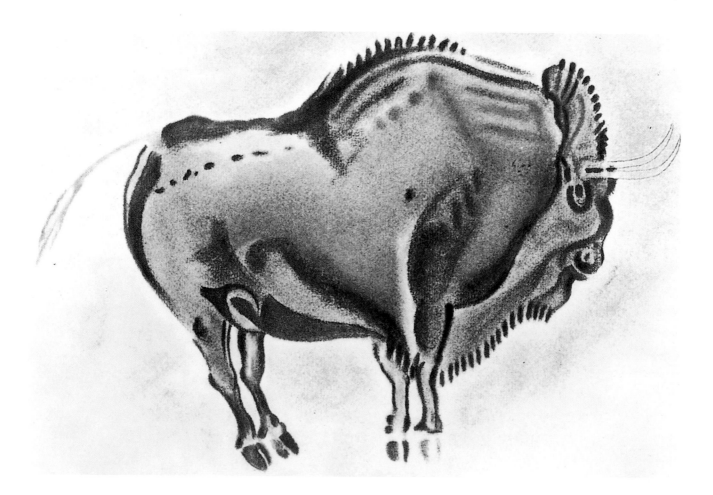

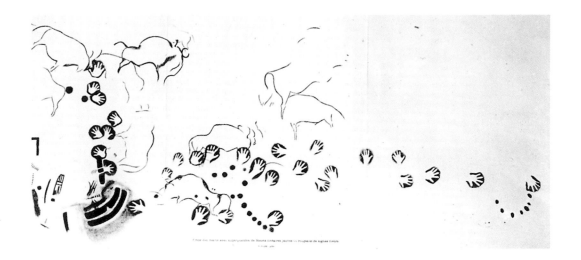

To him, *what could not be experienced through concrete physical contact could not be depicted;* the depiction itself was the parallel extended physical reality. These figures are as much reality to a primitive, pragmatic mind, and essentially alive, as reflections in water are alive, as footprints are along the muddy banks of a stream, as the imprint of a hand is in soft clay, as the shape of buttocks or body forms are when they are pressed into soft earth. Early man must have observed these phenomena of immediate, concrete impressions. Thus, they are the first recognizable visual realizations of "form" in graphic experience in the history of the human race. To see his footprints as moving, as real, as his other-same-self, to see animals leave footprints and bodyprints as well, led to the higher recognition of tracing the process on the walls of his cave. They are, therefore, not magical but starkly real, other-same-self depictive paintings of immediate, concurrent physical actuality; to drive an arrow into the animal figure ensured the success of the ensuing hunt.

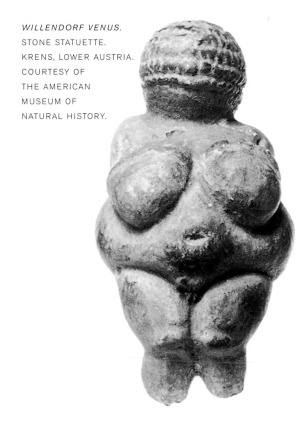

ATTRIBUTES Cave art shows in no way abstract, symbolic, or expressive figures. They do not in any way approach the modern simplification of form; nor do they in any sense employ refinement or stylization of idea. They are the very best

the caveman could do. His animals look more dimensionally real because he saw them as large, powerful, and vitally important to his survival. His human figures are nondimensional and flat because of his dimly realized, undeveloped concept of self in a small, nonindividuated tribal culture. Works such as these are the prehistoric antecedents of primitive magic figures, and they survive in the present day through superstitious ritual practice in the analogous use of voodoo figures, hate effigies, and devil dolls.

ANCESTRAL MAN: THE FIGURE OF MAGIC

PERIOD Neolithic Age (New Stone Age), widespread in Europe, Africa, Asia, the Americas; persists in many areas today (CIRCA 10,000 B.C.—4000 B.C.)

BACKGROUND The figure of ancestral man is a magical entity, endowed with supernatural qualities, animated with spirits of powerful ancestors and forces of nature. Modern primitive man, like his earlier counterpart, attempts to control nature under difficult and disparate conditions of life. With his ceremonial figures, idols, masks, totems, and charms, used in spirit-worship rituals, he hopes to exercise control over life and death; famine, disease, and war; fertility, bounty, and harvest. The figure of magic is used to control cause and effect in nature. It is a survival of the life process after death, and a return of the spirit powers into the life process.

ATTRIBUTES Ancestral man is not the living figure of actual existence as the figure of necessity is in cave art. Because it is a ceremonial figure, animated with qualities of supernatural existence, it is formal and strict according to ritual conventions and traditions. It is a depictive symbol rather than an image; it leans to simplified form, rather than the real. Its forms are undifferentiated, impersonal reductions into an abstract, rigid format, generally symmetrical, static, and severe. Frequently, such forms may show a wide variety of decorative motifs, but it is not decoration for aesthetic reasons or intrinsic embellishment. Rather, it is a decoration of meaning, purpose, and use, consistent with the original purpose of the ritual figure itself—that is, to enlarge upon its magical properties, its ability to control nature. Because the random forces of nature are unpredictable and frequently disastrous, the figure of magic often shows severity, fear, terror, and demonic violence. More often, such figures are inscrutable and remote, enigmatic as are the imponderable natural forces. They are humorless as a whole; but when they show humor, it is a terrible kind, arising from cruelty, irrationality, and retribution for misdeeds and misbehavior toward the spirits.

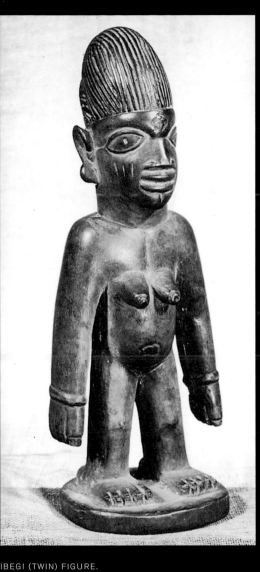

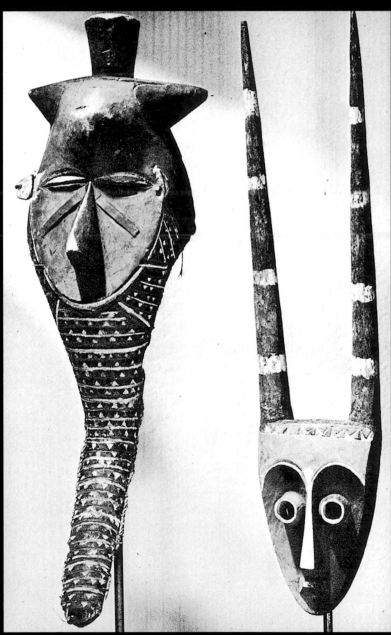

CEREMONIAL
ELEPHANT MASK AND
ANTELOPE MASK.
WOOD. BAPENDE, BELGIAN
CONGO. COURTESY OF
THE AMERICAN MUSEUM
OF NATURAL HISTORY.

IBEGI (TWIN) FIGURE.
FETISH FIGURE KEPT BY
A SURVIVING TWIN TO
APPEASE THE SPIRIT OF
HIS DEAD SIBLING. WOOD
STATUETTE. YORUBA,
NIGERIA. COURTESY OF
THE AMERICAN MUSEUM
OF NATURAL HISTORY.

YAMANTAKA, LORD OF
THE UNIVERSE, WITH
HIS SHAKTI. BRONZE
STATUETTE. TIBET.
COURTESY OF
THE METROPOLITAN
MUSEUM OF ART.

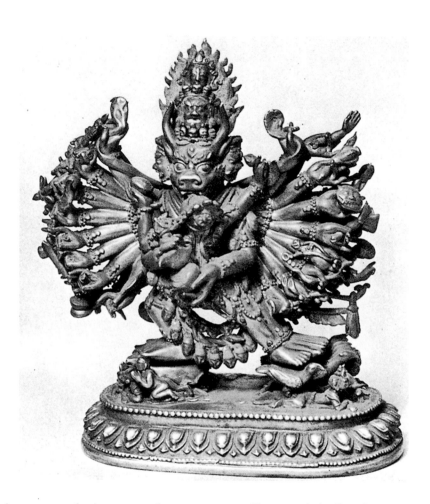

in design, and project an enduring eternal appearance. Characteristically, they are frequently made of durable stone and metals. Their placement in great temples, shrines, sanctums, and recessed niches gives them a frontal, abstract, somewhat unnatural look. Because they are part of the sacred structure that houses them, their position in closed places and their frontality of forms show they were meant to be seen from *one viewing direction only*. Portraits of great priests and royal god figures are symbolic portraits subsumed within the depiction of the god image with whom they are identified and whose worship they supervise. It is largely in this age that extensive decoration develops representing natural forces that the gods control. These are largely two-dimensional, symmetrical symbols revealing the bounty of plants and crops, fertility of animals, power and capability in war.

IDEAL MAN: THE FIGURE OF PERFECTION

PERIOD Age of Idealism, in southeastern Europe; Greek and Roman civilizations (CIRCA 900 B.C–A.D. 450)

BACKGROUND The transition from the dynastic authoritarian civilizations to the socially and culturally more advanced civilizations of Greece and Rome rests on the emerging relative importance of the individual, the persona, in society. Greece, sitting astride the Mediterranean strategically close to three continents, became an early great maritime power, inviting trade, migration of peoples, and cultural contact into its orbit.

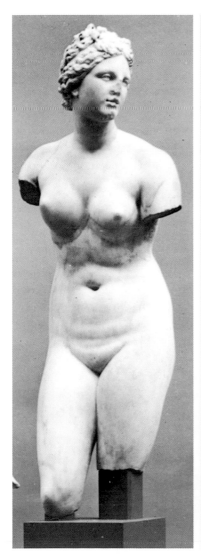 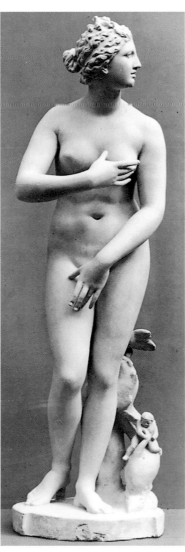

LEFT:
APHRODITE.
ANCIENT REPLICA
OF A GREEK WORK.
MARBLE STATUE.
COURTESY OF THE
METROPOLITAN
MUSEUM OF ART.

RIGHT:
MEDICI VENUS.
REPLICA OF ORIGINAL
IN THE UFFIZI
GALLERY, FLORENCE.
MARBLE STATUE.
GREECE.
COURTESY OF THE
METROPOLITAN
MUSEUM OF ART.

These gave rise to the freer, more flexible, dynamic social institutions in the Hellenistic world of soldier-citizens, democratic government, and political equality. As individualism developed in Greece and in her later Roman prototype, rational, prescientific observations of nature grew, and belief in the unity of man and gods in nature evolved, predicated on the existence of universal truth. Religion changed from the worship of nature gods to worship of the virtues and goodness of nature in gods. They believed in the Idea of the Good, the creative cause of the universe and ideal, perfect states of being, and laid emphasis on harmony, mathematical order, and perfection of the universal world, in coexistence and unity with the personal world.

ATTRIBUTES Greek and Roman art thus attempted to realize ideas of perfection in men and women as gods, derived from the real, empirically observed world of nature and universal truth. The figure of perfection is, therefore, constituted as a living figure, conceived according to reasoned mathematical proportions of ideal criteria. Because they are mortal and physical, these figures show carefully observed, personalized human form. Their attached god-ideal virtues, however, give them a symbolic grace, elegance, and charm, sustained in an aura of ideal serenity and dignity. Surface form is correct, refined, tactile, and sensual, projecting heroic attributes rather than the commonplace. The Greek figure of perfection differs from the structured two-dimensional frontality of Egyptian art in the living movement of the body, supple athletic form, resilient tensile grace, dynamically balanced in three-dimensional spatial depth—the art-style representation of individual importance in Hellenistic society.

MORAL MAN: THE FIGURE OF PIETY

PERIOD The Middle Ages, in Europe; Western civilization (Early Christian, Gothic, Scholastic periods) (CIRCA A.D. 500–A.D. 1400)

BACKGROUND The decline of Roman institutions and Hellenistic culture after the fall of the empire left Europe in a state of anarchy and decay. It was supplanted by medieval culture in the rise of feudalism, the revival of learning in the church, and the development of urban centers and trade in small principalities and duchies. The acceptance and spread of Christian doctrine brought cohesion in languages, thought, and culture in the West, in spite of the serfdom of people, warring princes, and chaotic conditions of life. Christianity replaced paganism and pantheism with a monotheistic moral religion, based on the belief that the phenomena of nature are the works of Divine Authority, that man is the reflection of God. Emphasis was placed on the virtu-

CRUCIFIXION
WITH THE VIRGIN
AND ST. JOHN.
BRONZE PLAQUE.
ELEVENTH CENTURY.
COURTESY OF THE
METROPOLITAN
MUSEUM OF ART.

ous, good life; man must choose between good and evil, the moral and immoral, if he is to be judged for his reward in heaven or punishment in hell. The goal of man's life was the good of his soul; his earthly body was the agency through which he would receive the eventual judgment. The mind of medieval man was always fixed on moral values and thoughts of life after death. Belief in the Second Coming of Christ as the first millennium drew near was a powerful influence on him; the old prophecies of doom and apocalyptic disaster filled his thoughts with the visions and anguish of the Last Judgment. The ascetic life, the austere outlook, deep piety, and acts of faith in response to the warnings of earthly sin and eternal punishment, were characteristic of the culture of the age.

ATTRIBUTES The figure of moral man, developed under the aegis of the church, was a tensely severe, deeply emotive projection showing extremes of fear, terror, spiritual torment, and religious ecstasy; otherwise, it presented an expressionless, austerely pious, ascetic spirituality in a withdrawn acceptance of fate. Because these figures are frequently seen in niches, panels, portals, gateways, and arches, they tend to be elongated and structured in the shallow, enclosed places assigned to them. In form, they are strict, wooden, stylized, symbolic distortions. The feudal hierarchy in society often reflects the hierarchy of figure sizes and figure positions according to their relative religious significance. Thus, Christ and the saints are shown much larger in scale than the worshipers below them. The tier perspective of this period is a product of feudal strictures and conventions. The isolation of shapes in their encapsulated spaces produces closed-in forms, abstract patterns within the limited depth of field. They are iconographic symbols in meaning and purpose; as such, while they serve a decorative end, they promulgate the idea that the church is haven and refuge from the evils of earthly existence.

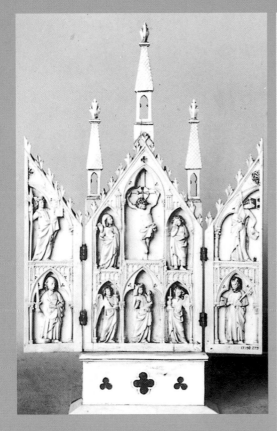

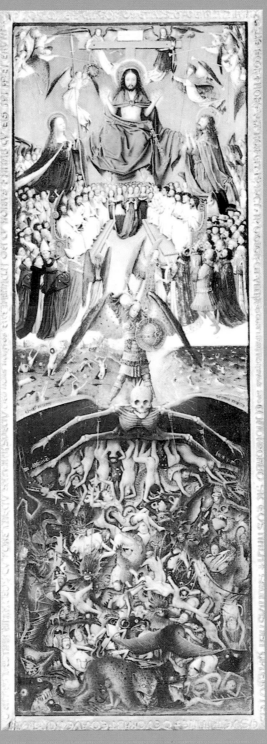

ABOVE:
TRIPTYCH. IVORY.
FOURTEENTH
CENTURY. ITALIAN.
COURTESY OF
THE METROPOLITAN
MUSEUM OF ART.

RIGHT:
THE LAST JUDGMENT.
OIL ON WOOD.
JAN VAN EYCK (D. 1441).
FLEMISH. COURTESY
OF THE METROPOLITAN
MUSEUM OF ART.

UNIVERSAL MAN: THE FIGURE OF PASSION

PERIOD Age of Humanism, in Europe; Renaissance era
(CIRCA A.D. 1400— A.D. 1600)

BACKGROUND Revival of learning in scholastic thought of the Middle Ages, advanced by the church in the spread of Christian belief, sought to regain the cultural heritage of Greece and Rome after the dark period in Europe. Idealism in philosophy, rationalism in thought, and individualism in society were merged in the Christian moral doctrine of the good life and the equality of men in the eyes of God. Scholastic philosophy propounded the humanist belief that faith and science could exist together for the betterment of mankind. The objective of the Renaissance, therefore, was to strive for an increased awareness of the processes of nature as a discovery of the works of God. An inevitable chain of progress in the life of men developed. The observation of nature ushered in the scientific age. Discoveries of the objective world, man and his place in nature, led to challenging concepts that ultimately assailed the conservatism of secular and religious authority. Growth of science, invention, exploration, productivity, nationalism, and new wealth brought the emerging individual consciousness to a crossroads in history and in art. The modern age had been born.

ATTRIBUTES In the figure of humanism, the Renaissance artists saw man as a monumental form, a figure of grandeur and hope, suffused with the longings, the strivings, and the passions of universal mankind. Still reflecting its medieval influences in the moral life, it moved to a new stage in aesthetic and emotive power from its precursor. In its correct anatomical forms, vital and writhing with energy, it symbolized life as it might be. It showed a consanguinity with reason and nature, with belief in God, with faith in man. In figure structure, it projected tensions and diagonal thrusts across great flexible arabesques of linear movement. Surfaces tended to be perfected according to the classical Greek ideal; linear contours were tactile, showing supple, muscular grace and anatomical clarity; form was heroic and strove for the monumental; solidity and enduring significance above and beyond ordinary experience were its functional aim. The Renaissance figure in

sculpture was never meant to be seen from one position only, but in the round, in a three-dimensional space. In painting, it was given its eternal, awe-inspiring effect through its architectonic structure, its symmetry and spatial balance, while its panoramic universality presented the moving, aspiring transcendental man of hope and passion.

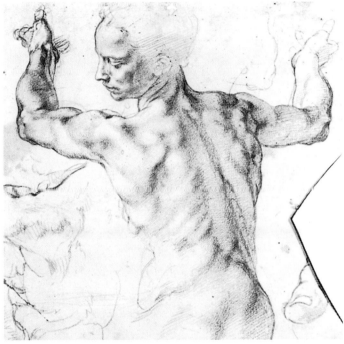

STUDIES FOR THE
LIBYAN SIBYL.
RED CHALK.
MICHELANGELO
(1475–1564). ITALIAN.
COURTESY OF THE
METROPOLITAN
MUSEUM OF ART.

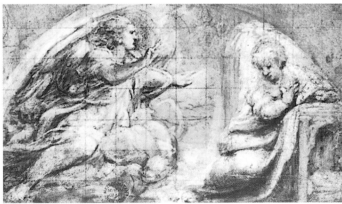

THE ANNUNCIATION.
CHALK WITH GOUACHE.
CORREGGIO (1489–1534).
ITALIAN. COURTESY
OF THE METROPOLITAN
MUSEUM OF ART.

INDIVIDUAL MAN: THE FIGURE OF PERSONALITY

PERIOD Age of Enlightenment, in Europe; baroque era
(CIRCA A.D. 1600–A.D. 1800)

BACKGROUND The growing fervor of nationalism, the increasing reliance on rational thought, and the advancing importance of the individual marked the culminating tensions and crises of absolute royal power and orthodox religious authority in the baroque era. The continuing movement in exploration, scientific progress and invention, the Reformation, the growth of mercantilism, and the diffusion of wealth in the rise of the powerful merchant-bourgeois class gave the Renaissance-humanist aspirations a new surge forward. Libertarian ideals caught the imagination of men everywhere: in England, the Glorious Revolution; in the New World, the American democracy; in France, the First Republic. The art of the period reflected the unease and the changing character of the times. It was an art based importantly on the human individual, on naturalism in outlook, on realism in insight. It was essentially an art of the portrait; the monumental in art was reduced to a representation of genre man in his social milieu; the heroic symbolic generalization was particularized to embrace the ordinary personal image. The feminine figure appeared for the first time in history as a nonidealized, emotional, living, pulsating form, respected as an equal to her contemporary opposite in art. The landscape evolved as a correlated entity with the portrait of the individual in his substantive background. The courtly, the refined, the ordinary people prevailed. The moods of nature fused with the moods of man; the flux of season, weather, and time of day coincided with the drama of feelings, emotions, and passions. The spectacle of the natural physical world merged in endless continuity with the individual human world.

ATTRIBUTES The art of the baroque emphasized chiaroscuro light on human fugitive skin surfaces, as distinguished from arbitrary monumental heroic sculpture form. It developed plasticity of surfaces as well as tactility of contours. In color, it changed the dense, monochromatic values of darkness into the luminous, chromatic transparencies of shadows. It produced the atmosphericity of spatial volume in conjunction with the planimetric recession of perspective. It created the surge toward the momentary and the spontaneous, the emotive and the expressive in human depiction, as differentiated from the stable and the controlled, the devotional and the significant in the enduring Renaissance tableaux. Symmetry and formalism were supplanted by dynamic imbalance and nonformality. The linear contour, the impeccable surface in painting, gave way to diffusion of edges, and brushed-in painterly surfaces. Sincerity, sympathy, motion, and vitality of human personality was the goal of the baroque in a time of dynamism and tension in human affairs.

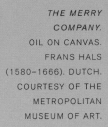

*THE MERRY
COMPANY.*
OIL ON CANVAS.
FRANS HALS
(1580–1666). DUTCH.
COURTESY OF THE
METROPOLITAN
MUSEUM OF ART.

*OLD WOMAN
CUTTING HER NAILS.*
OIL ON CANVAS.
REMBRANDT VAN RIJN
(1606–1669). DUTCH.
COURTESY OF THE
METROPOLITAN
MUSEUM OF ART.

PERSONAL MAN: THE FIGURE OF PATHOS

PERIOD Industrial Age, in Europe; romantic, realist, impressionist periods (CIRCA A.D. 1800–A.D. 1900)

BACKGROUND The results of eighteenth-century rationalism, free thought, and scientific and social progress brought the productivity of the machine age with its new techniques in communication, commercial expansion, and competition between nations and social classes to produce conflicts and crises in the leading countries of Europe. Heavy blows were directed against conservatism in government and social institutions; in France, especially, Napoleonic authoritarianism provoked the bitterest antagonism. The art of the era developed tendencies to nonconformism; patronage was held out to those artists who reflected conservative viewpoints and academic traditions; those who defied the strictures were rejected and scorned. Resistance gave way to rebellion in subject matter and style, in unorthodox, nonacademic experimentation, in subjective, emotive leanings. Archaeological discoveries, impelled by the fruits of Napoleonic conquest, anthropological beginnings in research of early cultures, growth of public museums and collections of historical, exotic, and Oriental art gave impulse to new expressive forms and independent movements in art. In the artist's desire for respect, to maintain personal dignity, to espouse libertarian views, to work freely without restraints, he sought release in rebellion, isolation in personal self-torture and exile, escape in bohemian dissolution, and exclusion in intellectual withdrawal and emotional fantasy.

ATTRIBUTES The art of this period reveals a diversity of figure interpretations. While the portrait continues, it is not a major force as it was in the baroque. Figures tend to be minimized within the landscape; the landscape becomes a major activity; and there is a new tendency to paint still life as the increasing concentration in subject matter. It is as if the artist needs some reassuring sense of stability, order, security, and serenity from the difficult afflictions he has to bear. The figure of realism gives distinction and validity to nineteenth-century art. While romantic painting stresses man's ideals and hopes, realist painting shows his human condition, his personal life, his pathos, suffering, and resolve to struggle against adversity. Its subjects are the lowly, the commonplace, the plebeian; the distorted, the lame, the grotesque; the clown, the beggar, the prostitute. It seeks beauty of the inner person, not of the outer appearances. It reveals nobility, grace, and human warmth and tenderness through toil, trouble, and attrition. Movements tend to turn inward, forms close and contract. The Renaissance explosive surge and expansion wither and shrink in realist form. Hope is converted into grim determination. Baroque concentration on facial importance congeals in realism to a gesture, a movement of the body, a fitful contraction

of tense hands and feet. Realism gains its immense power of pathos from its tormented forms locked in ineffable human poignancy. The figure of impressionism, while different in form, conceals a similar astringent outlook in its light and atmospheric radiance. It tells of the ease and relaxation of the ordinary people; they are responsive to their leisure, yet in their momentary impulses and spontaneous reactions to the thrusts of the industrial era, they are bystanders, spectators, and yearning seekers in a disjointed world of simulated pleasure.

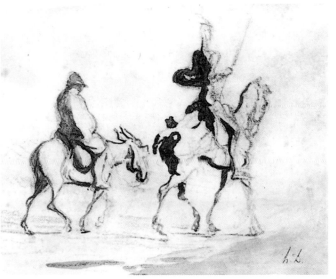

DON QUIXOTE AND SANCHO PANZA. CHARCOAL WITH INK. HONORÉ DAUMIER (1808–1879). FRENCH. COURTESY OF THE METROPOLITAN MUSEUM OF ART.

THE ARTIST'S MOTHER. CONTÉ CRAYON. GEORGES SEURAT (1859–1891). FRENCH. COURTESY OF THE METROPOLITAN MUSEUM OF ART.

OLD COURTESAN. BRONZE STATUE. AUGUSTE RODIN (1840–1917). FRENCH. COURTESY OF THE METROPOLITAN MUSEUM OF ART.

ANALYTICAL MAN: THE FIGURE OF INTROSPECTION

PERIOD Technical-Scientific-Analytical Age, in Europe and America; modern era (postimpressionism, cubism, expressionism, surrealism, abstraction, etc.— twentieth century)

BACKGROUND The modern era in art may be said to begin in the late nineteenth century in France with the defeat of Louis Napoleon, the occupation of France by German forces, and the creation of the Third Republic. It is no accident that France, which had been hailed earlier as the leading exponent of culture and the arts in Europe, should become the birthplace of the new modernism in art. The rejected, disenchanted inheritor of a proud cultural past, publicly disinherited and humiliated, unleashed his creative energies into a multiplicity of concepts and forms, far beyond the comprehension of the public and press of his time. With the exception of a few sympathizers, he was derided and downgraded to virtual isolation from society. The turn of the new century, which saw a further increase in invention and technological growth, also saw great concentrations of nationalist power and irredentist rivalries, which eventually spilled over into revolution and world war. Caught up in the cataclysm of events, the artist sought refuge within himself. Henceforth, the artist gave primacy to his subjective, emotionalistic, existential tendencies. The end of impressionism saw the decline of the objective visual image in art. Objectivity dissolved into subjectivity; images and appearances turned into symbols and essences; empirical realism vaporized into egocentric, analytical art. The touchstone of modern art lies in its dual personality of spontaneous, impulsive, voluntaristic activity joined with the psychological, subconscious wellspring of feeling and emotion.

ATTRIBUTES In broad scope, there appear to be four main currents of figure concepts in modern art, which may be said to have motive power to project *inner states of being* in expressive form. These may not be totally definitive or inclusive, but they are presented here for purposes of general understanding. They are the *synesthetic;* the *kinesthetic;* the *cryptesthetic;* and the *cerebresthetic,* as described and illustrated in the following pages.

> *SYNESTHETIC*　　The sensate-reaction form, evolved from sense reactions induced by emotive experiences of pleasure feelings, energy drives, and primitive sensual urges.

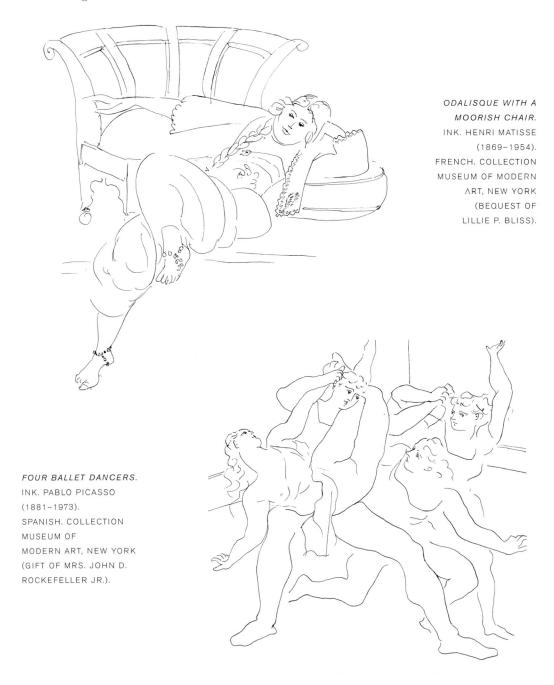

*ODALISQUE WITH A
MOORISH CHAIR.*
INK. HENRI MATISSE
(1869–1954).
FRENCH. COLLECTION
MUSEUM OF MODERN
ART, NEW YORK
(BEQUEST OF
LILLIE P. BLISS).

FOUR BALLET DANCERS.
INK. PABLO PICASSO
(1881–1973).
SPANISH. COLLECTION
MUSEUM OF
MODERN ART, NEW YORK
(GIFT OF MRS. JOHN D.
ROCKEFELLER JR.).

> *KINESTHETIC* The physical reflex form, induced by nonrational physical reflexes or neuromuscular excitation through feelings of tension, irritation, agitation, or annoyance.

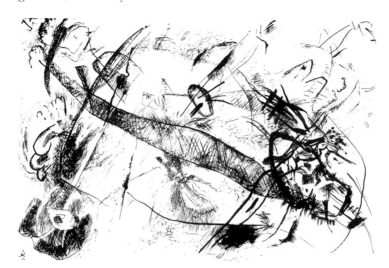

STUDY.
PEN AND INK.
WASSILY KANDINSKY
(1866–1944). RUSSIAN.
COLLECTION
MUSEUM OF MODERN
ART, NEW YORK.

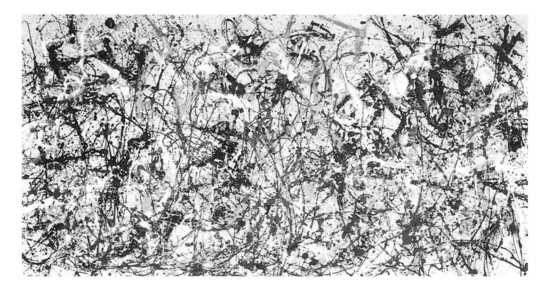

AUTUMN RHYTHM.
OIL ON CANVAS.
JACKSON POLLOCK
(1912–1956).
AMERICAN.
COURTESY OF
THE METROPOLITAN
MUSEUM OF ART.

> *CRYPTESTHETIC* The empathy-anxiety form, derived from anxiety and pain in withdrawn, hidden feelings of frustration, fear, and despair, to anguish, chaos, and dread.

STATES OF MIND–THE FAREWELLS.
THOSE WHO STAY. THOSE WHO GO.
PENCIL. UMBERTO BOCCIONI
(1882–1916). ITALIAN.
COLLECTION MUSEUM OF MODERN ART,
NEW YORK (GIFT OF VICO BAER).

HEAD OF AUTUMN.
INK.
PAVEL TCHELITCHEW
(1898–1957).
AMERICAN. COLLECTION
MUSEUM OF MODERN
ART, NEW YORK
(GIFT OF LINCOLN
KIRSTEIN).

> *CEREBRESTHETIC* The intellectual reasoned form, revealed through a reasoned process of logic to arrive at time-space relativity of forms, wit-play interrelationship of shapes, mechanics of structure, dynamics, and design.

MAN WITH GUITAR.
OIL ON CANVAS.
GEORGES BRAQUE
(1882–1963). FRENCH.
COLLECTION MUSEUM OF
MODERN ART, NEW YORK
(BEQUEST OF
LILLIE P. BLISS).

BELOW:
DAYBREAK.
OIL ON CANVAS.
IRENE RICE PEREIRA
(1907–1971). AMERICAN.
COURTESY OF THE
METROPOLITAN MUSEUM
OF ART (GIFT OF
EDWARD I. GALLAGHER JR.,
1955. THE EDWARD
JOSEPH GALLAGHER III
MEMORIAL COLLECTION).

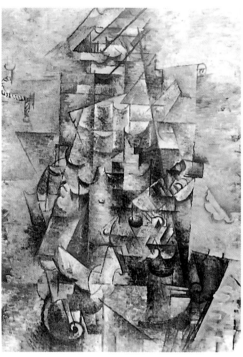

Art and artists may be analyzed according to their major characteristics and simply grouped as the following summary shows. While not all-inclusive, they are:

> The synesthetic: impressionism, fauvism, Blue Rider expressionism—Monet, Renoir, Matisse, Derain, Marc, etc.

> The kinesthetic: abstraction, futurism—Kandinsky, Boccioni, etc.

> The cryptesthetic: postimpressionism, Die Brücke expressionism, surrealism, dadaism—Munch, Ensor, Rouault, van Gogh, Gauguin, Picasso, Kirchner, Nolde, Klee, Chagall, Dalí, etc.

> The cerebresthetic: cubism, constructivism, nonobjectivism, purism—Picasso, Braque, Gris, Malevich, Mondrian, Gabo, etc.

Frequently, individual works of art may have aspects of more than one of the above form characteristics, such as works by Ensor, Kokoschka, Picasso, and others. The reader is asked to investigate for himself where older art persists with additional refinements, in Maillol, Lachaise, Lehmbruck, Epstein, Orozco, Rivera; or where new and old unite, as in de Chirico; or where the new goes into further transitions in the involutions of abstract impressionism, abstract surrealism, abstract expressionism.

In summary, we may arrive at the conclusion that the new modernism in art has attempted to remove the general objective experience from the figure concepts of older art, and has let it become an *artifact of the mind and the emotions.* To understand this premise will give meaning and insight to the esoteric inventions of the figure in the art of today.

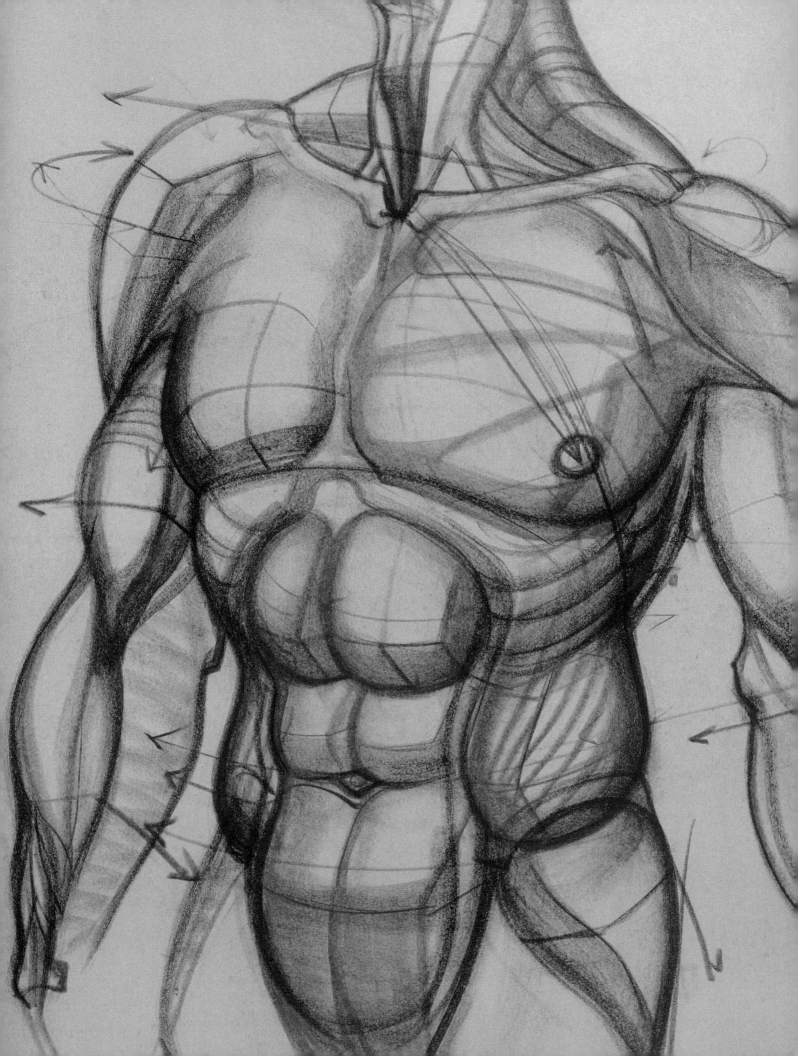

IV.

PROPORTIONS
AND MEASUREMENTS
OBSERVATIONS ON
CHANGING PROPORTIONS

THE CANON OF PROPORTIONS of the human figure is equivalent, so to speak, to
the foot-rule in measurement, the axiom in geometry, the polestar in navigation. It pro-
claims the universal human norm, the ideal criterion of discipline in art. But to speak of
an ideal criterion in the figure is to take a fixed position similar to laying out a Procrustean
bed of human proportions. It presents the uneasy choice of chopping the figure or stretch-
ing it to fit, without regard to the relative individual expression. It lies in the ambiguous
position of being absolutely right in general and totally incorrect in particular.

Traditionally and historically, the figure has long been established as seven
and one-half heads in length. Ever since the artists of Greece developed its proportions
some twenty-four hundred years ago, it has asserted its authority based on the rational
order of geometry correlated with the ultimate ideal of absolute universal truth. The
sculptures of Phidias were held concomitant with the architecture of Ictinus and
Callicrates. These were developed from the mathematics of Pythagoras and were
embodied in the Platonic-Aristotelian world system of the Idea of the Good. Thus, the
ideal human construct and the perfect architectural structure were conceived as uni-
versal architectonic entities; the purity and perfection of the one was consistent with
the order and harmony of the other.

Certainly, the artists of Rome recognized the superbly stable values of the
Hellenistic system and defined the Roman canon of proportions according to the
Greek authority. In the Renaissance revival of art and learning, fifteenth-century artists
sought to advance the spirit of humanism in the tradition of Hellenism. Da Vinci and
Dürer sought to rediscover the Greek canons in the light of new knowledge. And
because the Renaissance was the dawn stage of the modern scientific era, the Greek

figure has tended to survive in art today unchanged as the ideal criterion of human proportions, seven and one-half heads in length.

However, while we may understand the survival of the Greek tradition, the values of modern life impose great misgivings on the acceptance of the old system. In the fifteenth century, even the meticulous Dürer gave up his quest when he found that the ideal figure did not suit his art, while Michelangelo, and El Greco later, discarded it altogether to favor giantism and elongation in their figures of humanity and devotion. We live in a sharply contrasted world of semantics, relativity, and speed. More than ever, the new needs in art contradict the old figure. To maintain a fixed canon of proportion is to continue to believe in the fixed stars, the finite universe, and zero as the end of a quantity. It would rule out of existence such ideas as below zero, second sight, listening with the third ear, the fourth dimension, the sixth sense, the fifty-minute hour, the minute that seems a year, and the expanding universe. It would rule out Picasso and cubism, Kandinsky and abstraction, van Gogh, Matisse, Chagall, Barlach, and Soutine, as well as primitive art.

We are faced with a contradiction. Why advance a standard of proportion for the figure at all? If the unstable dimensions of life are changing the relationships in art so quickly, perhaps the only reliable index in art is the artist's own personal judgment. Why not let the creator of art be the sole judge and arbiter of its rules, including proportion? Well, hardly; even here we face a final judgment as absolute as the former, for it would enshrine as principle the chaos of unlimited personal opinions against the concept of agreed collective experience.

The course is somewhere in the middle ground. A figure proportion *is necessary to art;* but it must first be a proportion of its own era, and second, it must respond to the artist's problems in his time. That is to say, from the first it must be a figure not of demigods, nature gods, or gods of nature, but of modern aspiration, inspiration, and human nature. It should be a figure of the *general agreement* in the culture, like a statistical average in which everyone has his part. Second, as to the artist's problems, proportion should be used in the learning stage of art, not its goal. It should be understood as a point of departure, like the Greenwich meridian; it should lead to new expressive adventures in the sequence of artistic growth. It is, therefore, a *student's* proportion, not a master's, as it was in Greece. It is meant to be a preparatory stage only in creative invention and is proposed as a measure of common sense in figure skill for the student in art, not an imposition upon the master of art.

The premise advanced here is a *principle of preparation,* not a Procrustean canon of proportions. It is no absolute; no fixed or rigid determinant, no terminus;

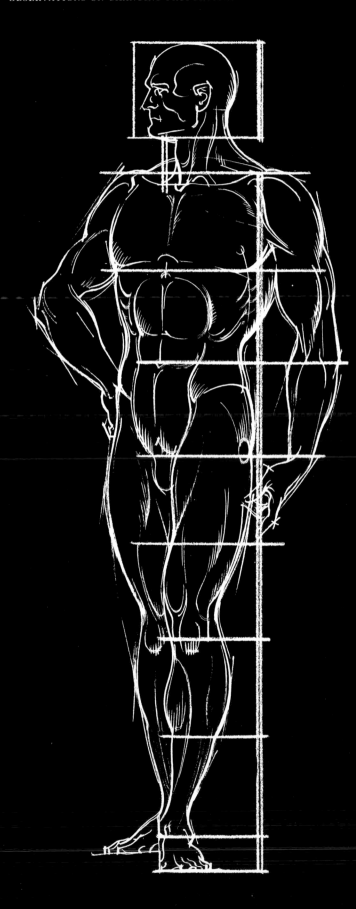

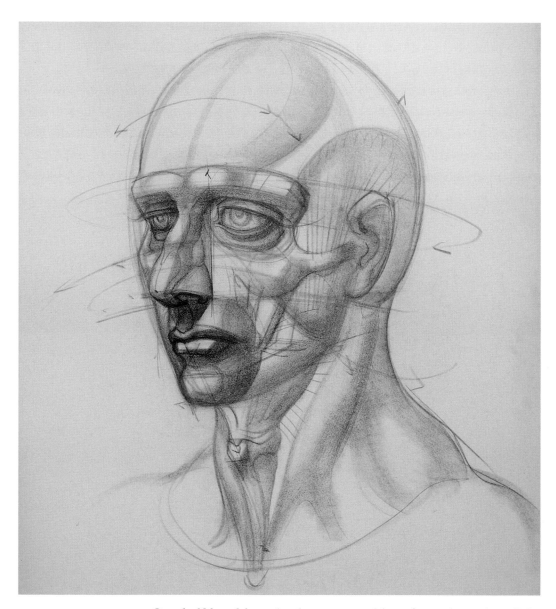

THE NECK One-half head long in the erect position, from the point of the chin to the pit of the neck.

THE ARM Two and three-fourths heads long, from the collarbone attachment to the wrist, it divides at the elbow across the line of the umbilicus. The wrist lies on the position of the great trochanter, across the line of the pubic arch in front and the coccyx bone in the rear. The hand length adds three-fourths of a head to the arm; thus, the total length of the arm is three and a half heads.

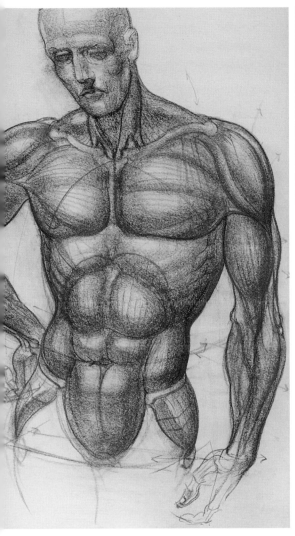
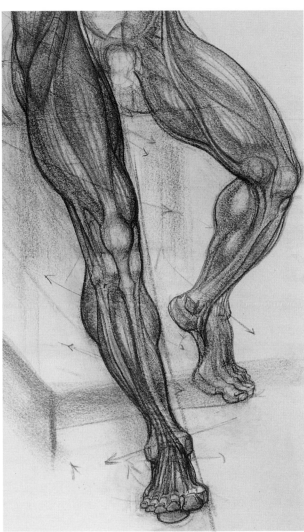

THE LEG Four heads long, from the great trochanter to the high inner ankle bone, it divides midpoint at the knee. The foot adds one-fourth of a head to the length; thus, the total length of the leg is four and one-fourth heads.

THE HAND Three-quarters of a head in length, or the distance from the point of the chin to the hairline; the width is one-quarter of a head wide, or the distance from the base of the nose to the point of the chin.

THE FOOT The foot length is equal to the length of the forearm, or one and a third heads long; the width at the front of the foot is one-half head wide.

The finer details of measurement in the body are developed in chapter 5, "Details of Anatomy," and are integrated with the specific descriptions of each of the figure sections.

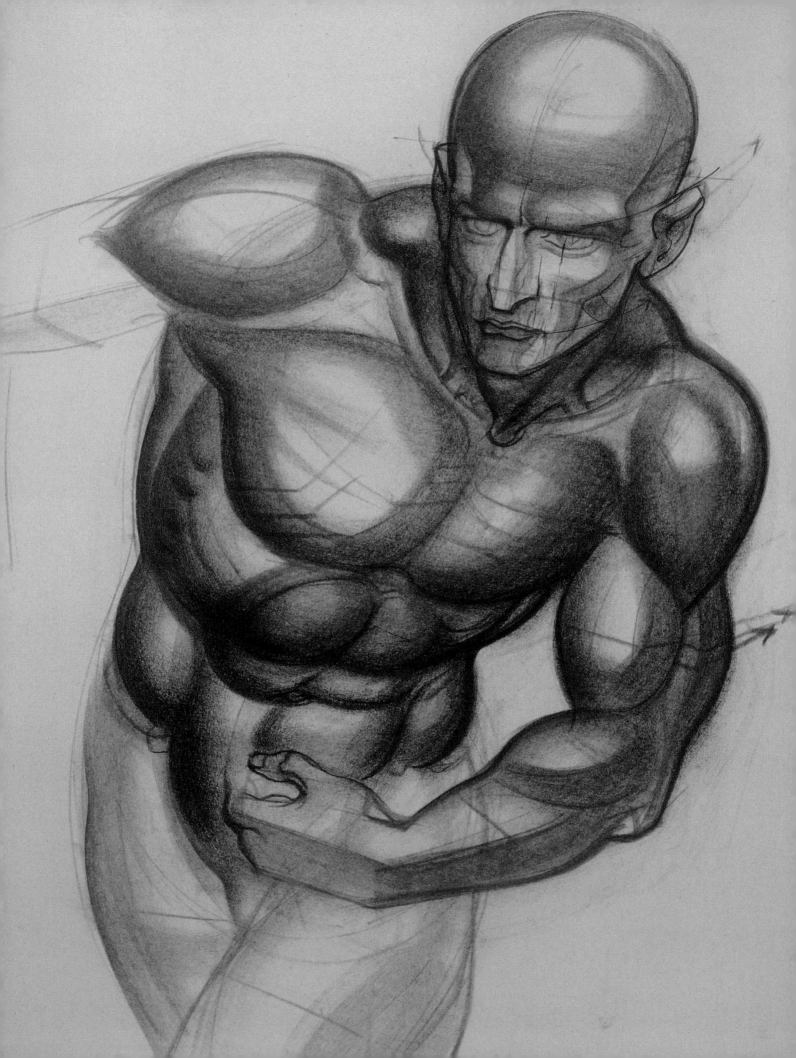

V.

DETAILS OF ANATOMY

THE HEAD

THE GREAT MASSES The head consists of two major masses: the cranial mass or ball of the head and the tapered cylinder of the face. Each has a strongly developed form at its base. The ball of the head ends in a curved ridge of bone just over the eyes—the frontal ridge or visor of the brow. The tapered cylinder of the face ends in the curved ridge of the lower mandible, the horseshoe of the jaw.

> *MEASUREMENTS* Seen in side view, the cranial mass ends at the bridge of the nose under the visor of the brow, halfway down the length of the head, from the top of the crown to the base of the chin. To the rear, the occipital bulge on the head ends lower, on a line midway between brow and chin, drawn across the skull.

> *PROPORTIONS* From the front, the head is ovoid in shape. From the side, two such egg shapes superimpose one over the other. Seen in front view, the width of the head is two-thirds the length; dividing the head lengthwise in equal halves, from crown to chin, will produce two parts of the width of the head. One of these parts spaced three times in the length of the head will achieve the proportion of the egg mass, a ratio of 2:3—two parts width, three parts length. From the side view, using the superimposed egg shapes, one upright, the other on its side joined at the top, the head consists of three triangular equal parts: jaw hinge to middle of the crown, jaw hinge to bridge of the nose.

THE BASIC SHAPES OF THE HEAD:
THE CRANIAL MASS AND
THE CYLINDER OF THE FACE.

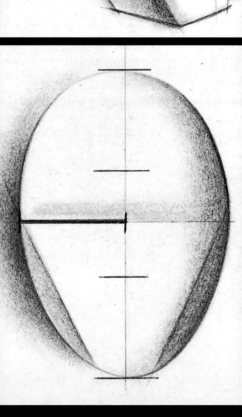

SKULL STRUCTURE OF THE HEAD,
SIDE VIEW. THE
FACIAL AREA IS ONE-THIRD THE
ENTIRE HEAD MASS.

PROPORTIONS OF
THE HEAD, FRONT VIEW.

THE SECONDARY MASSES In general, there are nine important secondary masses in the head, all of them concentrated in the facial area. They are: (1) the brow ridge; (2) the tapered wedge of the nose; (3) the cheekbone; (4) the eye socket; (5) the barrel of the mouth; (6) the box of the chin; (7) the angle of the lower jaw, or jaw point; (8) the side arch of the cheekbone; (9) the shell of the ear.

> *MEASUREMENTS* (1) The brow ridge is at mid-distance from crown to chin. (2) The wedge of the nose is at midpoint on the face from brow to chin. (3) The cheekbone ends on a line drawn across the base of the nose. (4) The eye socket opens at the brow ridge and ends on a line drawn at midpoint across the nose (5) The barrel of the mouth begins at the nose base and ends two-thirds the length down from nose to chin. The width of the barrel ends at points drawn directly under the centers of the eye sockets. (6) The box of the chin occupies the remaining third from nose to chin base. (7) The angle of the jaw, the jaw point, lies on a line drawn across the lower lip of the mouth barrel. (8) The side arch of the cheekbone angles up from the cheekbone and attaches at the ear on a line drawn across the bottom of the eye socket. (9) The shell of the ear, fixed behind the jaw, lies across the positions of the brow ridge and base of the nose.

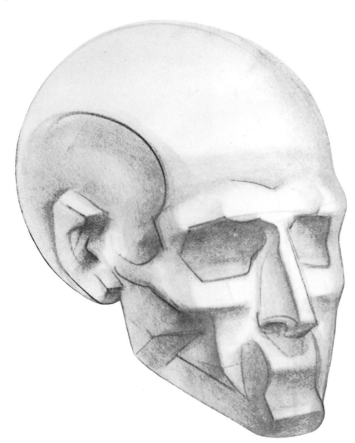

THE GREAT MASSES OF
THE HEAD WITH THE
SECONDARY MASSES ADDED,
THREE-QUARTER VIEW.

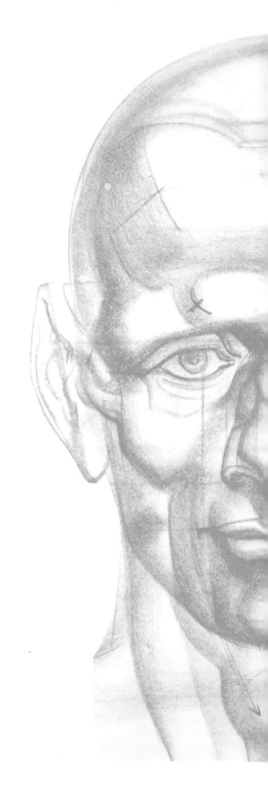

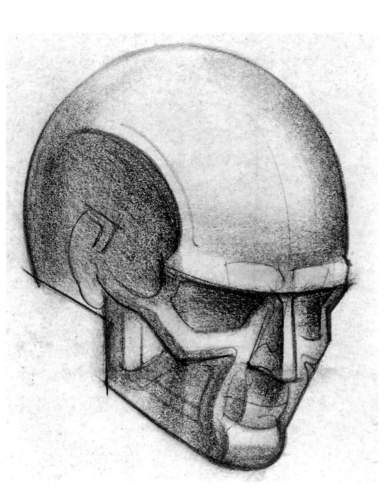

POSITIONING OF THE SECONDARY FACIAL MASSES.

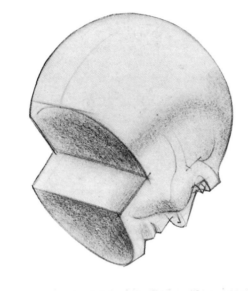

LOCATION OF THE FACIAL
MASSES IN VARIABLE
VIEWS OF THE HEAD.
THE BROW AT MIDPOINT
ESTABLISHES THE
PLACEMENT OF
SMALLER FORMS.

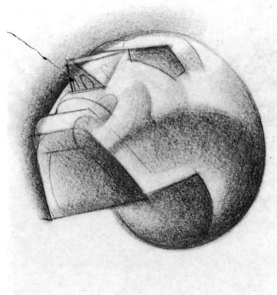

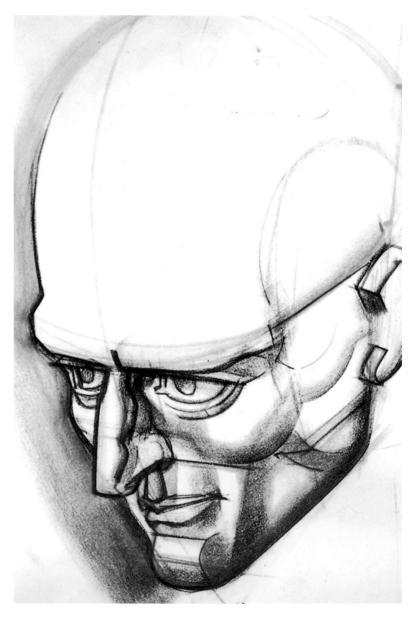

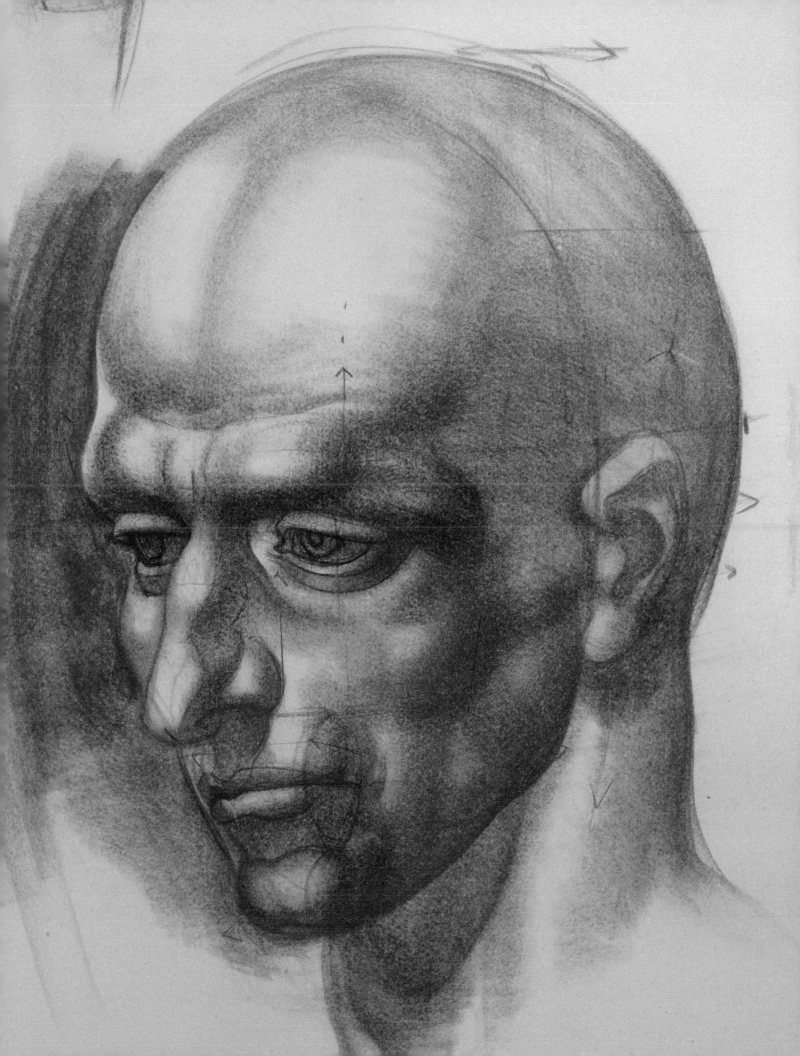

THE MOVEMENT OF THE HEAD To *rotate the head* from a full front view to a three-quarter or seven-eighths turn, including the side position, the first problem that presents itself is the amount of the back of the head to be drawn in at specific stages of the rotation. The solution can be developed easily using the following procedure: (a) First draw a full front view of the head shape, with no details. Now draw in the bisecting centers, vertical and horizontal lines, dividing the head in equal parts in both directions. (b) To make the head turn, place a *new center line* down the length at a three-quarter position from the first center line. (c) Measure the distance between the old and new centerline. This is the *amount* of turn, or rotation, of the head. (d) Take this exact measure and place on the head at the back. This will give the correct amount of shape to the skull corresponding to the amount of turn.

If the turn is increased, the increased amount will be added. Try it first right turn, then left. Notice that if the turn goes to the full side view, it will gain exactly at the back of the head what has been lost from the front. The same system can be applied to the up-and-down movement of the head. The change of line across the brow horizontally, when moved down to a new placement, will be measured and added to the top of the head.

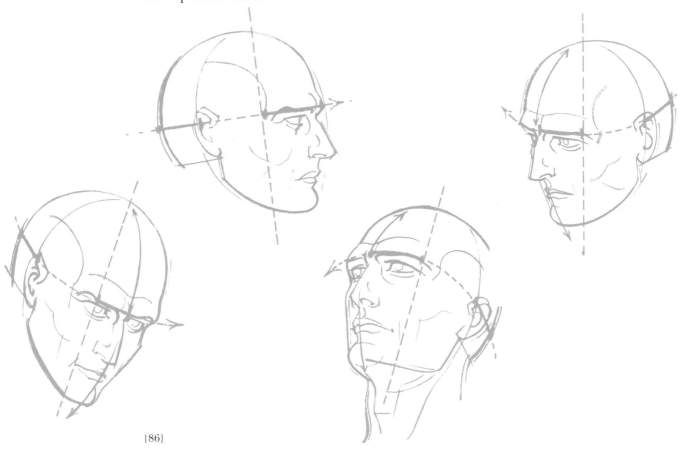

We must take note of a second problem in the rotation of the head—the *placement of the jawline* on the head as it turns. Notice, as the head moves, in whatever position it is drawn, the jawline tends to remain stable. The head as an upright ovoid mass, rotating on the neck, retains a *constant width* across the head as it turns. The jawline width, therefore, will not change, no matter how much is added to the back of the head.

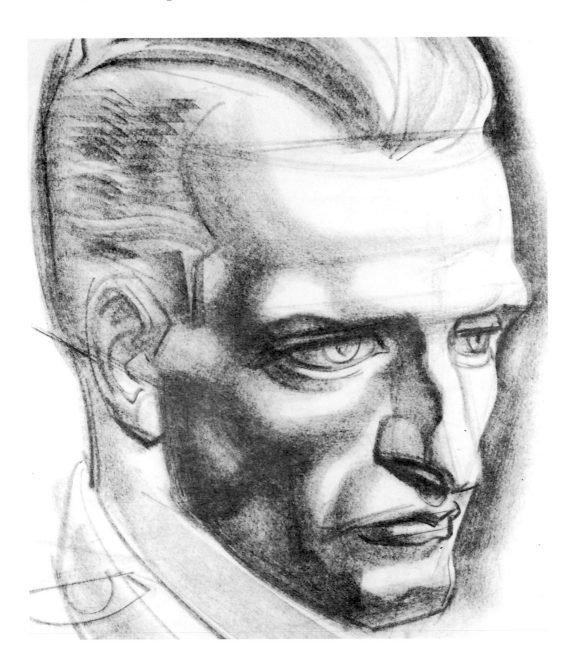

Let us consider a third problem in rotation—the *side plane of the head,* the form edge, moving from the temporal arch down the corner of the brow and cheekbone to the side of the chin. Observe how this edge tends to divide the front and side of the face along a line drawn almost exactly in half between the lengthwise centerline of the face and the jawline. It will do this in whatever turn position the head has been drawn because of the constant curves across the frontal mass of the face.

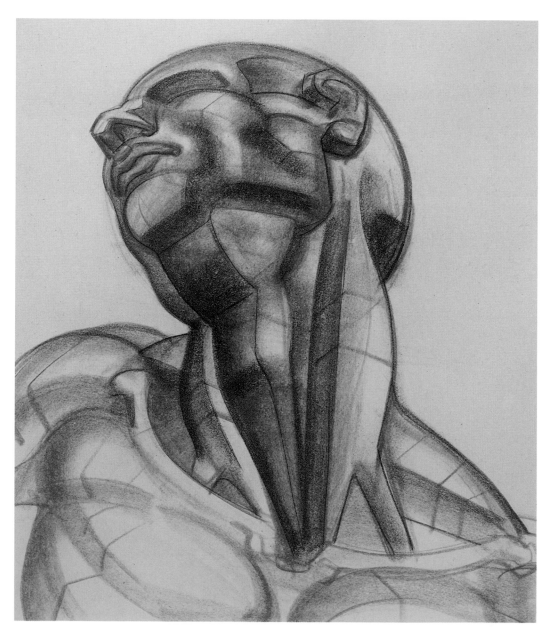

DETAILS OF THE FACE: THE FEATURES

> *THE EYE* The eyeball, almost as large as a golf ball, in the human head is an exposed internal organ of the body protected by great structures of bone, the brow ridge (superciliary arch) and the cheekbone (zygomatic bone). It is suspended from the roof of the eye socket (orbit). The eyelids curve like short visors on the eye; the upper curves wider across the fuller circumference of the orb, while the lower turns on a shorter arc, around the base area. Seen from a side view, the lower lid lies angled down almost forty-five degrees from the upper lid. Surrounding the eye is the orbicularis muscle, enclosing and circling the orbit. It gives little shape, however, to the surface form of socket and cheekbone.

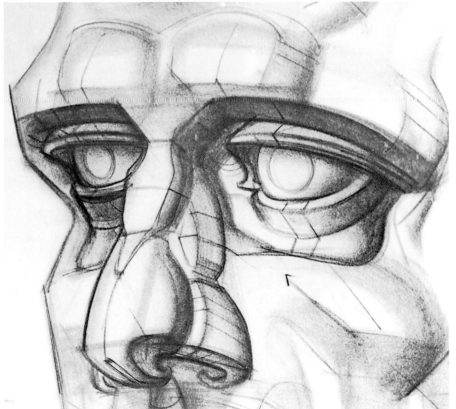

THE EYELIDS
APPEAR AS VISORS
SURROUNDING
THE ORB.

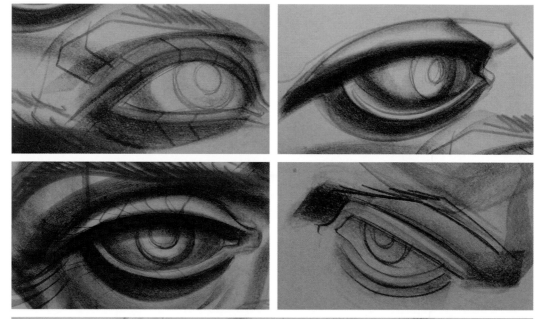

THE EYE POSITION,
SIDE VIEW, STARTS
ON A LINE
DRAWN UP FROM
THE NOSTRIL WING.

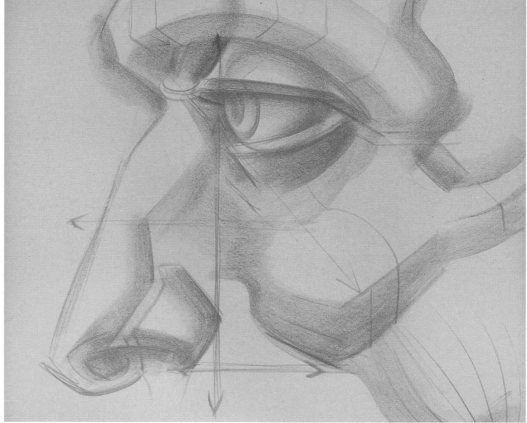

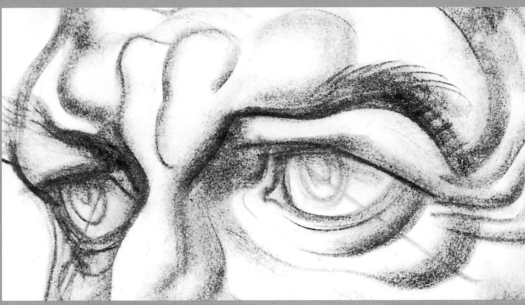

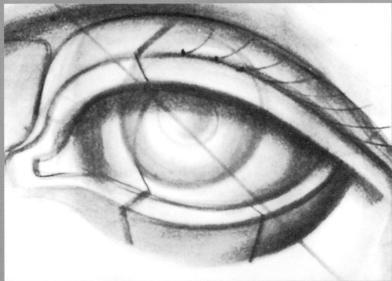

THE AXIS OF THE EYE.
THE UPPER LID ARCHES
HIGH INSIDE THE SOCKET,
WHILE THE LOWER LID
CURVES TO THE OUTSIDE
OF THE SOCKET.

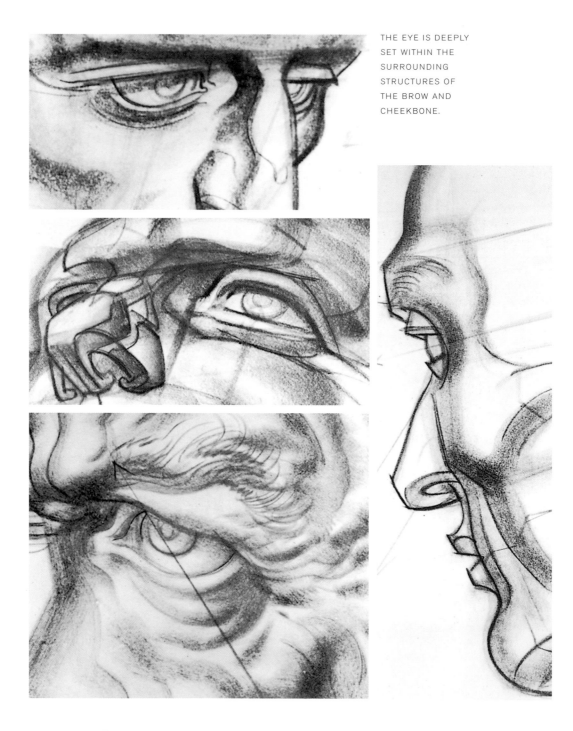

THE EYE IS DEEPLY
SET WITHIN THE
SURROUNDING
STRUCTURES OF
THE BROW AND
CHEEKBONE.

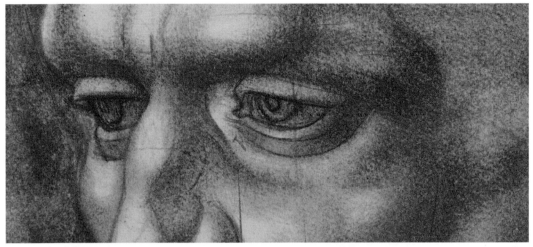

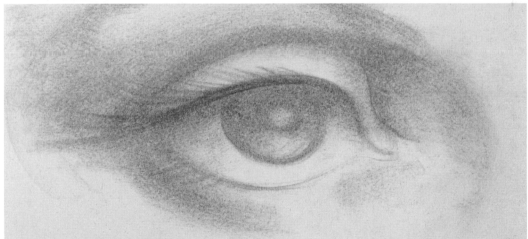

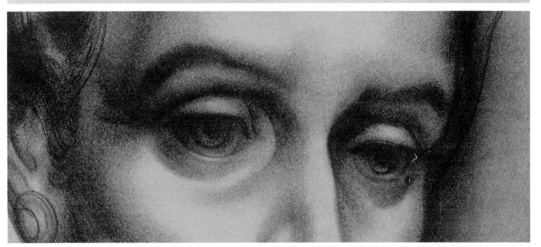

> *THE NOSE* The nose consists of four important masses: the upper nasal mass, tapered and wedged into the cartilaginous (alar) ball of the nose, and the two wings (ala) of the nostrils. The ball of the nose swings into a furrowed hook (septum) under the base and meets the pillars of the upper lip. The nostril wings, moving from the ball of the nose, flare out to the sides, the length of an eye apart. The nostril cavities are triangulated in shape and should be drawn large enough to accommodate the thickness of a finger.

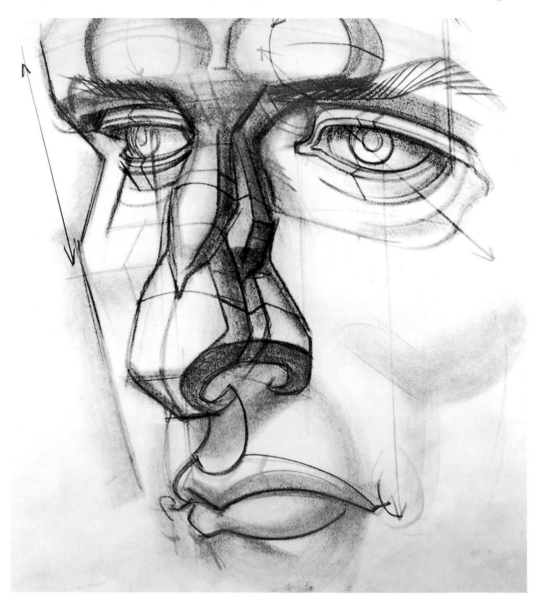

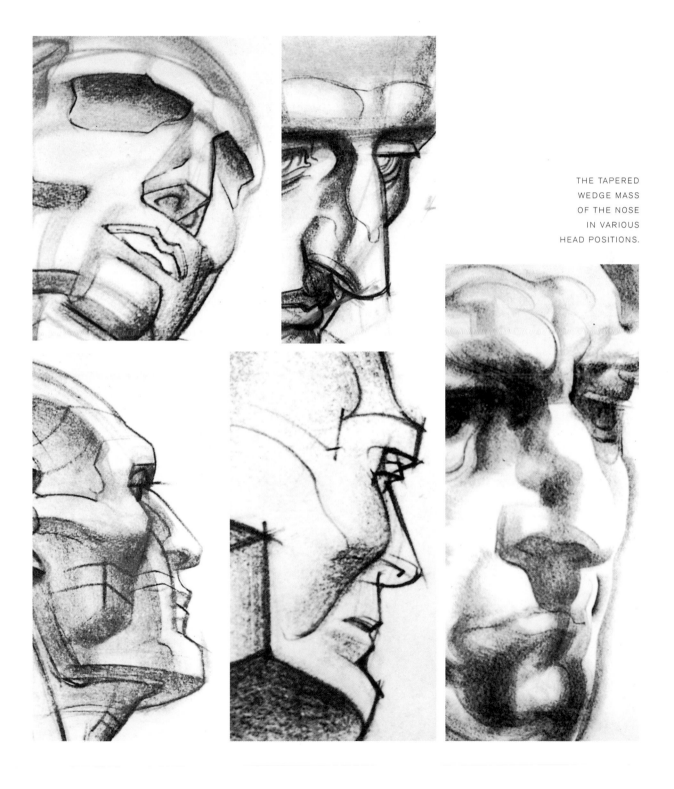

THE TAPERED
WEDGE MASS
OF THE NOSE
IN VARIOUS
HEAD POSITIONS.

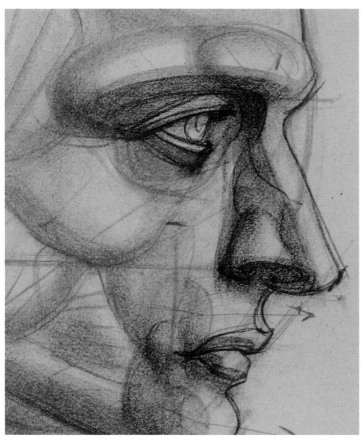

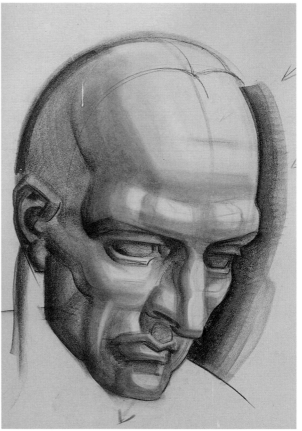

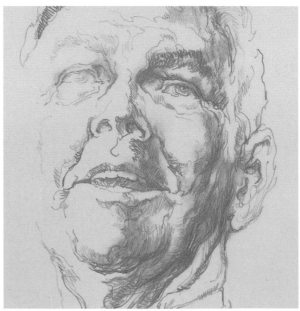

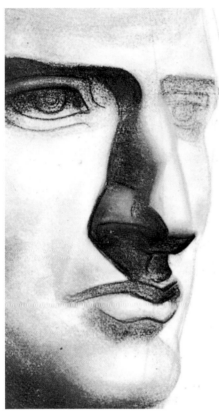

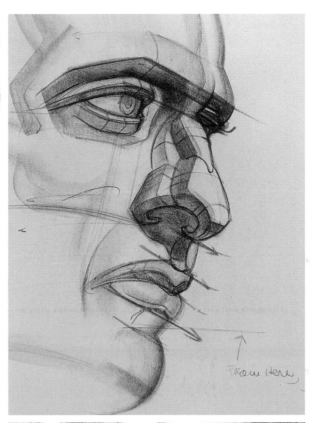

THE HOOK OF
THE NOSE (SEPTUM)
DESCENDS
LOWER THAN THE
NOSTRIL WINGS.

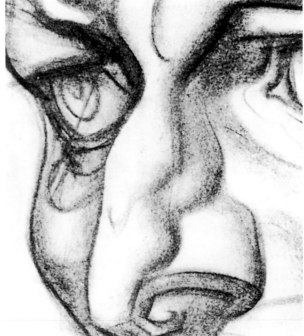

> *THE LIPS* The lips are surrounded by a sphincter muscle (orbicularis oris) and attach at the sides of the mouth to the buccinator muscle, which crosses horizontally from the jaw. The upper lip, wider than the lower, is shaped like a flattened M. The groove of the M (philtrum) thrusts forward like the prow of a ship (tubercle). The lower lip is developed like an extended W. The center groove receives the tubercle of the upper lip, while the arms of the W form two elliptical lobes. Both lips have thinly edged margins that rim their forms.

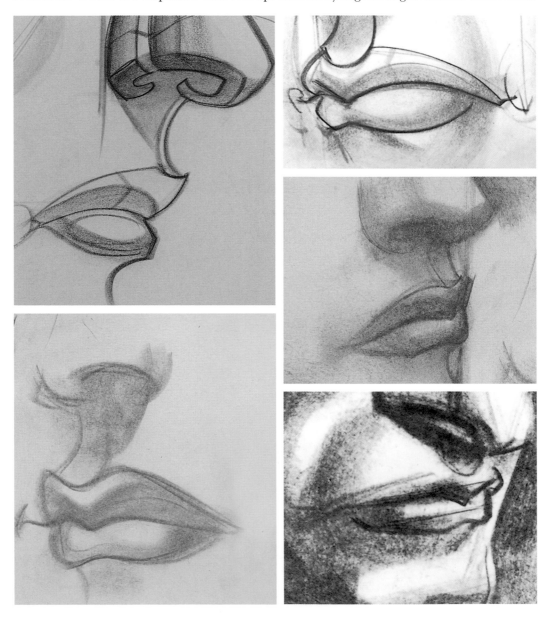

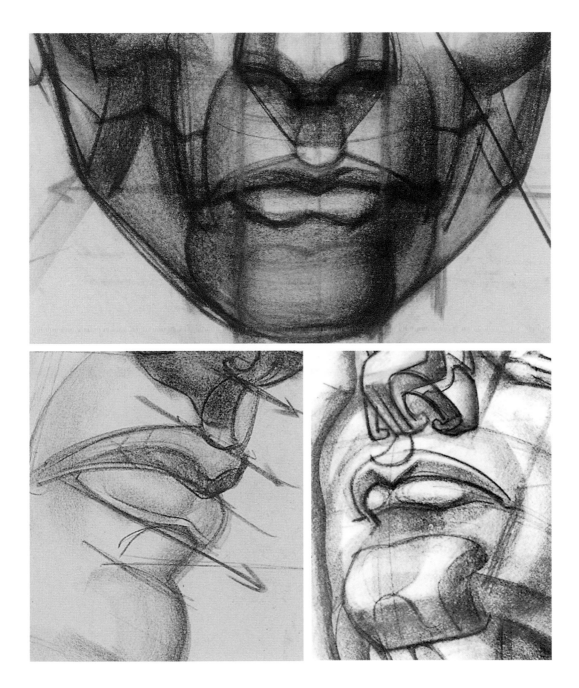

> *THE EAR* The ear is shaped like a shell, wider at the top rim, narrower at the lobe. It consists of four major shapes: the outer, wider rim (helix), the inner rim (anti-helix), the cover of the ear opening (tragus), and the lobe (lobule). The ear can be divided into equal thirds lengthwise: first, at the upper rim where it enters the bowl of the ear; second, the length of the tragus; third, the fleshy lobe. The inner rim is divided at the top into two arms and shaped like a bent Y. Emphasis in drawing should be given to the hard forms of the cartilage, and softened on the fleshy lobe. The bowl of the ear should be drawn large enough to accommodate a thumb.

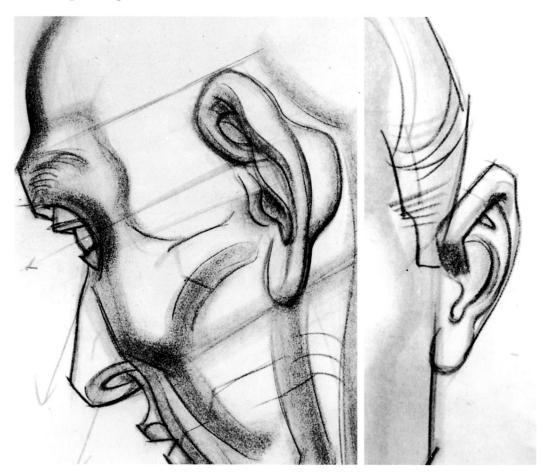

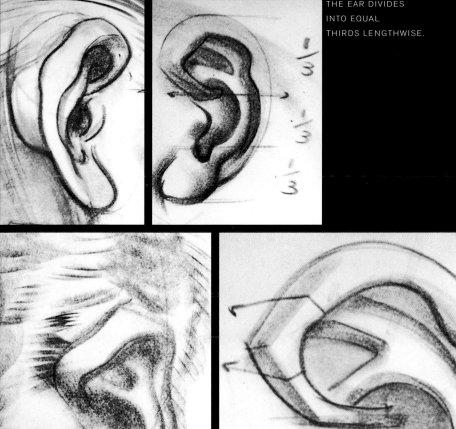

⅓

⅓

⅓

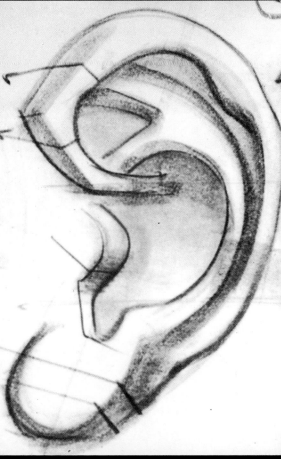

THE MAJOR MUSCLE MASSES The muscle masses that give shape to the face are grouped for simplicity in drawing and articulation of form. The strong masseter muscle, locking in the angle of the jaw from the cheekbone, controls the form of the wide part of the cheek. It completes the forty-five-degree contour line of the inner orbit of the dropping eye, from the bridge of the nose, obliquely across the face, to the jaw point. The zygomatic muscle starts angularly down from the front of the cheekbone to the outer upper curve of the mouth. The crease around the mouth is the edge of this muscle. The buccinator completes the crease at the tight knot in the corner of the mouth and moves across to the jaw, under the masseter. Because it is deep-set, it shows as a depressed area in the middle of the lower cheek. The triangularis, at the wide outer part of the chin, moves from the corner of the mouth to the front jaw. The quadratus starts under the lower lip and slants toward the triangularis on the front jaw protrusion. The cleft in the chin is thus exposed. The temporal arch, the somewhat hollow area of the temple, lies above the zygomatic or cheekbone arch and to the side of the brow ridge. Although it is filled in with a broad flat mass—the temporal muscle—it is still depressed enough to receive the bulge of the upper palm of the hand. The forward edge of this muscle clearly exposes the temporal line, the side plane of the forehead.

1. TEMPORAL
2. FRONTALIS
3. ZYGOMATIC ARCH
4. ORBICULARIS OCULI
5. MASSETER
6. ZYGOMATICUS
7. ORBICULARIS ORIS
8. BUCCINATOR
9. TRIANGULARIS
10. QUADRATUS
11. MENTALIS

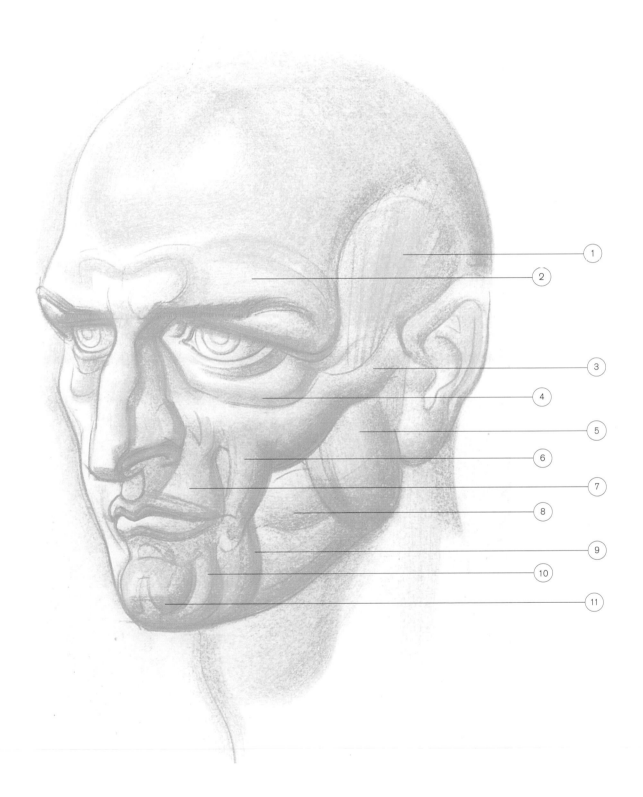

WRINKLES OF THE FACE Wrinkling in the face can be generalized into a system of three major patterns: the frontal, the oblique, and the lateral. The *frontal group* starts centrally around the nose, circles the chin, and drops on the understructure of the jaw into the neck. The upward movement from the nose forms a sharp compression at the bridge and moves in deep furrows to the forehead, bending slightly outward. The *oblique group* moves from the inside orbit of the eye obliquely down the center of the cheek, cuts across the center of the jaw, and turns under the middle undersurface of the neck. On the brow, it rings the bulge of the frontal sinus above the eye and forms a curved movement across the middle of the forehead. The *lateral group* starts at the outer corner of the eye, the crow's-feet, and spreads backward to the ear, down to the masseter muscle and around the jaw point to the neck. Upward, the crow's-feet wheel around the outer edge of the brow and thrust high in thin wrinkles toward the front forehead. These are the major wrinkle patterns, usually developed in the deep recesses of bone and channels between muscles. Variations according to age and muscular flaccidity will account for refinements in the drawing of particular individuals.

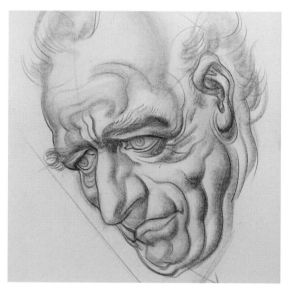 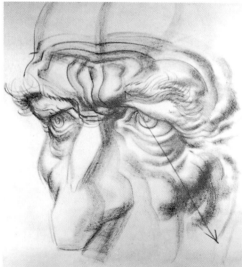

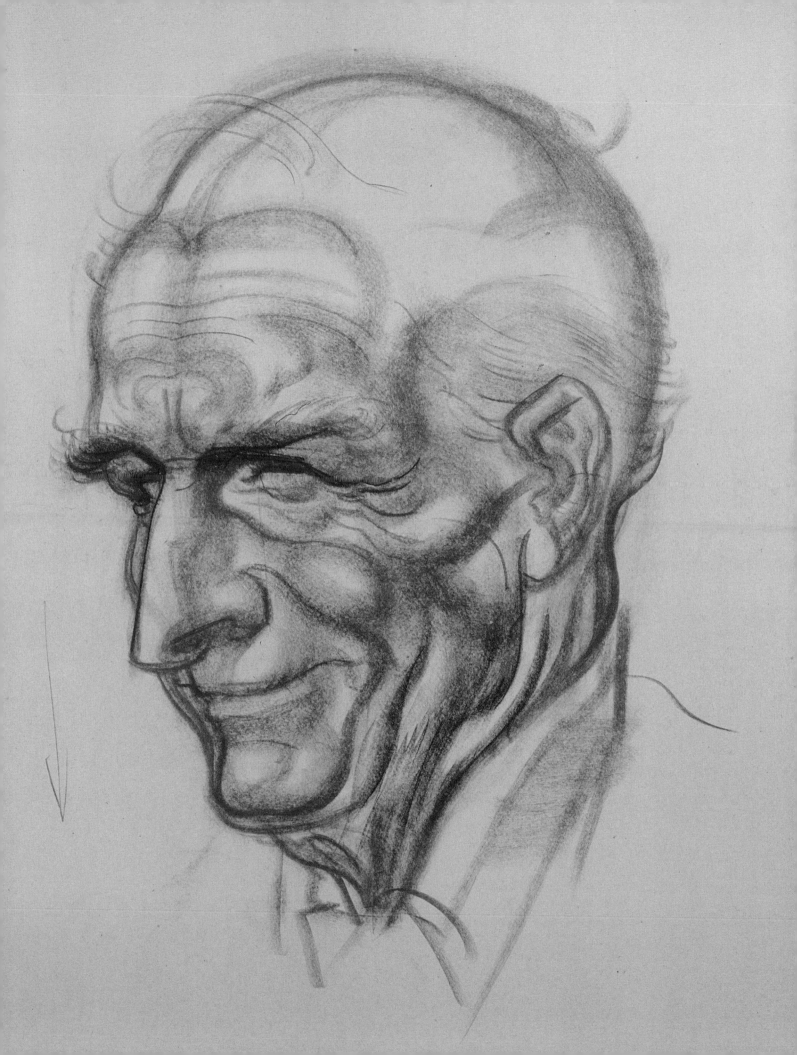

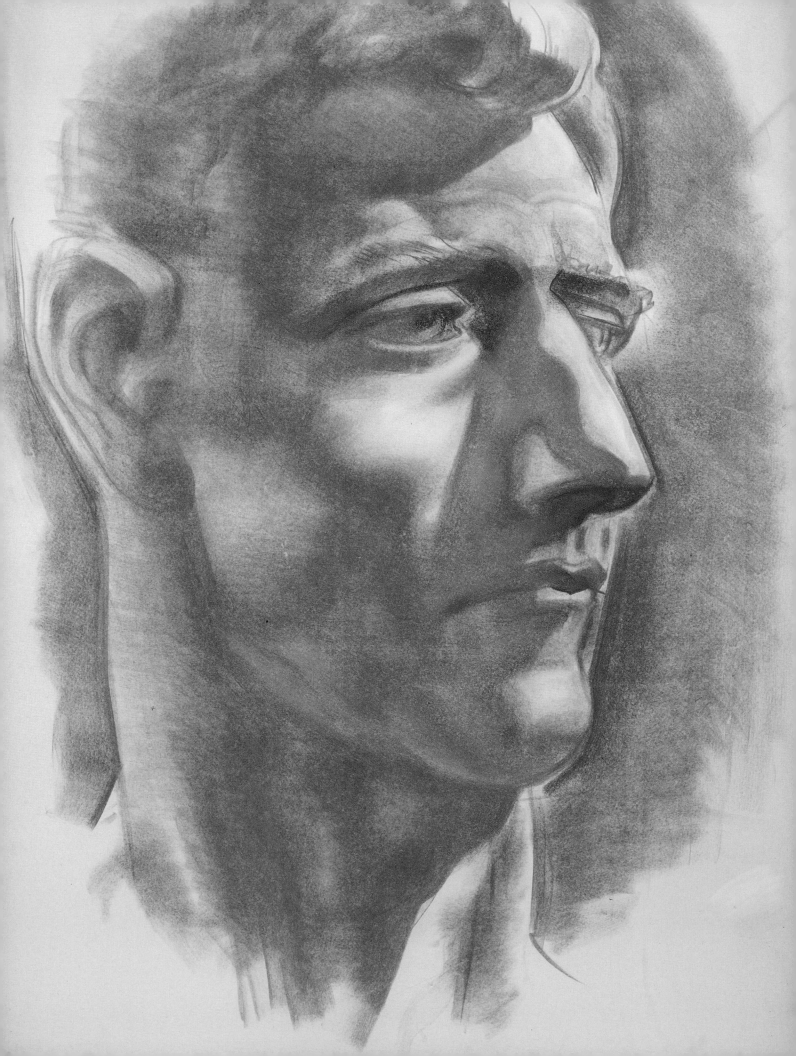

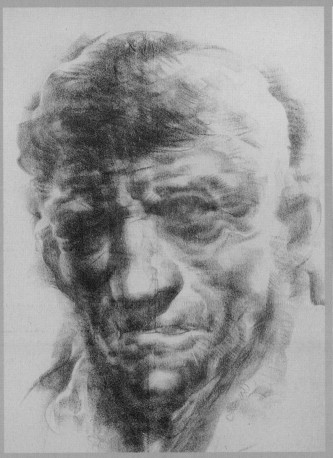 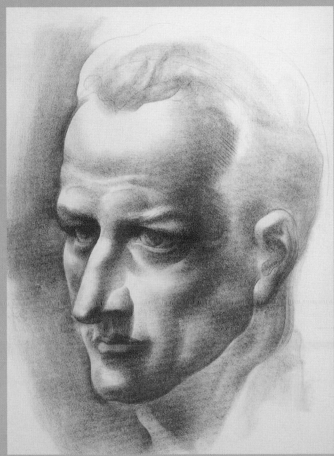

FACIAL CHANGES AND CHARACTERIZATION In form structure, the head generally shows three basic shapes or variations: the long head, or dolichocephalic; the round head, or mesocephalic; and the broad head, or brachycephalic. These are the variants from which the artist can observe individual minor characteristics. We may observe that long heads generally show elongations of form in nose, ears, and chin, and that broad heads reveal squared, broad forms. However, individual differences show a remarkable variety of digressions from accepted ideas of form. The individual has his unique qualities, and these should be observed against the background of general knowledge. The variety of heads presented here shows how the study of the individual has dictated the interpretation of character and the manner of expression.

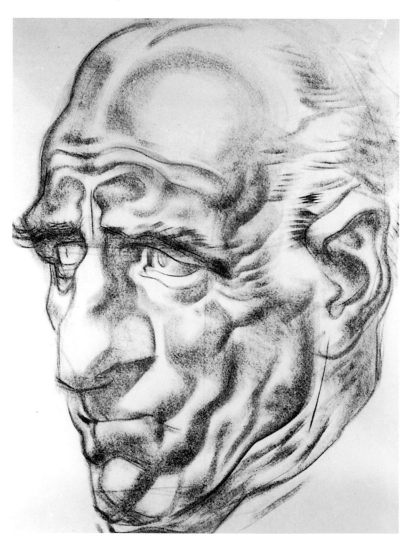

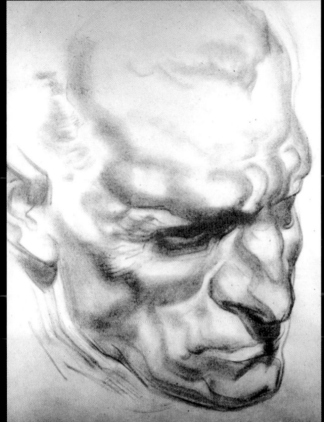
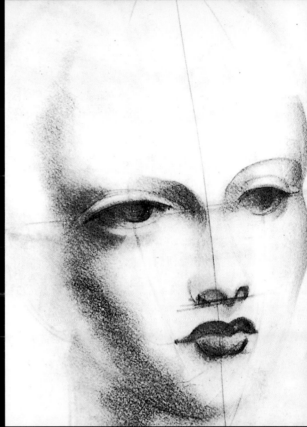

THE THREE BASIC HEAD TYPES:
BROAD (BRACHYCEPHALIC); ROUND
(MESOCEPHALIC);
AND LONG (DOLICHOCEPHALIC).

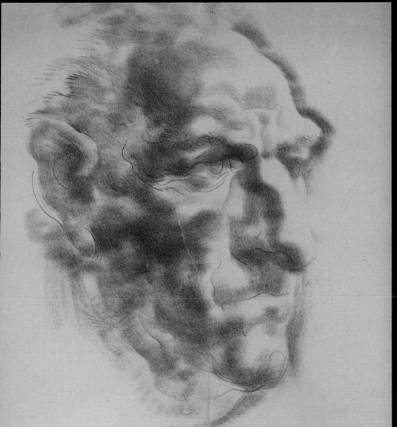

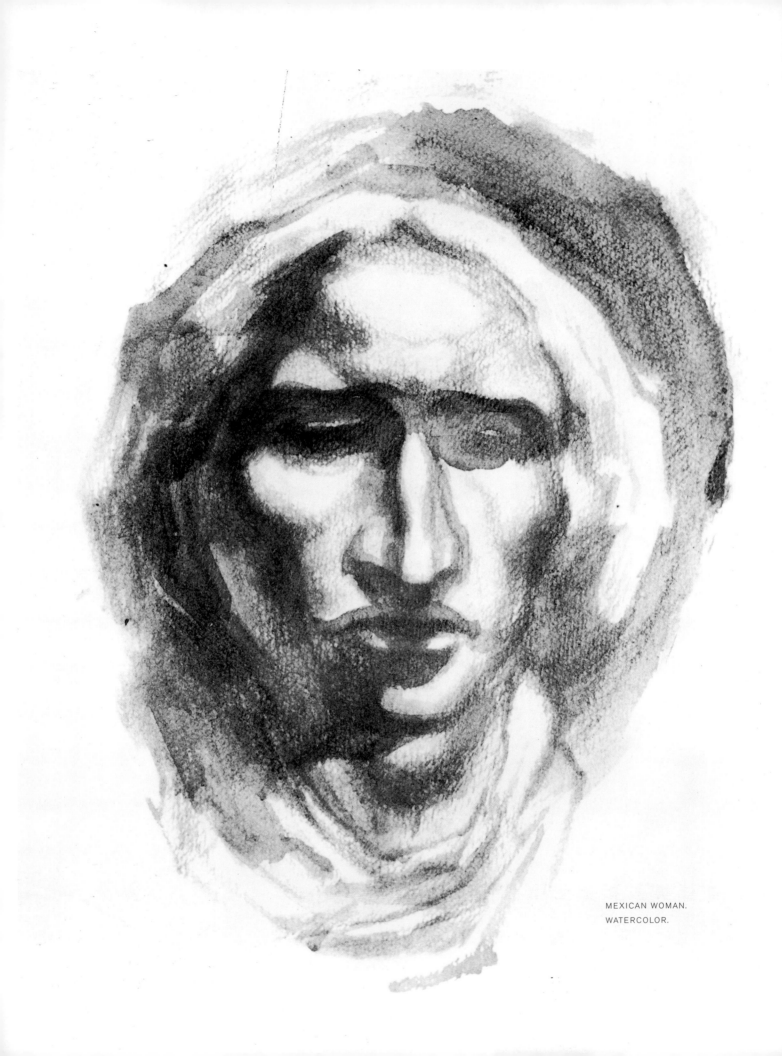

MEXICAN WOMAN.
WATERCOLOR.

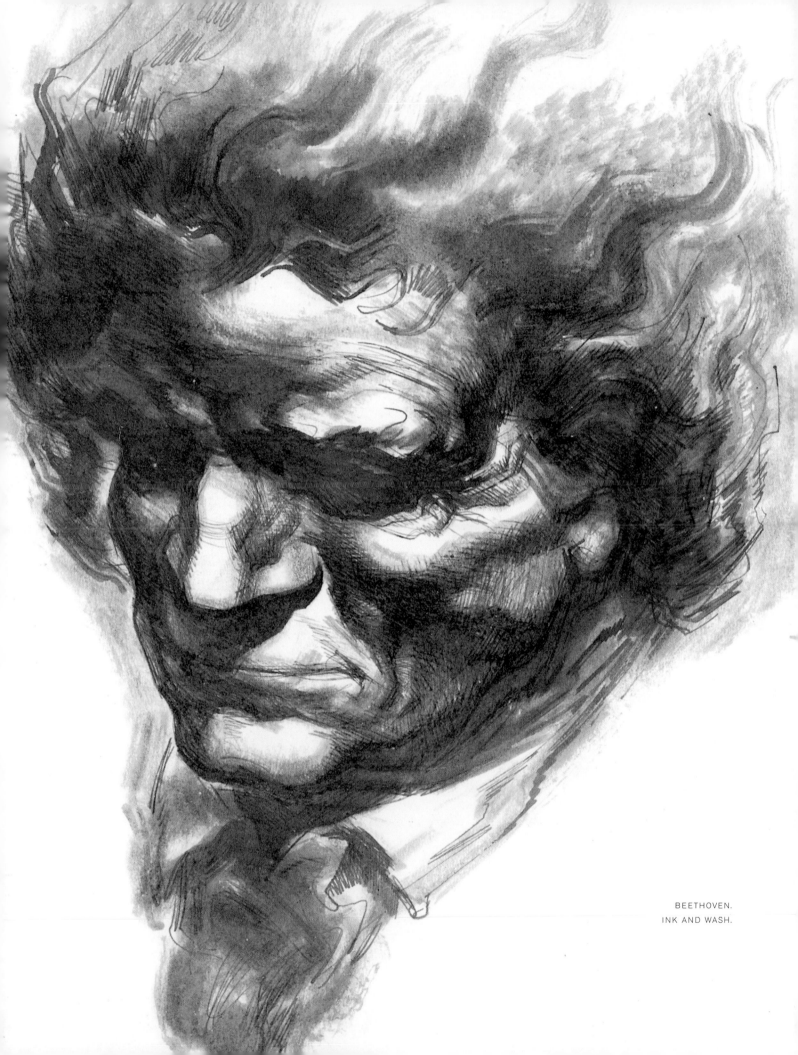

BEETHOVEN.
INK AND WASH.

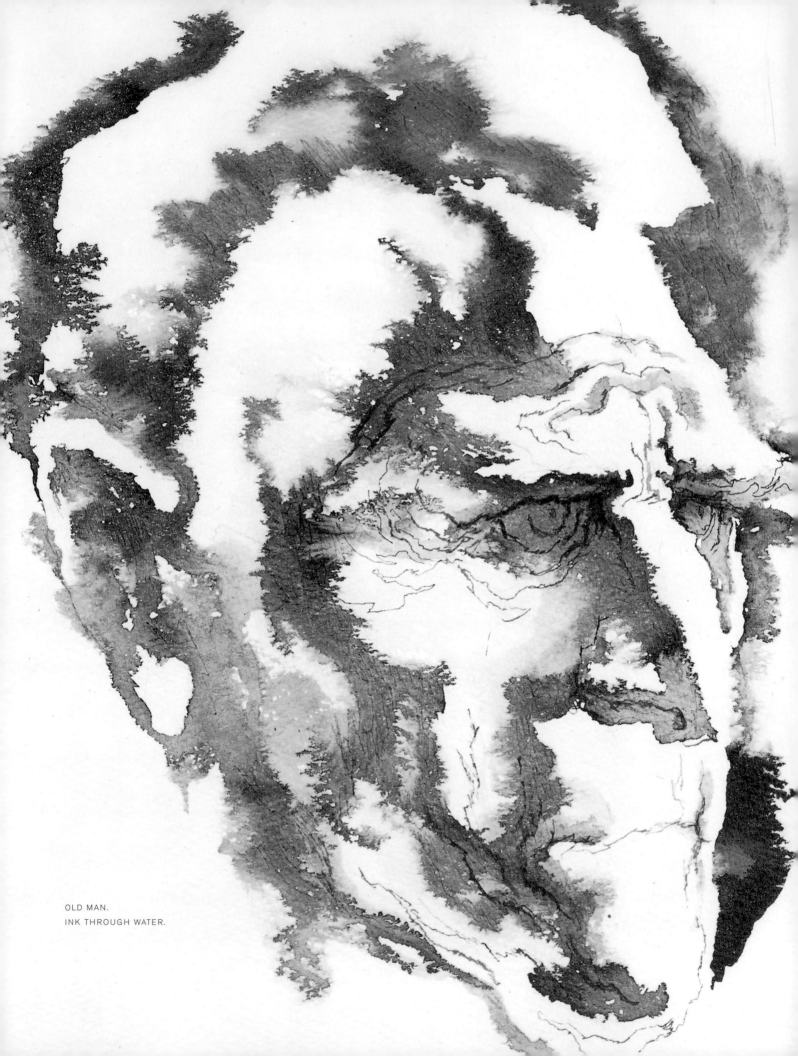

OLD MAN.
INK THROUGH WATER.

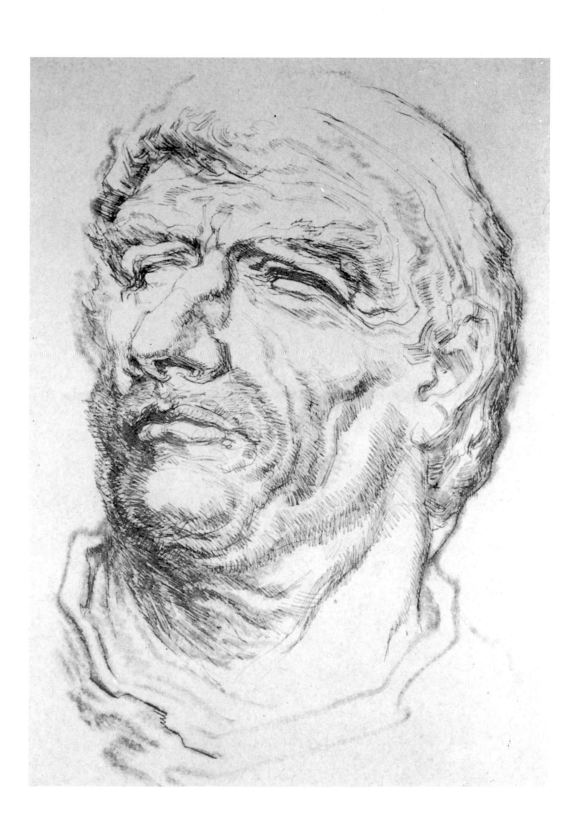

SAUL.
INK AND CRAYON.

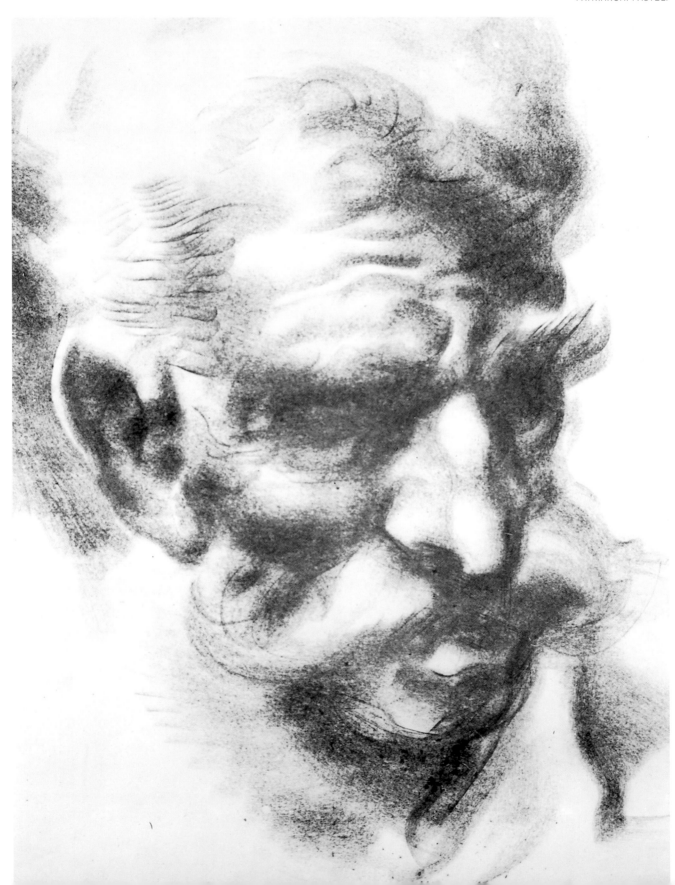

BLIND MAN. INK AND COLOR.

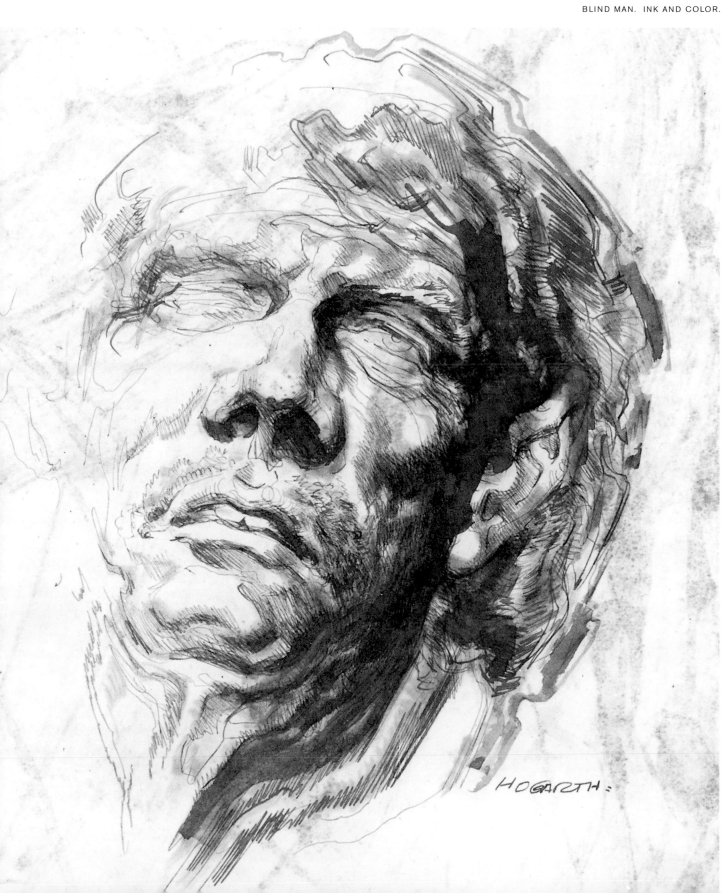

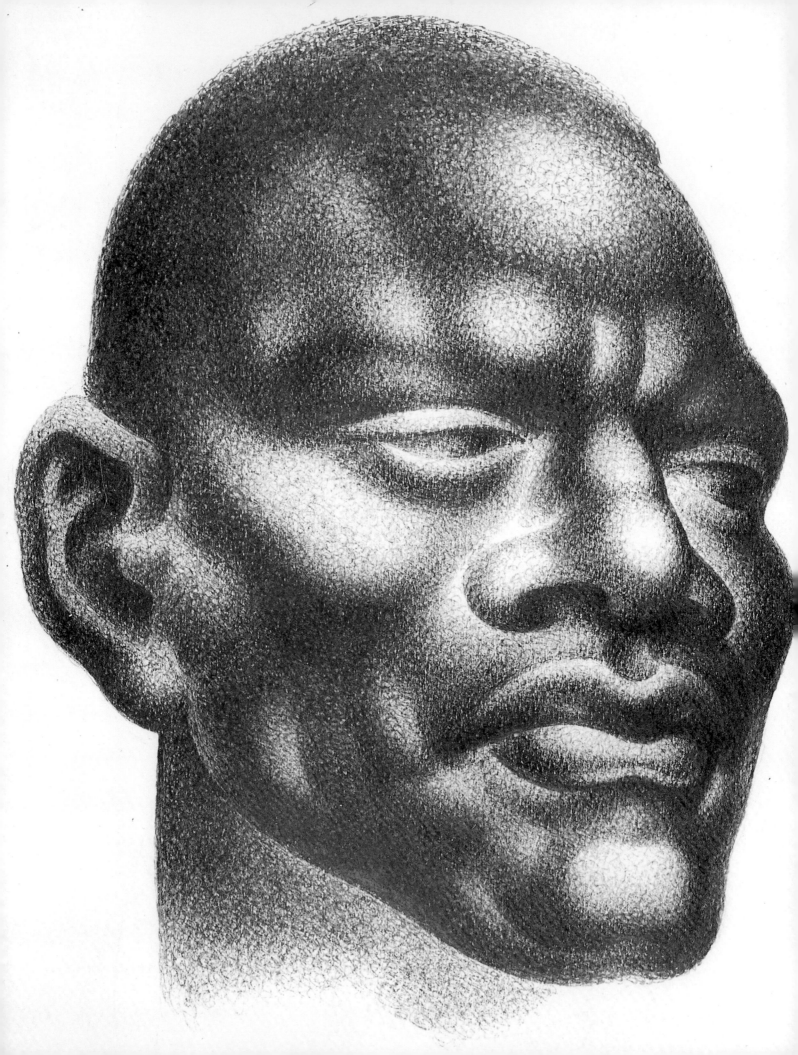

(OPPOSITE)
NEGRO. INK, SCRIBBLE
TECHNIQUE.

JAKE. COLORED INK.

THE NECK

THE MASSES The column of the neck originates at the base of the skull and curves back and downward in a large arc to a position ending at the collarbones. Quite low in the back of the neck, the projecting spinous process, a hard tuberosity of bone, can be felt with the palm in the middle recess between the shoulder muscles. This projection identifies the beginning of the rib cage to the rear. To the front, the column ends at the occlusion of the clavicles, the collarbones at the pit of the neck. The neck column consists of five important masses. They give shape and form to the neck. When they are drawn badly, the form is destroyed. Further, the cervical vertebrae, the seven neck bones, have no external form-producing effect whatsoever. The five neck shapes are: the middle tracheal funnel, starting from the wide slope under the jaw and tapering to the upper box of the larynx (the Adam's apple), and wedging into the pit of the neck; the two winding side masses of the sternomastoid, moving out from behind the ear to the front collarbones; and the two back neck muscles, the upper arms of the trapezius, attached to the base of the skull and widening onto the back shoulders. These groups are easily observed and retain their distinctive forms in all manner of views. The trapezius, seen frontally, has a deep fossa, or trench, between its thick form and the collarbone.

1. DIGASTRIC ANTERIOR
2. SUBMAXILLARY GLAND
3. STYLOHYOID AND DIGASTRIC POSTERIOR
4. HYOGLOSSUS
5. LARYNX
6. OMOHYOID
7. STERNOHYOID
8. STERNOMASTOID
9. TRAPEZIUS
10. LEVATOR SCAPULAE
11. OMOHYOID
12. CLAVICLE

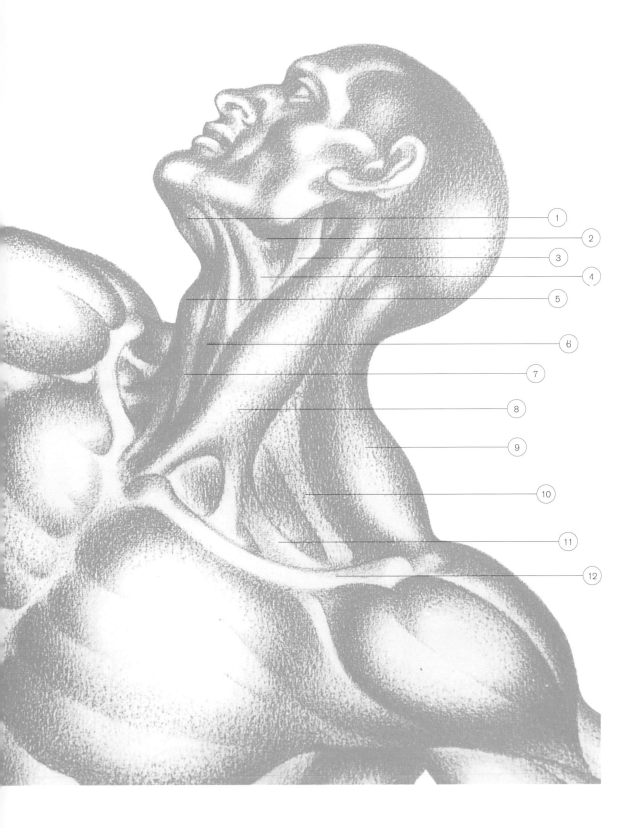

MEASUREMENTS In the erect figure, the neck from the front is one-half a head in length from the jaw to the pit of the neck. From a side view, the neck meets the jaw midpoint between the chin contour and the jaw point. The width of the neck frontally is not quite as wide as the jaw. However, on the line of the Adam's apple, just under the jaw, the sternomastoids begin to compress while the trapezius broadens across the shoulder area.

THE MAJOR
MASSES
OF THE NECK.

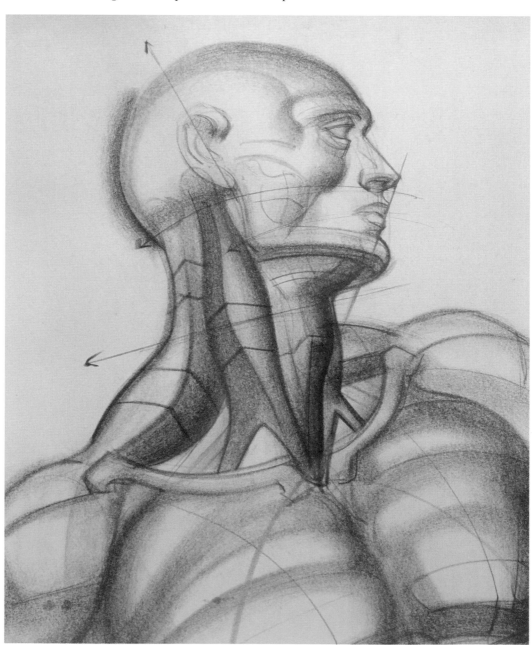

THE SEVENTH CERVICAL
VERTEBRA POSITIONED
ACROSS THE LINE
OF THE SHOULDERS.

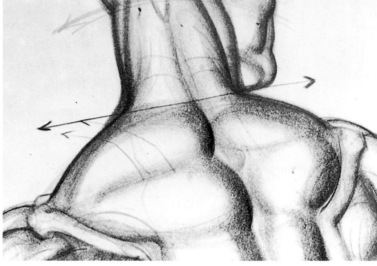

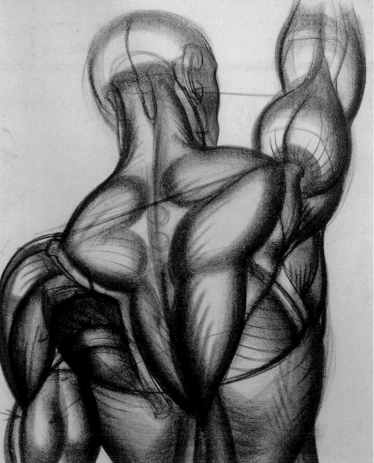

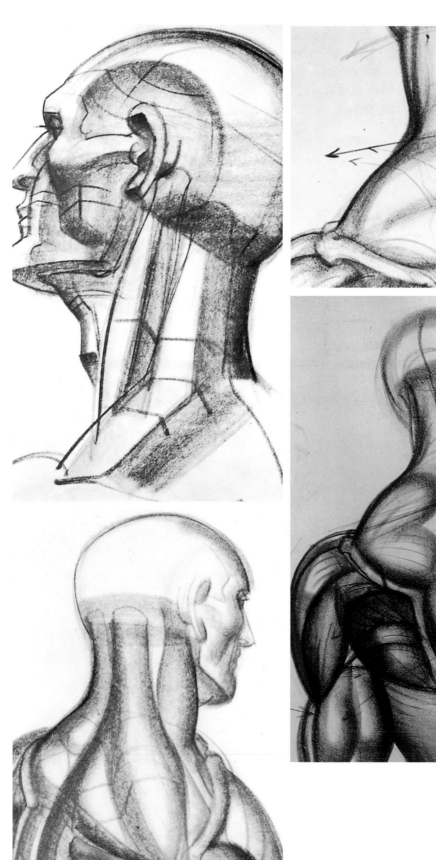

POINTS TO REMEMBER IN DRAWING The head in turning, twisting, and stretching movements constantly pulls the neck with it as it moves. It is wise, therefore, to observe the position of the chin and its direction in the drawing. The neck, as a rule, invariably follows the action position of the chin. If the head twists, the neck will twist to follow the chin.

Because the above is true, the box of the larynx will tend to remain centrally located just under the jaw arch. Now, observe carefully: A line starting from the center of the nose, and drawn through the center of the lips, will continue down and drop onto the box of the larynx. This will invariably occur in almost every position of the head, from ordinary to extreme views, up or down. Thus, great control of head and neck relationship can be mastered without difficulty in placement.

The head on the column of the neck acts like a floating, bobbing cork on water. The movement of the body tends to upset the head. But the head, controlling the activity of the body, acts like a gyroscope to oppose the movement of the upper torso. It is a good idea, therefore, to balance the head generally in *opposition* to the action of the torso, unless, of course, the head must be shown otherwise for some special reason.

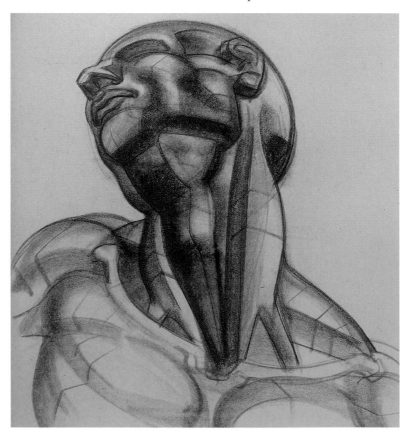

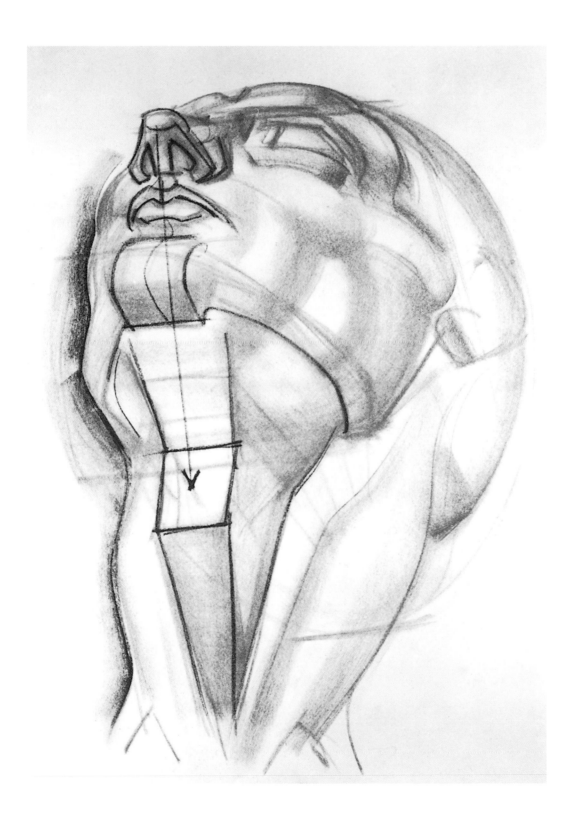

THE TORSO

THE UPPER TORSO MASSES The upper thoracic mass of the torso, the rib cage, is shaped like a wedged box; broad across the collarbones, it descends and compresses to the rib base above the elbows. The entire wedge is balanced like a box tipped backward on its edge at a fifteen-degree tilt. The entire length in this position is one and two-thirds heads long. The front slope of the chest is thrust forward the length of a head to the diaphragm arch and tapers two-thirds of a head to the base of the cage. The back slope on the trapezius is thrust only two-thirds of a head backward, and compresses one full head length down to the rib base.

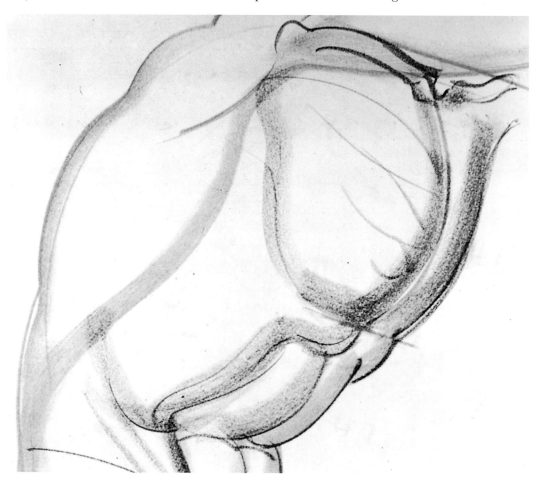

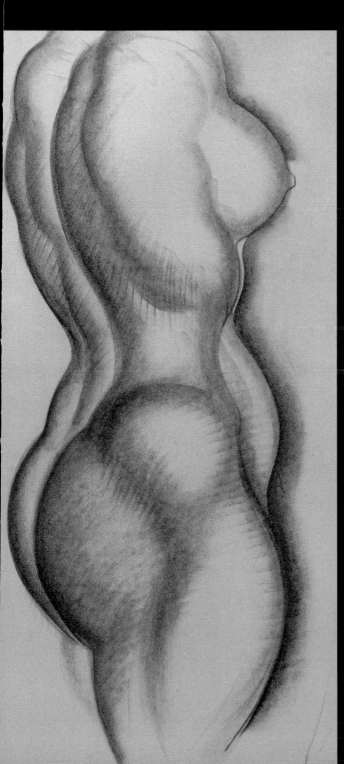

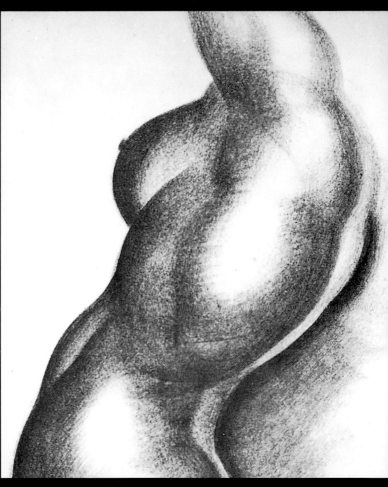

THE FORWARD
SLOPE OF
THE UPPER
TORSO MASS.

THE FRONT TORSO
DESCENDS A HEAD
LENGTH TO THE
DIAPHRAGM ARCH.

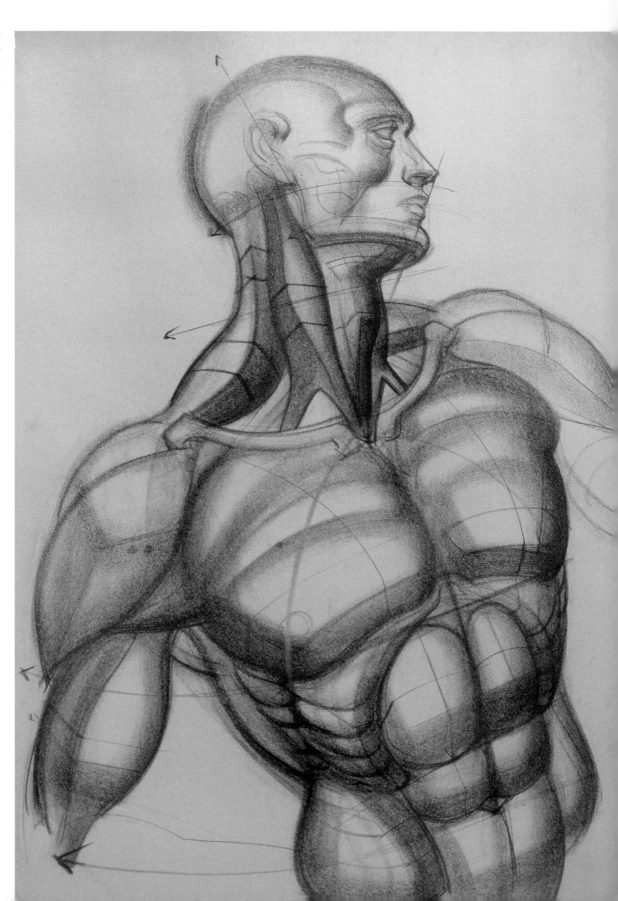

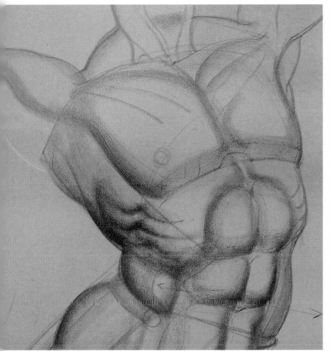

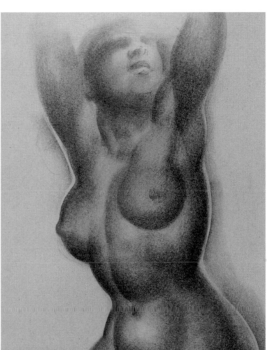

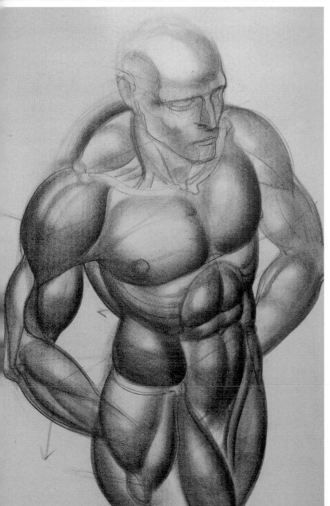

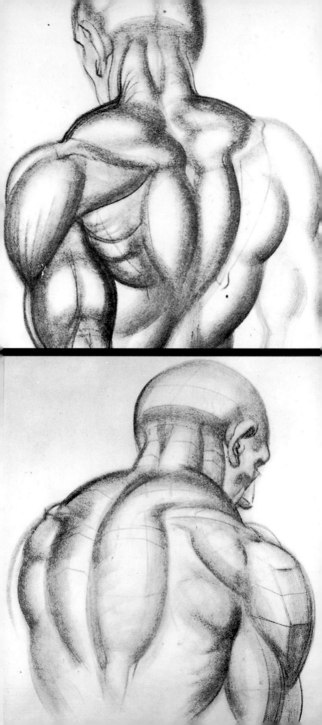

THE LOWER TORSO MASS The lower mass of the torso, the pelvic mass, is shaped like a flattened wedge box, narrow at the waist and wider at the buttocks. The mass is tipped forward at the abdomen and slopes backward at a fifteen-degree angle, opposing and balancing the movement of the rib cage. The two masses are separated by a space one-half a head in length, from the rib cage to pelvic girdle.

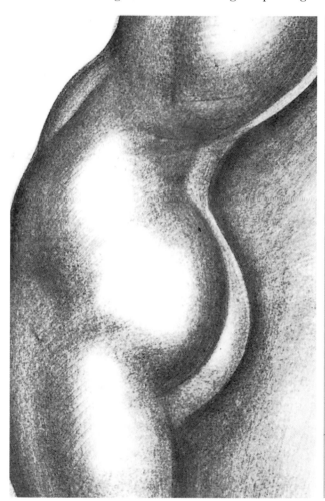

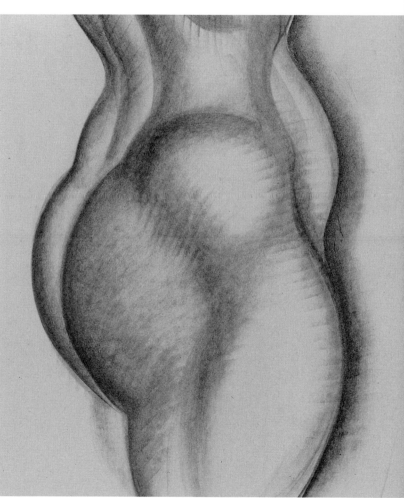

THE BACKWARD
TILT OF
THE PELVIC MASS.

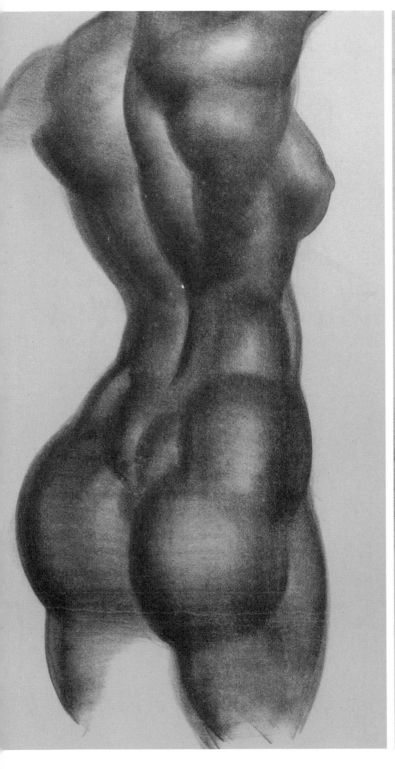

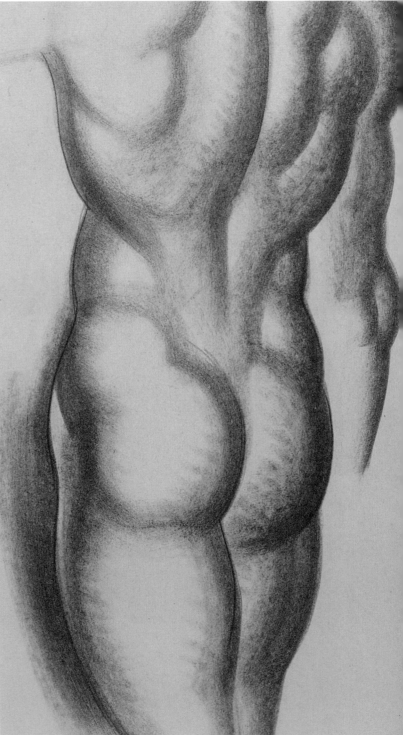

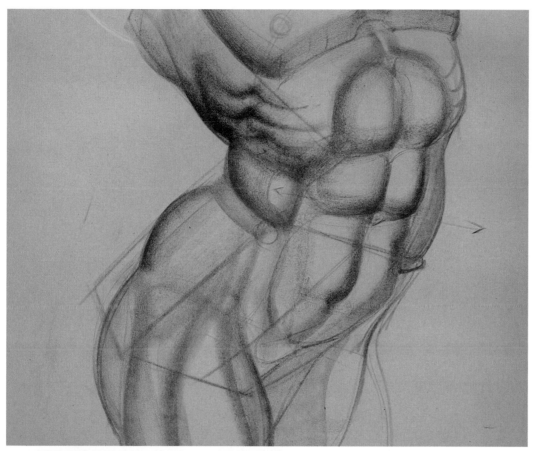

THE MID-AXIAL
REGION OF THE
TORSO: THE PELVIC
MASS BALANCES
AND OPPOSES
THE UPPER TORSO
IN MOVEMENT.

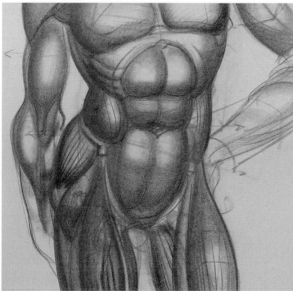

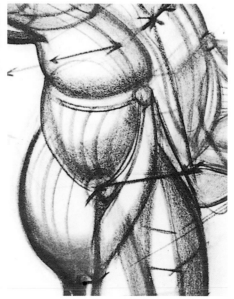

THE MAJOR MUSCLE MASSES The front torso contains five important muscle masses: the two pectoral chest masses, divided centrally by the sternum; the abdominal mass, rectus abdominis, the sheath of the internal organs, divided into three tiers horizontally and two columns vertically by the linea alba, revealing six sections; and the side support muscles connecting ribs and pelvis, the two externus oblique masses. The smaller muscles of the ribs, the serratus anterior group, lie transversely on the ribs under the pectorals. With the arms down, five serratus slots may be seen. With the arms up, a sixth becomes visible on either side of the rib cage, high up under the borders of the pectorals in line with the nipples.

1. SPLENIUS CAPITIS
2. STERNOMASTOID
3. TRAPEZIUS
4. DELTOID
5. LEVATOR SCAPULAE
6. OMOHYOID
7. CLAVICLE
8. BICEPS
9. STERNUM
10. TERES MAJOR
11. PECTORALIS MAJOR
12. LATISSIMUS DORSI
13. SERRATUS ANTERIOR
14. LINEA ALBA
15. RECTUS ABDOMINIS
16. UMBILICUS
17. EXTERNUS OBLIQUE
18. INGUINAL LIGAMENT

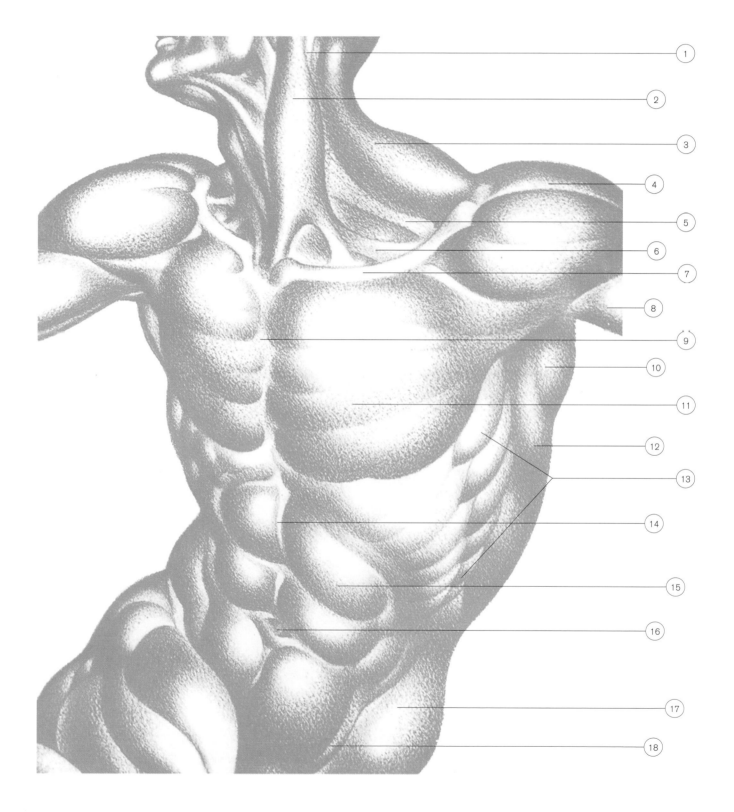

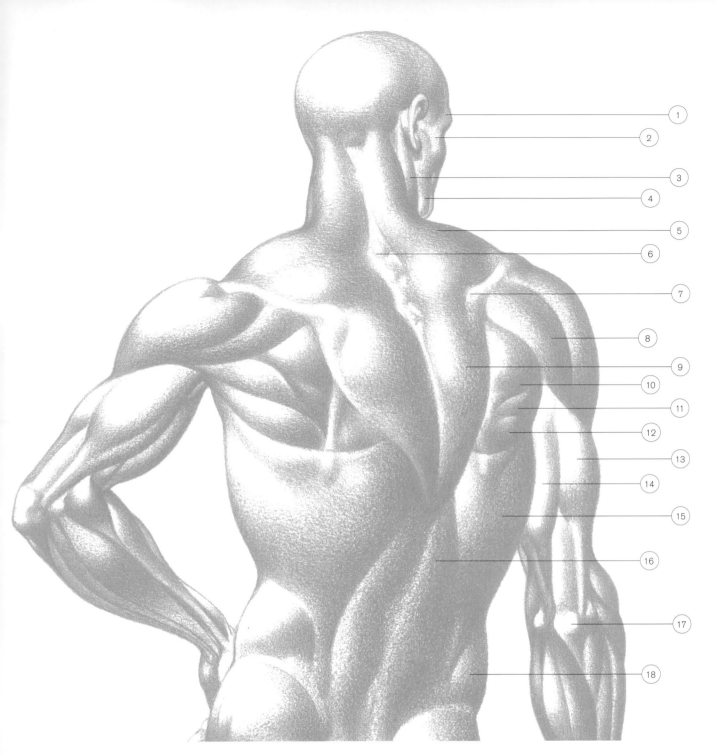

1. SUPERCILIARY ARCH
2. ZYGOMATIC BONE
3. STERNOMASTOID
4. MASSETER
5. TRAPEZIUS
6. SEVENTH CERVICAL VERTEBRA
7. ACROMION
8. DELTOID
9. TRAPEZIUS
10. INFRASPINATUS
11. TERES MINOR
12. TERES MAJOR

13. TRICEPS—LATERAL HEAD
14. TRICEPS—LONG HEAD
15. LATISSIMUS DORSI
16. SACROSPINALIS
17. OLECRANON
18. EXTERNUS OBLIQUE
19. ILIAC CREST
20. GLUTEUS MEDIUS
21. GLUTEUS MAXIMUS
22. TRICEPS—MEDIAL HEAD
23. BRACHIALIS

24. ANCONEUS
25. BICEPS
26. BRACHIALIS
27. PALMARIS LONGUS
28. FLEXOR CARPI RADIALIS
29. EXTENSOR CARPI ULNARIS
30. FLEXOR CARPI ULNARIS
31. EXTENSOR DIGITORUM
32. EXTENSOR CARPI RADIALIS BREVIS
33. BRACHIORADIALIS
34. EXTENSOR CARPI RADIALIS LONGUS

The back torso comprises fourteen large muscle groups, seven on each side of the spine. These are: the kite-shaped trapezius high up on the back, connecting skull and shoulder blades and tapering into the spine; the latissimus dorsi, or sling muscles, attaching high under the arm and descending to the back of the pelvis; the externus obliques, continuing from the front and anchoring on the arch of the pelvis; the sacrospinalis columns, the erectors of the spine, centrally located in the lower middle of the back; the gluteus medius masses, buttressing the inside curves of the hip arches at the sides; the gluteus maximus masses, the buttocks, thrusting from the inside rear of the pelvis and sacrum and attaching into the legs; and, finally, the muscle groups on the shoulder blades, the deltoid, infraspinatus, teres minor, and teres major, all of them crossing to the arm.

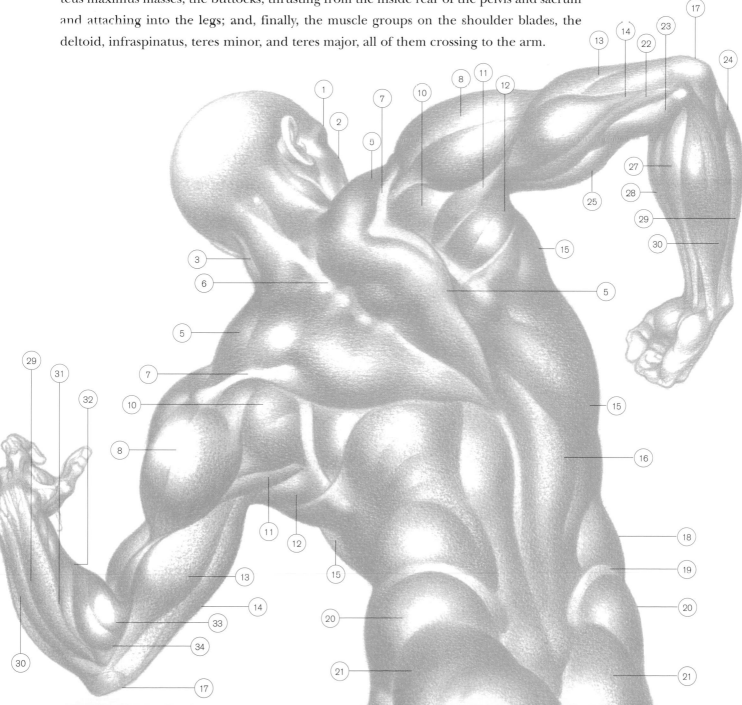

MEASUREMENTS The torso, front view, measures overall three heads in length, while the back torso measures three and one-half heads in length. The front measurements divide thus: from a line drawn across the collarbones to the base of the pectorals, one head length; from the pectoral line to the umbilicus, or navel, a second head length; from the navel to the pubic arch, a third head length. The lower visceral mass of the abdominis frontally can be seen as a head shape within the pelvic basin.

The measurements of the back torso show these divisions: from a line drawn across the extreme widths of the shoulder blades to the base points of the blades, one head length; from the points to the mid-position of the externus oblique muscles, a second head length (it will be noted that this line is drawn from across the navel position, front); from this mid-position to the end of the spine, or coccyx bone (the pubic arch rear), a third head length; and from the coccyx to the base of the buttocks, one-half head length.

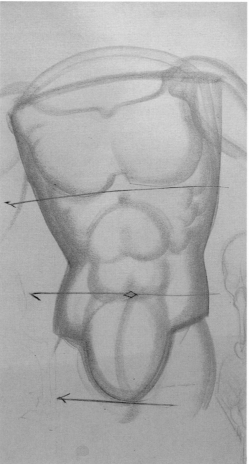
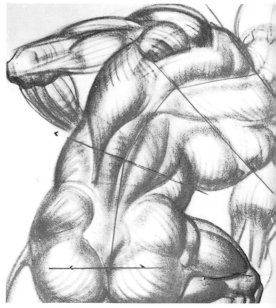

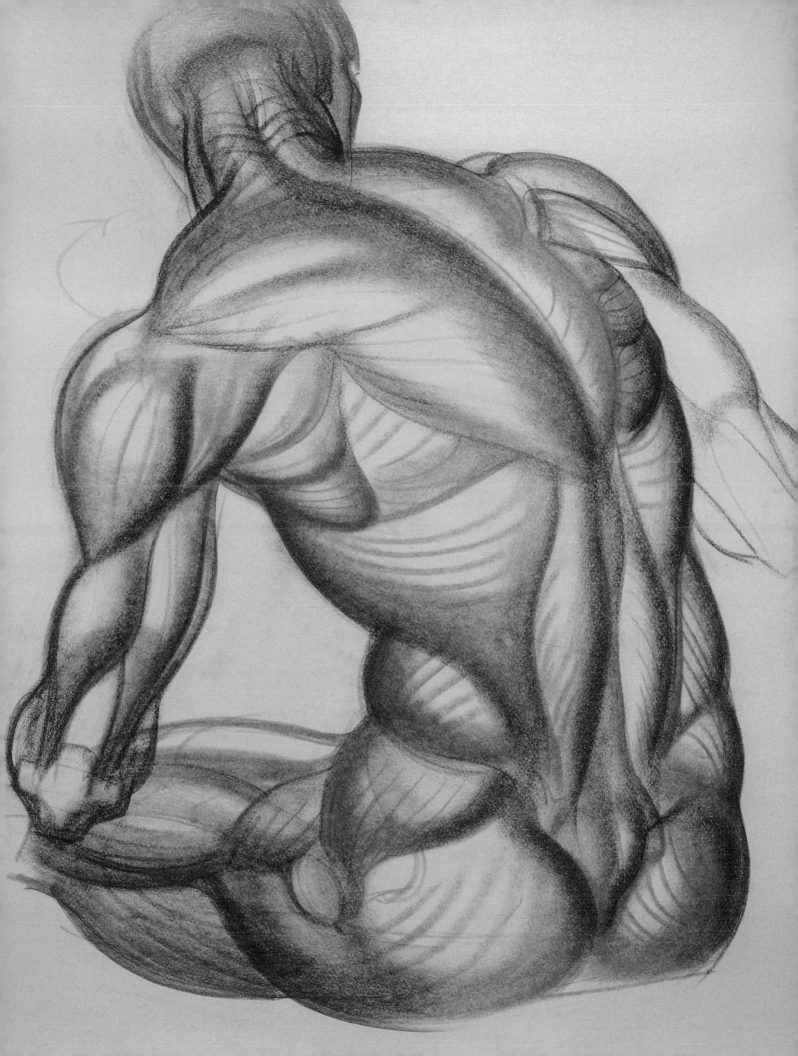

POINTS TO REMEMBER IN DRAWING The entire group of back muscles can be easily positioned with the M diagram of the back. The large M should be placed on the back rib cage at a height just lower than the shoulders and drawn down to the shoulder blade points. The arms of the M identify the edges of the shoulder blades. The blades can thus be affixed. The inside of the M, the deep V, is the tapered line of the trapezius. Thus, the mass of trapezius above easily falls into place. The side latissimus masses can now be laid in under the arms of the M to the inner V. The middle lower groups, erectors and obliques, descend and widen from under the point of the inner V. Location and placement of muscle masses with this device will produce facility in the drawing of foreshortened or extreme views of the back in body movement.

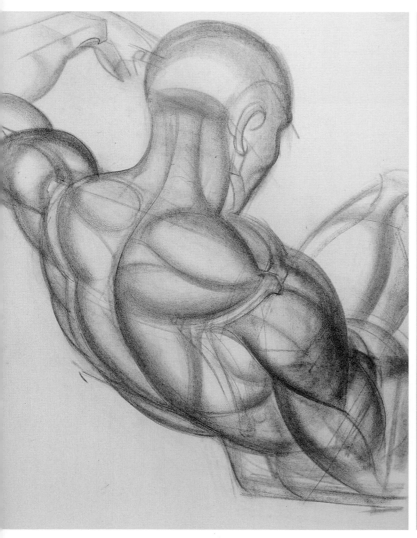

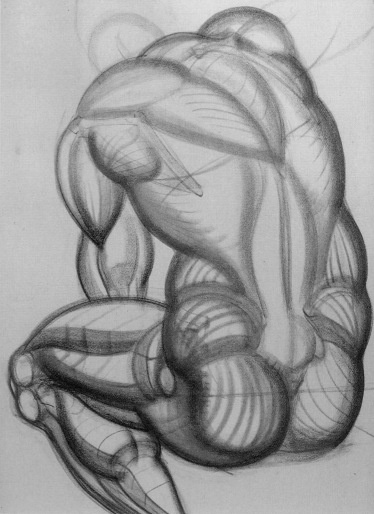

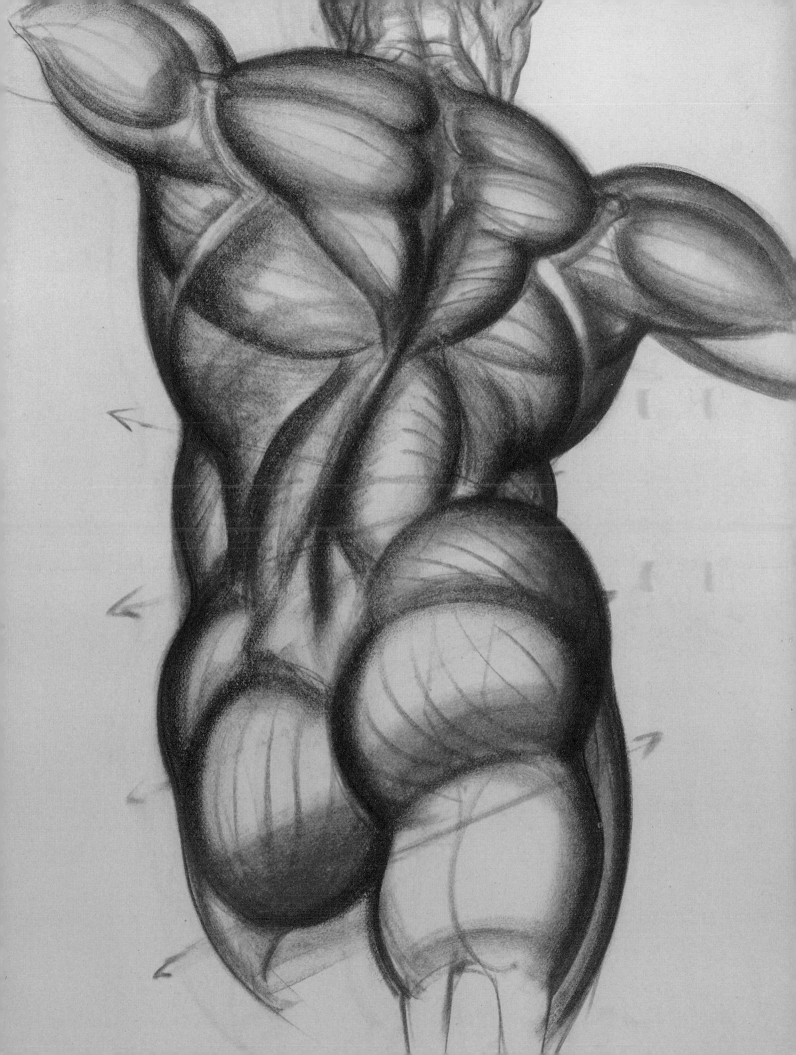

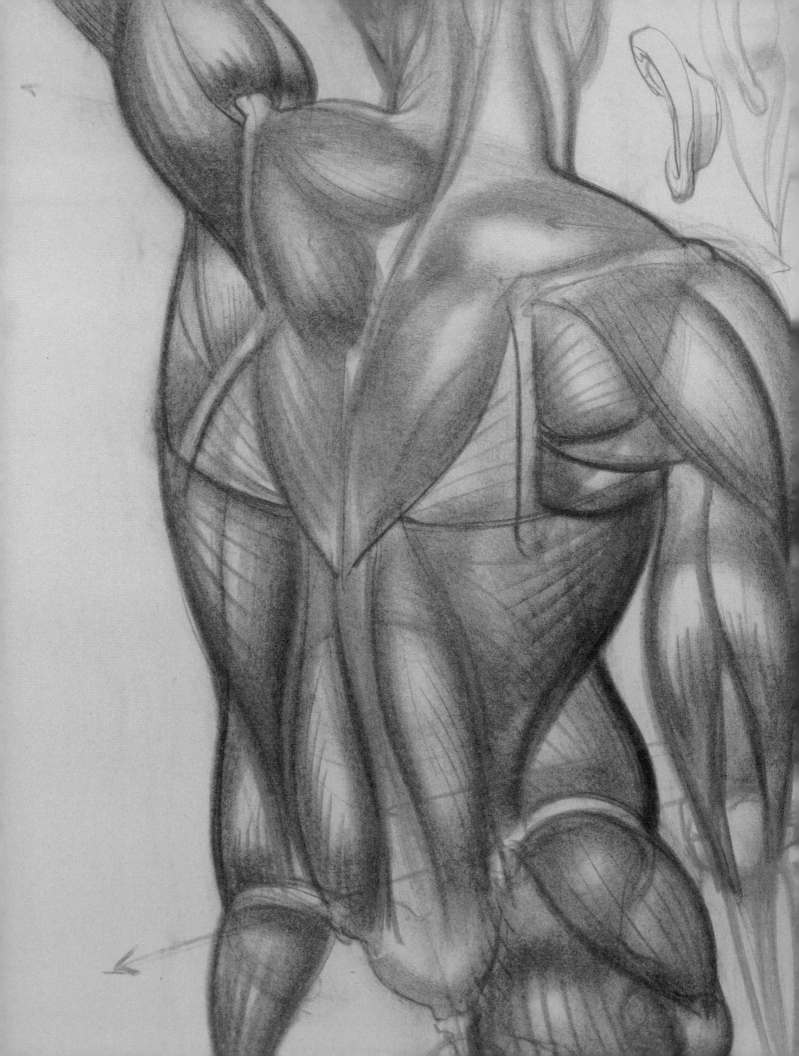

The front torso at the shoulders and collarbones has the appearance of a sloping diamond shape. In difficult views, across or down, this shape enables the artist to locate the neck tunneling in and to place the origin of arms across the shoulders.

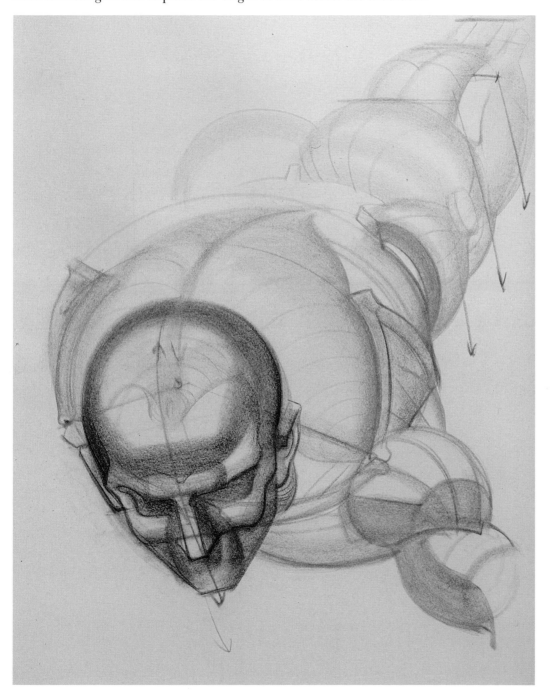

To place the serratus muscles on the rib cage correctly, a line drawn from the pit of the neck through the nipple will cross the pectorals and rib cage at a curving forty-five-degree angle to the base of the ribs. This line, below the pectorals, holds the five serratus slots in place.

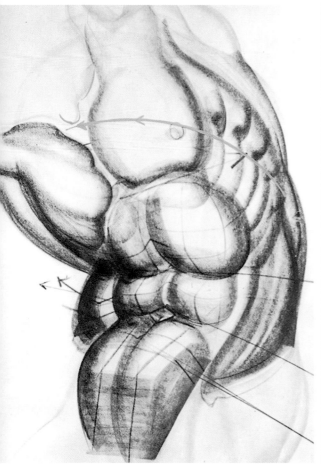
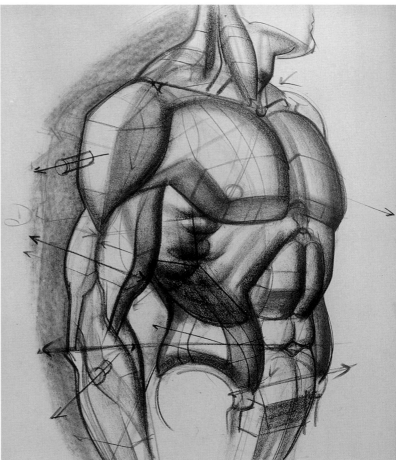

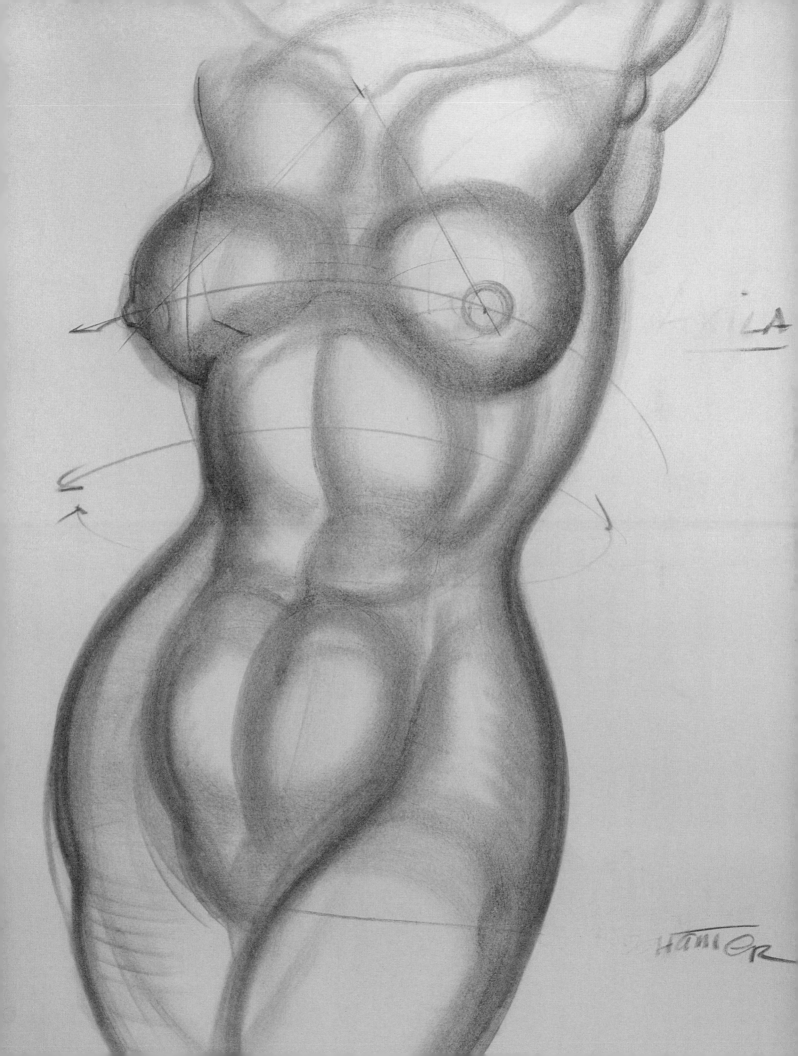

AXILA

Hamer

The collarbones, seen together, have the appearance of a coat hanger turned upside down. Taken separately, the form of each clavicle presents an elongated s line of movement from *any* viewing position.

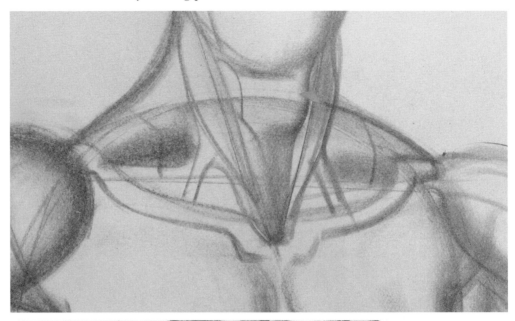

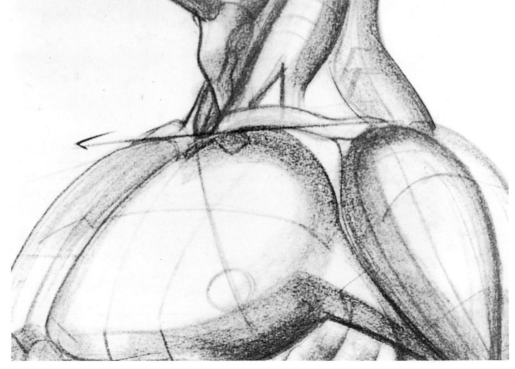

The pelvic mass, rear view, has a distinct *butterfly shape* in drawing. The two upper wings are the gluteus medius masses under the iliac, or pelvic, curves. The lower wings are the gluteus maximus, or buttock masses. In the separations of the upper and lower wings, the great trochanter protrusions of the leg bones appear.

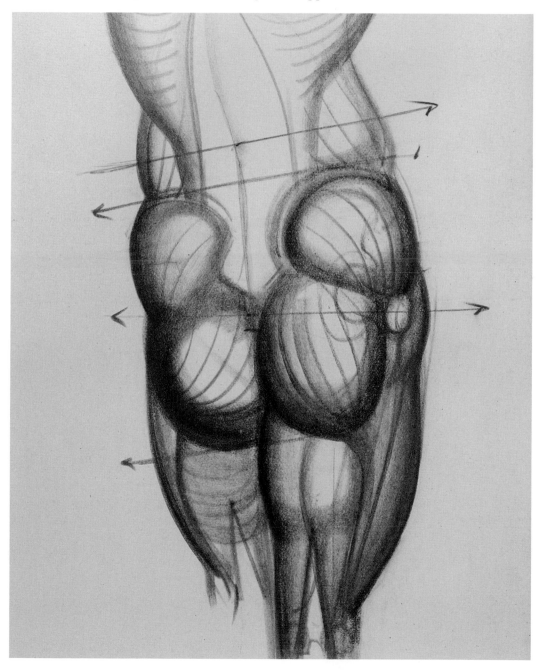

The shoulder blades should be understood as a floating anchor of bone on the back. This "anchor" attaches to the arm bone and moves freely, swinging or sliding like a gate with every movement of the arm. When the arm is up, the acromion, the high ridge of the blade, swings down; when the arm is down, the acromion swings up.

Note well: The entire muscle mass of the upper torso around the body has one major function—to move the arms. The mid-axial mass, front and rear, bends, twists, or stabilizes the two torso masses. The lower torso mass, below the pelvic girdle, activates the legs.

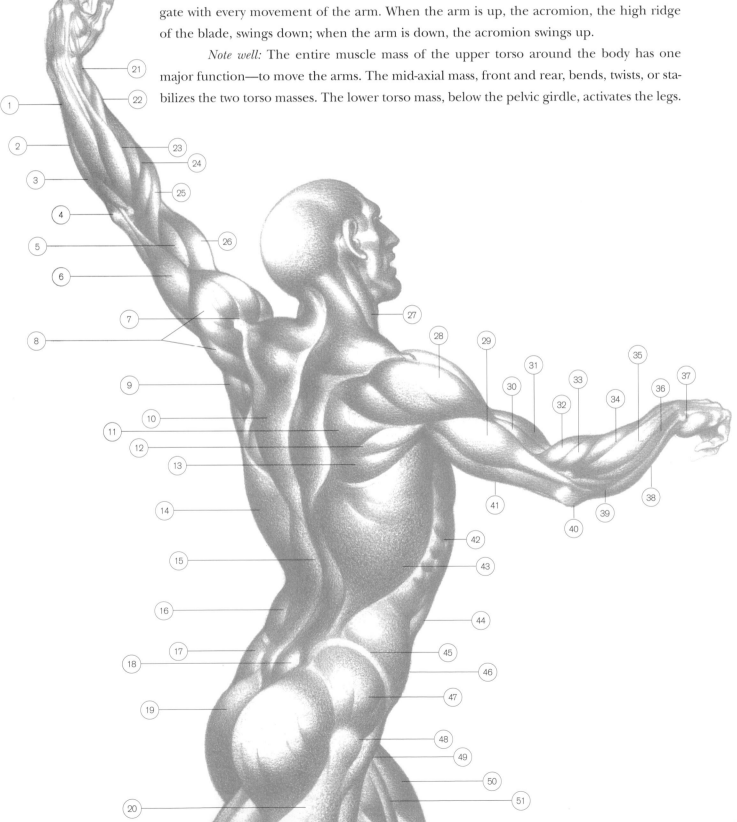

1. EXTENSOR DIGITORUM
2. EXTENSOR CARPI ULNARIS
3. ANCONEUS
4. OLECRANON
5. BRACHIALIS
6. TRICEPS
7. ACROMION
8. DELTOID
9. INFRASPINATUS
10. TRAPEZIUS
11. INFRASPINATUS
12. TERES MINOR
13. TERES MAJOR
14. LATISSIMUS DORSI
15. SACROSPINALIS
16. EXTERNUS OBLIQUE
17. GLUTEUS MEDIUS
18. SACRUM
19. GLUTEUS MAXIMUS
20. VASTUS EXTERNUS
21. EXTENSOR POLLICIS BREVIS
22. ABDUCTOR POLLICIS LONGUS
23. EXTENSOR CARPI RADIALIS BREVIS
24. EXTENSOR CARPI RADIALIS LONGUS
25. BRACHIORADIALIS
26. BICEPS
27. STERNOMASTOID
28. DELTOID
29. TRICEPS—LATERAL HEAD
30. BRACHIALIS
31. BICEPS
32. BRACHIORADIALIS
33. EXTENSOR CARPI RADIALIS LONGUS
34. EXTENSOR CARPI RADIALIS BREVIS
35. EXTENSOR DIGITORUM
36. EXTENSOR CARPI ULNARIS
37. ULNAR HEAD
38. FLEXOR CARPI ULNARIS
39. ANCONEUS
40. OLECRANON
41. TRICEPS—LONG HEAD
42. SERRATUS ANTERIOR
43. LATISSIMUS DORSI
44. RECTUS ABDOMINIS
45. ILIAC CREST
46. EXTERNUS OBLIQUE
47. GLUTEUS MEDIUS
48. GREAT TROCHANTER
49. TENSOR FASCIAE LATAE
50. RECTUS FEMORIS
51. SARTORIUS

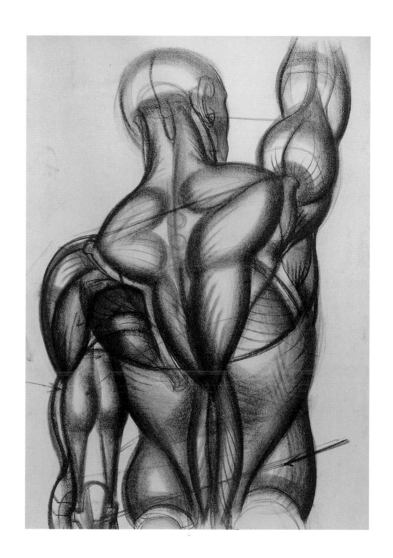

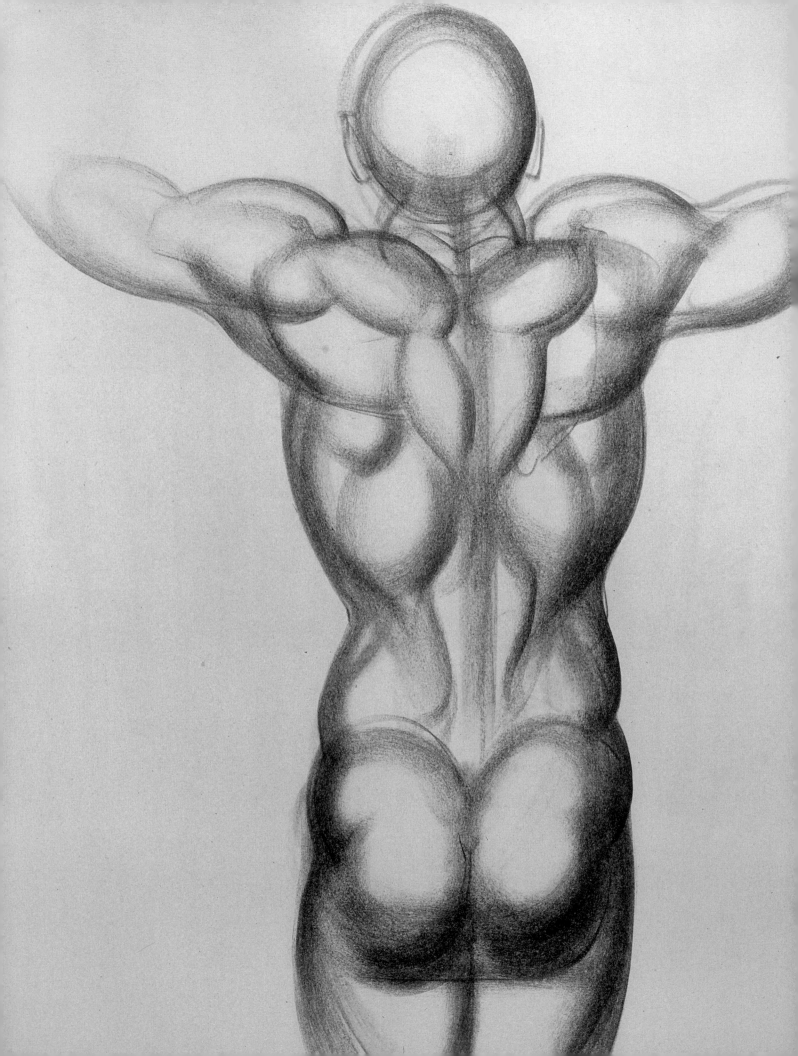

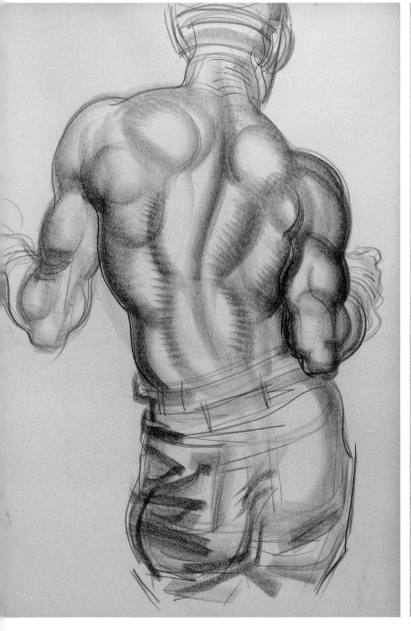

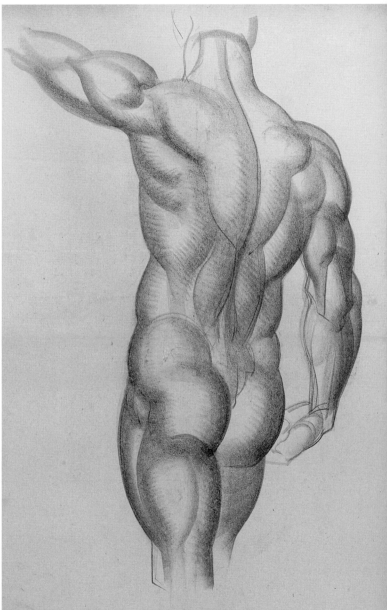

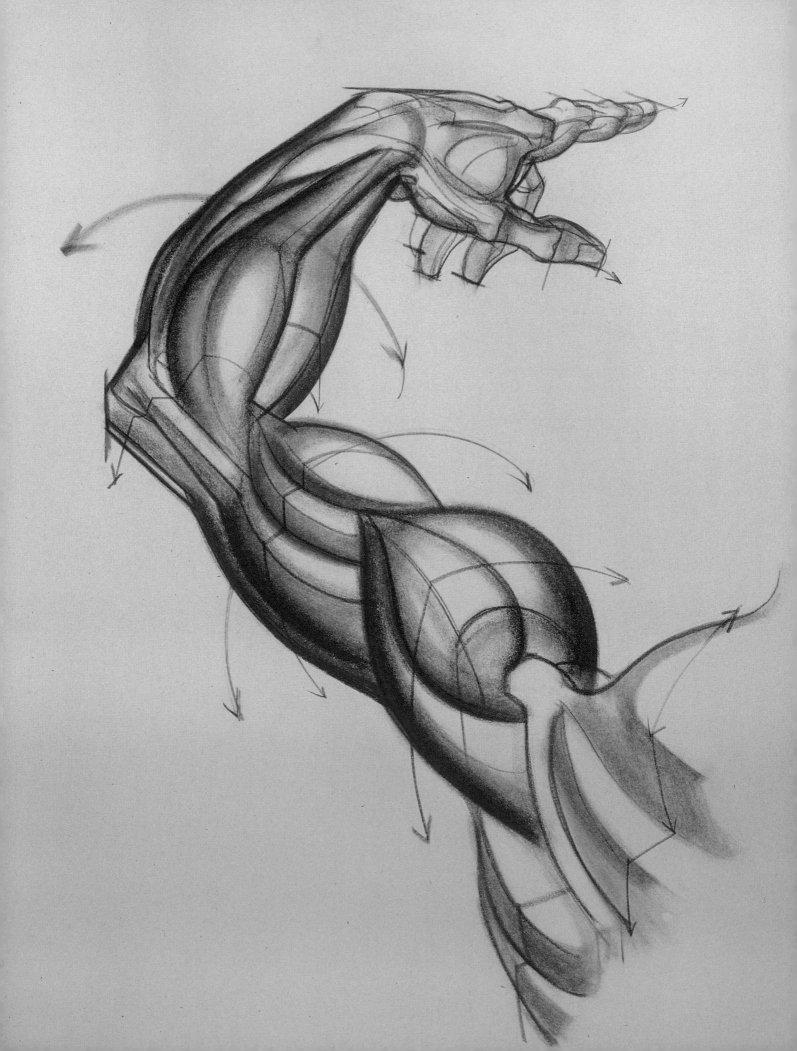

THE ARM

THE UPPER ARM The upper arm is a rather flat, elongated tapered form from shoulder to elbow, surmounted by a broad, high mass of muscle. The member consists of three major muscle masses: the biceps frontally, with the brachialis as a component for bending the lower member; the triceps to the rear for straightening it; and the deltoid to the side, high up—the shoulder mass—for raising the entire arm. The thrust of shapes on the upper arm presents a constant opposition: The biceps and triceps move frontward and backward, while the deltoid, higher up, thrusts sideward and upward. The deltoid may be compared to the gluteus masses of the lower torso. Each group elevates its lower member. The deltoid raises the arm front, side, and back; the glutei raise the leg side and rear only.

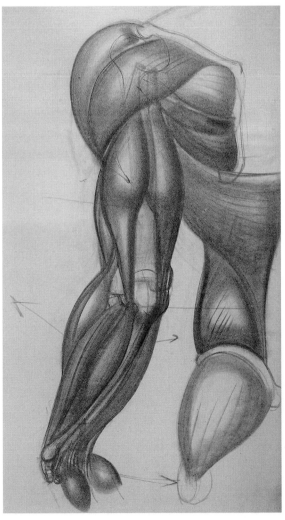
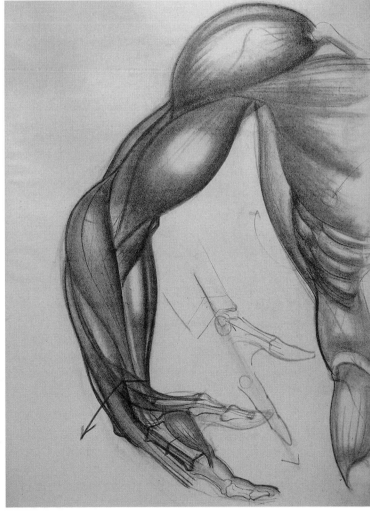

THE LOWER ARM The lower arm presents a roundly developed tapered mass from elbow to the flattened form of the wrist. The masses of the forearm lie opposed to the upper arm masses, moving generally from outside to inside against the torso. The forearm consists of three important muscle groups: the under forearm group, the flexors, for bending the palm and clenching the fingers; the outer forearm group, the extensors, for straightening the palm and opening the fingers; and the brachioradialis group, the supinators, attached to the upper elbow on the outside of the arm and descending the length of the forearm to the inside of the wrist, for rotating the palm of the hand outward. A fourth smaller muscle, the pronator, originates on the inner elbow projection of the humerus and crosses to the forearm to perform rotation of the palm inward to the body.

1. INTEROSSEUS
2. LUNATE PROMINENCE
3. EXTENSOR POLLICIS BREVIS
4. ABDUCTOR POLLICIS LONGUS
5. EXTENSOR CARPI RADIALIS BREVIS
6. EXTENSOR CARPI RADIALIS LONGUS
7. BRACHIORADIALIS
8. BRACHIALIS
9. BICEPS
10. DELTOID
11. CLAVICLE
12. ADDUCTOR POLLICIS

13. ABDUCTOR POLLICIS BREVIS
14. PALMARIS LONGUS
15. FLEXOR CARPI RADIALIS
16. PRONATOR TERES
17. MEDIAL EPICONDYLE
18. BRACHIALIS
19. TRICEPS—MEDIAL HEAD
20. TERES MAJOR
21. PECTORALIS MAJOR
22. LATISSIMUS DORSI
23. SERRATUS ANTERIOR

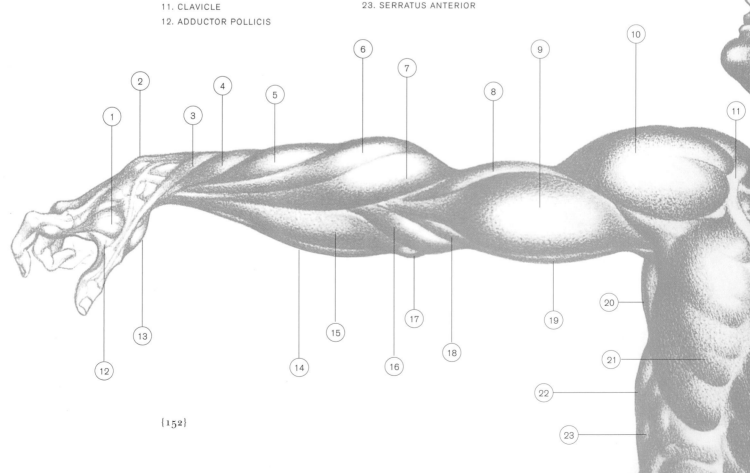

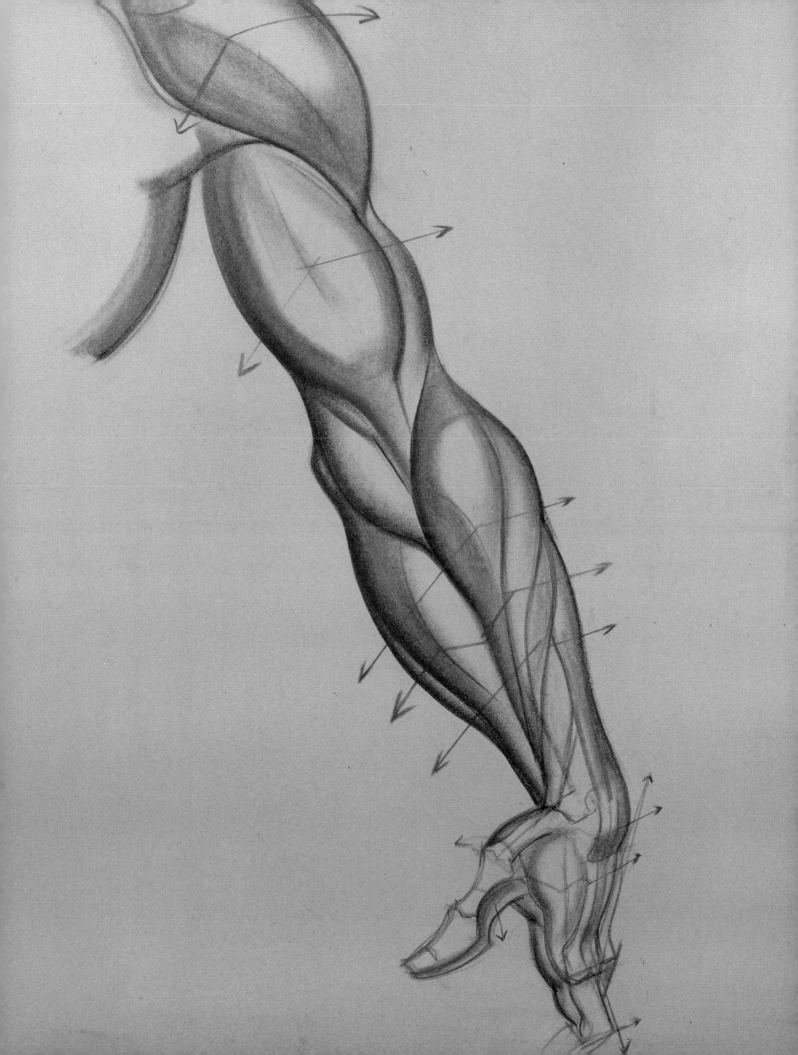

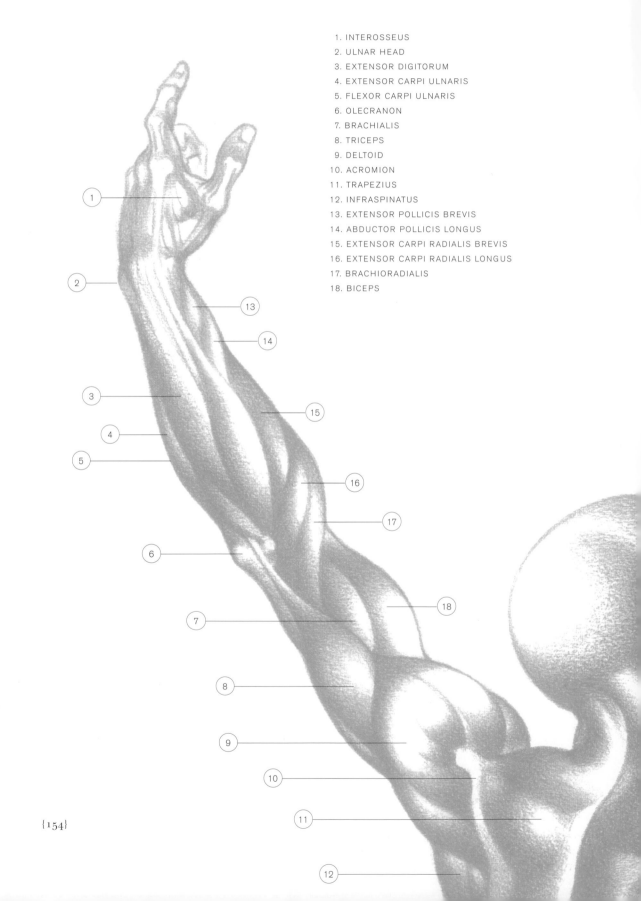

1. INTEROSSEUS
2. ULNAR HEAD
3. EXTENSOR DIGITORUM
4. EXTENSOR CARPI ULNARIS
5. FLEXOR CARPI ULNARIS
6. OLECRANON
7. BRACHIALIS
8. TRICEPS
9. DELTOID
10. ACROMION
11. TRAPEZIUS
12. INFRASPINATUS
13. EXTENSOR POLLICIS BREVIS
14. ABDUCTOR POLLICIS LONGUS
15. EXTENSOR CARPI RADIALIS BREVIS
16. EXTENSOR CARPI RADIALIS LONGUS
17. BRACHIORADIALIS
18. BICEPS

1. TRICEPS—LONG HEAD
2. TRICEPS—LATERAL HEAD
3. TRICEPS—MEDIAL HEAD
4. BRACHIALIS
5. MEDIAL EPICONDYLE
6. OLECRANON
7. FLEXOR CARPI RADIALIS
8. PALMARIS LONGUS
9. FLEXOR CARPI ULNARIS
10. EXTERNUS OBLIQUE
11. ILIAC CREST
12. GLUTEUS MEDIUS
13. GREAT TROCHANTER
14. ABDUCTOR POLLICIS LONGUS
15. EXTENSOR CARPI RADIALIS LONGUS
16. BRACHIORADIALIS
17. PRONATOR TERES
18. LATISSIMUS DORSI
19. BICEPS
20. DELTOID
21. TERES MAJOR
22. TERES MINOR
23. ACROMION
24. INFRASPINATUS

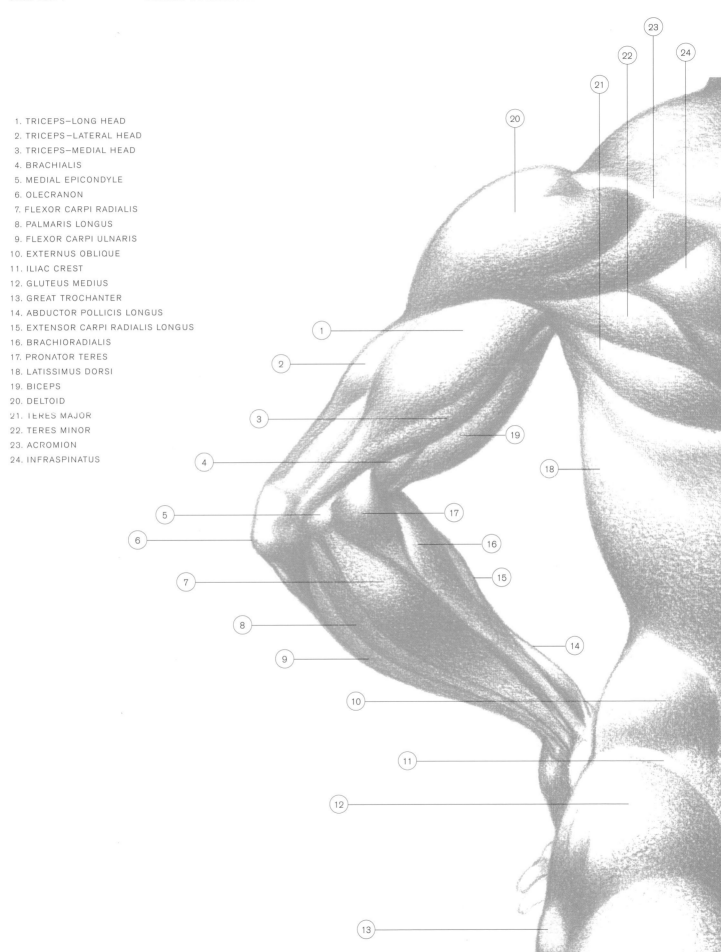

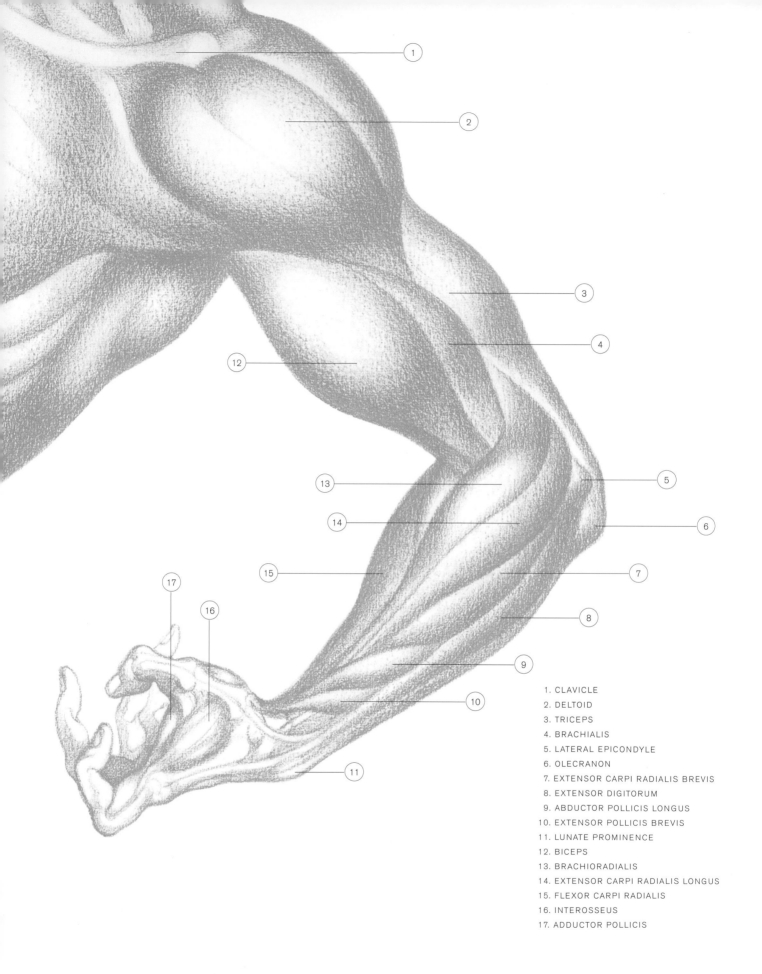

1. CLAVICLE
2. DELTOID
3. TRICEPS
4. BRACHIALIS
5. LATERAL EPICONDYLE
6. OLECRANON
7. EXTENSOR CARPI RADIALIS BREVIS
8. EXTENSOR DIGITORUM
9. ABDUCTOR POLLICIS LONGUS
10. EXTENSOR POLLICIS BREVIS
11. LUNATE PROMINENCE
12. BICEPS
13. BRACHIORADIALIS
14. EXTENSOR CARPI RADIALIS LONGUS
15. FLEXOR CARPI RADIALIS
16. INTEROSSEUS
17. ADDUCTOR POLLICIS

1. TRAPEZIUS
2. CLAVICLE
3. DELTOID
4. TRICEPS—LONG HEAD
5. TRICEPS—LATERAL HEAD
6. BICEPS
7. BRACHIALIS
8. BRACHIORADIALIS
9. EXTENSOR CARPI RADIALIS LONGUS
10. OLECRANON
11. ANCONEUS
12. BRACHIORADIALIS
13. EXTENSOR CARPI RADIALIS LONGUS
14. EXTENSOR CARPI RADIALIS BREVIS
15. EXTENSOR DIGITORUM
16. EXTENSOR CARPI ULNARIS
17. FLEXOR CARPI ULNARIS
18. TERES MAJOR
19. ULNAR HEAD
20. PECTORALIS MAJOR
21. LATISSIMUS DORSI
22. SERRATUS ANTERIOR

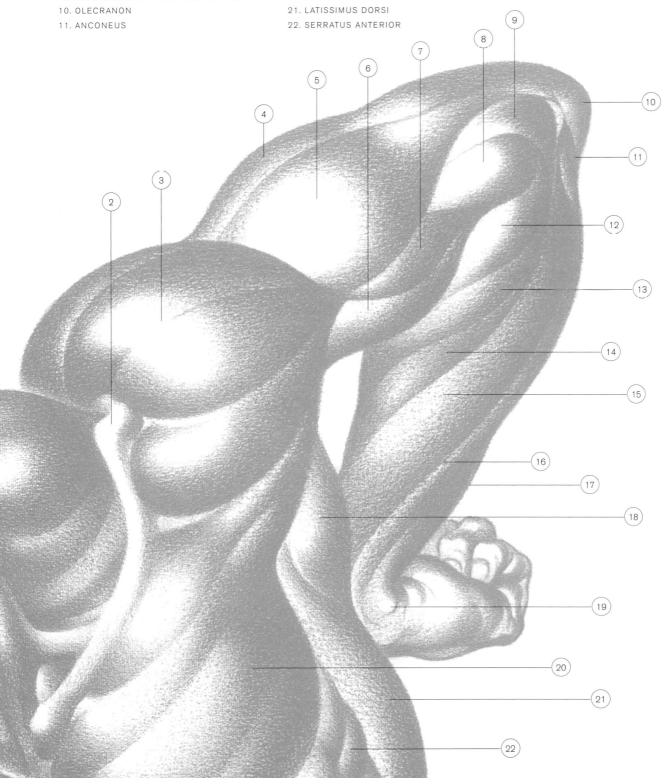

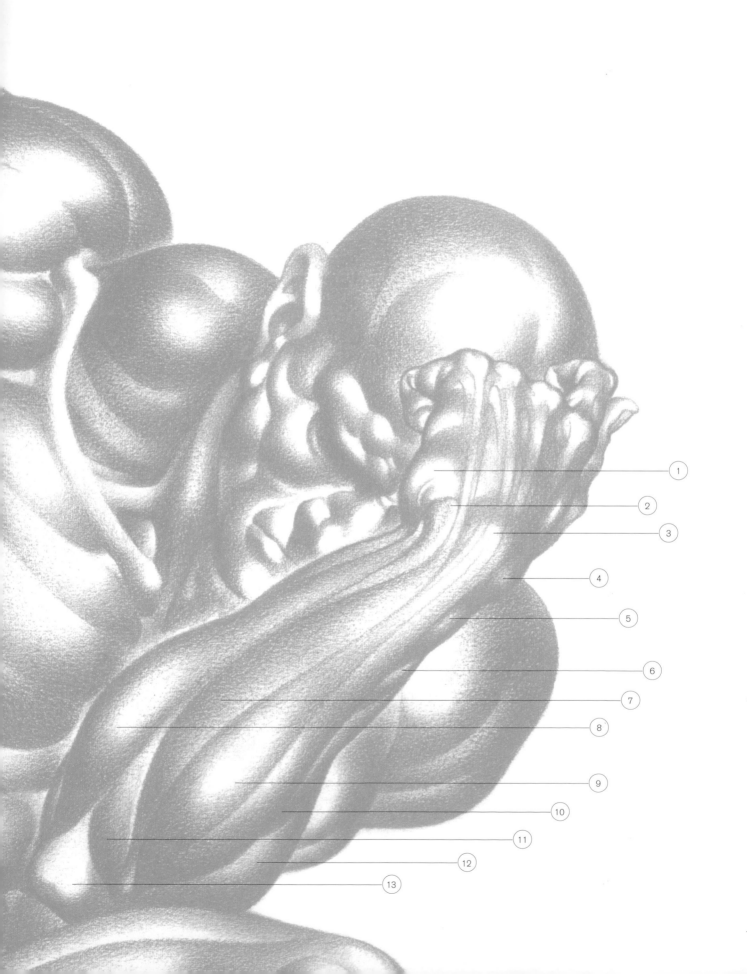

1
2
3
4
5
6
7
8
9
10
11
12
13

MEASUREMENTS The upper arm, starting at the shoulder girdle, drops to a line drawn across the torso from the umbilicus through the mid-position of the externus oblique. Thus, the bend of the elbow lines up with the navel. From this position, the lower arm moves down to the wrist at a point in line with the great trochanter, the bony prominence high on the side of the leg. This point lies on the line drawn across the lower torso from the pubic arch (front) to the coccyx bone (rear). We must note that the deltoid muscle is fully a head-length deep on the side of the arm, and this position lies across the line of the base of the pectorals on the chest (front) and across the base of the shoulder blades (rear). The biceps muscle in the front upper arm is one head in length from pectoral to forearm. The entire arm may be said to be two and three-quarters heads in length, from shoulder height to wrist. With the hand added, the arm is three and a half heads long.

1. ABDUCTOR DIGITI QUINTI
2. ULNA BONE
3. LUNATE PROMINENCE
4. RADIUS BONE
5. EXTENSOR POLLICIS BREVIS
6. ABDUCTOR POLLICIS LONGUS
7. EXTENSOR CARPI ULNARIS
8. FLEXOR CARPI ULNARIS
9. EXTENSOR DIGITORUM
10. EXTENSOR CARPI RADIALIS BREVIS
11. ANCONEUS
12. EXTENSOR CARPI RADIALIS LONGUS
13. OLECRANON

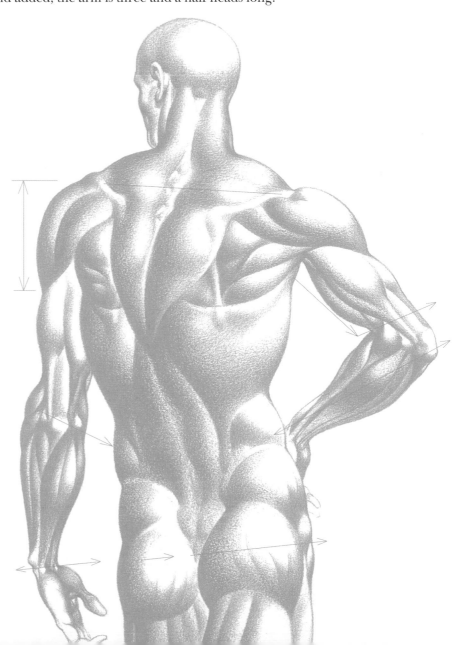

THE ELBOW The elbow presents a large, triangulated protruding surface at the back joint of the arm. The backward projection, or olecranon—the elbow protrusion of the ulna—is a broad, hooked form that acts as a locking device in straightening the arm. It narrows to a thin wedge. On either side of this prominence, the upper arm bone, the humerus, opens a fossa to receive it. The humerus base has two large side projections, both of which are visible from the rear; the inner is larger and more dominant. The elbow area thus formed, with its side points wide and hook thrust back, appears visually like an inverted pyramid support. The head of the radius, seen on the side upper forearm, is hardly visible under the arched mound of the brachioradialis muscle.

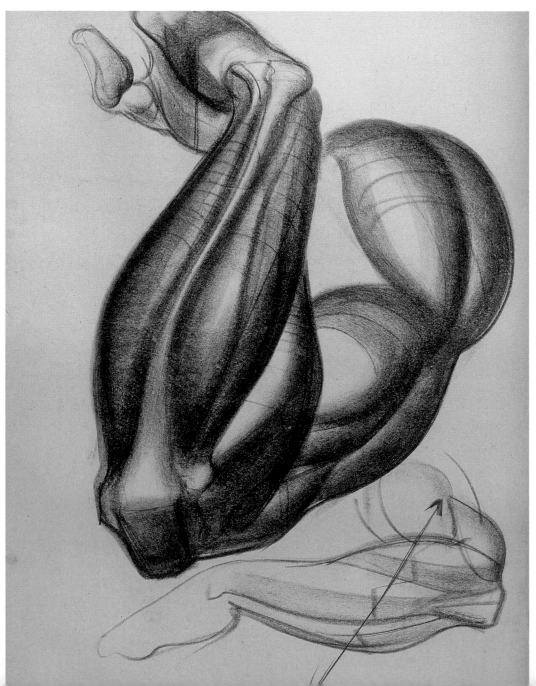

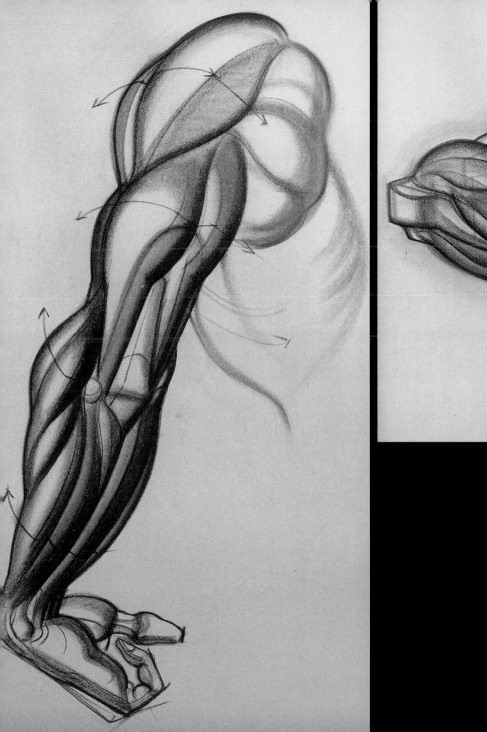
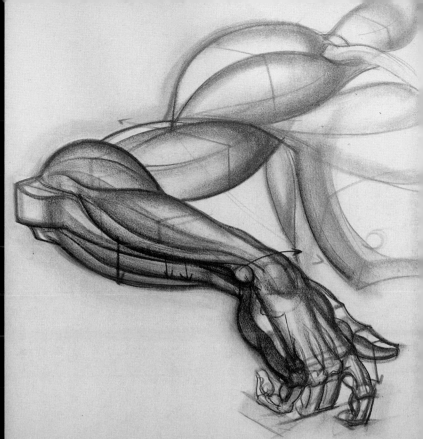

POINTS TO REMEMBER IN DRAWING The flat part of the wrist is locked to the flat part of the palm. It *never* changes. Thus, as the arm turns, the palm turns.

The turn of the palm on the forearm can complete a full half circle, or a 180-degree arc of movement from supination to pronation.

The flexor muscle mass on the under forearm is separated from the upper extensor mass by the line of the ulna, the bony edge running from the elbow to the outside head of the wrist.

The arms have tremendous freedom of movement. To understand their capacity for activity, the arms must be understood to attach to the body not at the shoulders, but into the pit of the neck. The clavicles, therefore, are really additional extensions to the arm lengths; thus, the complex of bone lengths produces a mechanism with an unusual ability for movement.

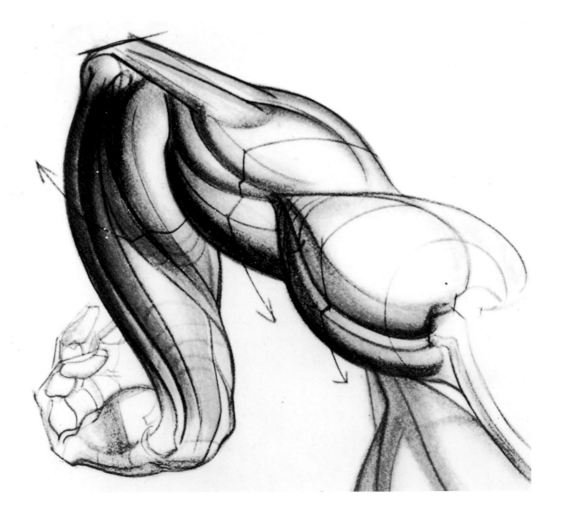

1. DELTOID
2. PECTORALIS MAJOR
3. BICEPS
4. TRICEPS
5. BRACHIALIS
6. BRACHIORADIALIS
7. EXTENSOR CARPI RADIALIS LONGUS
8. EXTENSOR CARPI RADIALIS BREVIS
9. ABDUCTOR POLLICIS LONGUS
10. EXTENSOR POLLICIS BREVIS
11. EXTENSOR DIGITORUM
12. EXTENSOR CARPI ULNARIS
13. GLUTEUS MEDIUS
14. ILIAC CREST

15. GLUTEUS MAXIMUS
16. TRAPEZIUS
17. ACROMION
18. CLAVICLE
19. PRONATOR TERES
20. FLEXOR CARPI RADIALIS
21. PALMARIS LONGUS
22. INTEROSSEUS
23. INFRASPINATUS
24. TERES MINOR
25. TERES MAJOR
26. LATISSIMUS DORSI
27. EXTERNUS OBLIQUE
28. FLEXOR CARPI ULNARIS

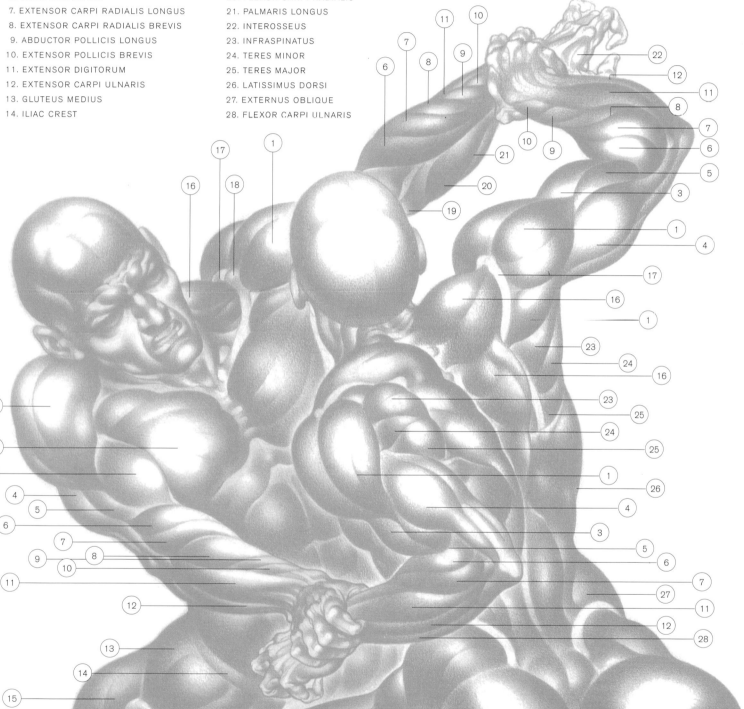

THE HAND

THE MASSES OF THE HAND The palm of the hand is a flat, square-shaped wedge of form, somewhat thicker and wider at the wrist, and slightly narrower and thinner at the fingers. The palmar side has three mounded masses: the thenar group, or ball of the thumb; the hypothenar prominence above the little finger; and the lumbrical pads across the base of the palm. A deep, triangulated hollow lies in the center of the palm. The interosseus muscles are below, but they present little surface appearance. The dorsal, or back, view of the palm presents a hard, bony surface, dominated by the series of tendons moving down from wrist to fingers across the projecting ramp of knuckles.

Two muscle forms are visible on the back palm: the rather large interosseus muscle between thumb and forefinger, and the abductor minimi muscle on the outer edge of the palm above the little finger.

The fingers show no muscular masses; their undersurfaces are soft and padded for gripping and clenching, while their top surfaces are quite skeletal, revealing marked protrusions of the knuckle capsules.

The wrist bones on the back surface of the palm show a major mound when the palm is flexed: the lunate or semilunar carpal bone, lying between the occlusion of the radius and ulna at the wrist. Over this mound, the ramp of extensor tendons descends to the fingers.

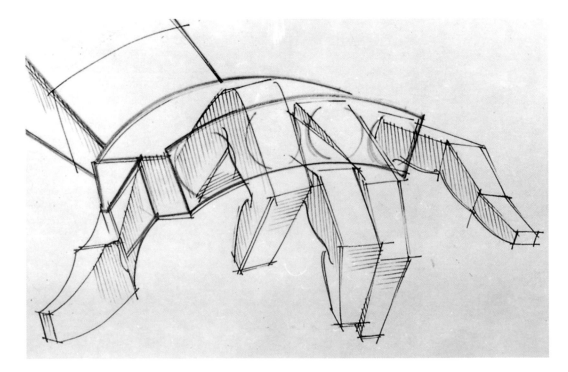

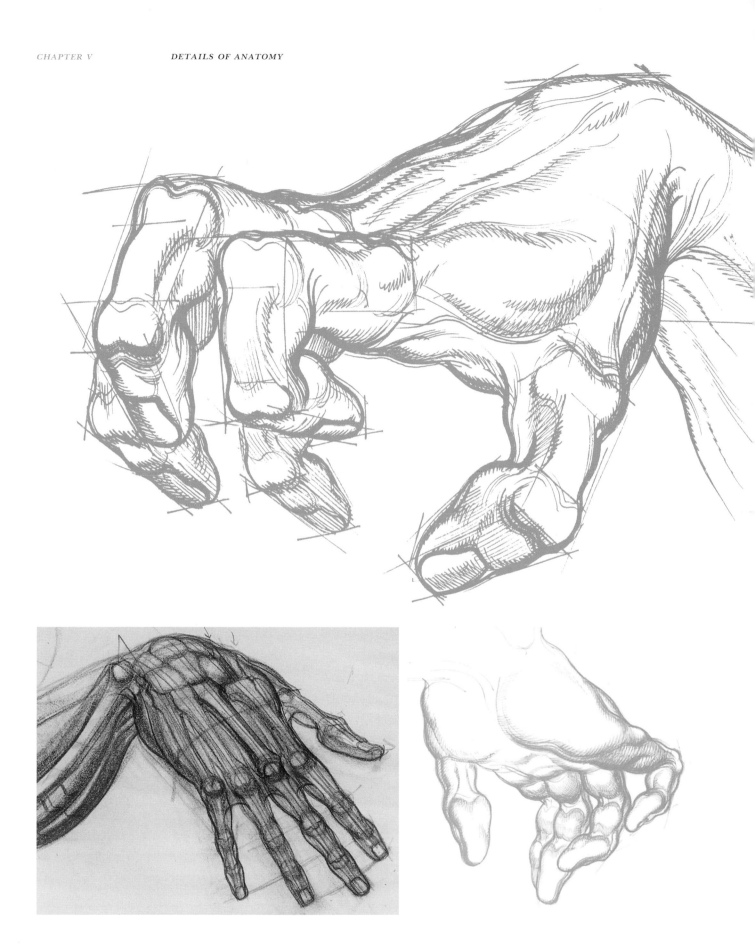

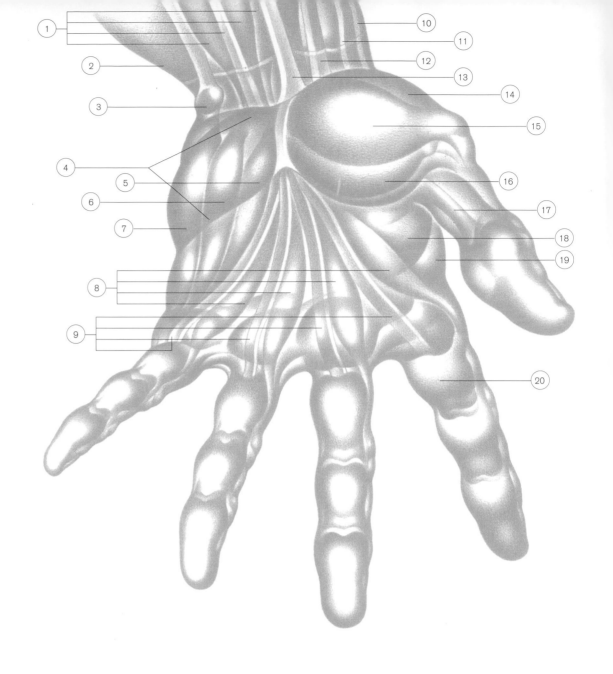

1. FLEXOR DIGITORUM SUBLIMIS
2. FLEXOR CARPI ULNARIS
3. PISIFORM BONE
4. PALMARIS BREVIS
5. OPPONENS DIGITI QUINTI
6. FLEXOR DIGITI QUINTI BREVIS
7. ABDUCTOR DIGITI QUINTI
8. LUMBRICALS
9. TENDONS—FLEXOR DIGITORUM SUBLIMIS
10. EXTENSOR POLLICIS BREVIS

11. ABDUCTOR POLLICIS LONGUS
12. FLEXOR CARPI RADIALIS
13. PALMARIS LONGUS
14. OPPONENS POLLICIS
15. ABDUCTOR POLLICIS BREVIS
16. FLEXOR POLLICIS BREVIS
17. TENDON—FLEXOR POLLICIS LONGUS
18. ADDUCTOR POLLICIS
19. INTEROSSEUS
20. FINGER PAD

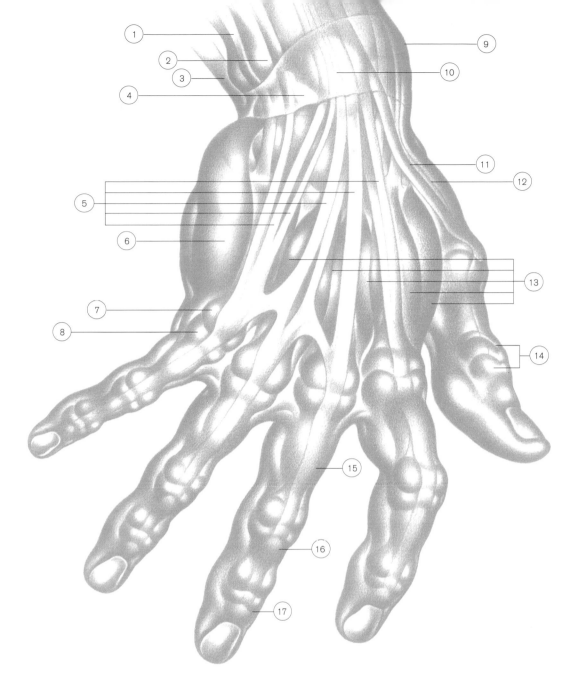

1. TENDON—EXTENSOR CARPI ULNARIS
2. ULNA BONE
3. FLEXOR CARPI ULNARIS
4. ANNULAR LIGAMENT
5. TENDONS—EXTENSOR DIGITORUM
6. ABDUCTOR DIGITI QUINTI
7. HEAD—FIFTH METACARPAL
8. BASE—FIFTH PROXIMAL PHALANX
9. STYLOID PROCESS—RADIUS BONE
10. LUNATE PROMINENCE
11. TENDON—EXTENSOR POLLICIS LONGUS
12. TENDON—EXTENSOR POLLICIS BREVIS
13. INTEROSSEUS MUSCLES
14. KNUCKLE CAPSULE
15. PROXIMAL PHALANX (I)
16. MEDIAN PHALANX (II)
17. TERMINAL PHALANX (III)

MEASUREMENTS The length of the hand measures three-quarters the length of a head, or the distance from chin to hairline on the face; the width of the hand measures the distance from nose to chin. The finger lengths derive their measurements according to the middle third finger of the hand. It is the longest finger and is equal to the length of the palm. Thus, using the middle finger as a norm, the lengths of the index finger and the fourth finger end at the base of the fingernail of the middle finger, while the little finger ends at the second finger joint of the fourth finger. The thumb wedge starts in the mid-position of the palm. The first joint lines up with the knuckles of the palm and then ends at the position of the first knuckle of the index finger.

Each finger section, with the exception of the thumb, divides at two-thirds the length of a *preceding* section. For instance, in the index finger, the first section, phalanx I, is a third longer than the middle section, phalanx II—or the other way around: Phalanx II is two-thirds as long as phalanx I; the smallest, phalanx III, is therefore two-thirds as long as phalanx II. This measuring system applies to all the four fingers of the hand. The thumb, however, is simpler: Its two sections, phalanges I and II, are of equal lengths.

Fingernail lengths lie across the midpoint of the terminal finger sections, phalanx III of each finger, including the thumb.

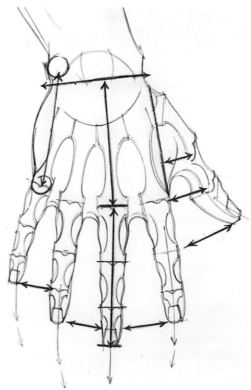

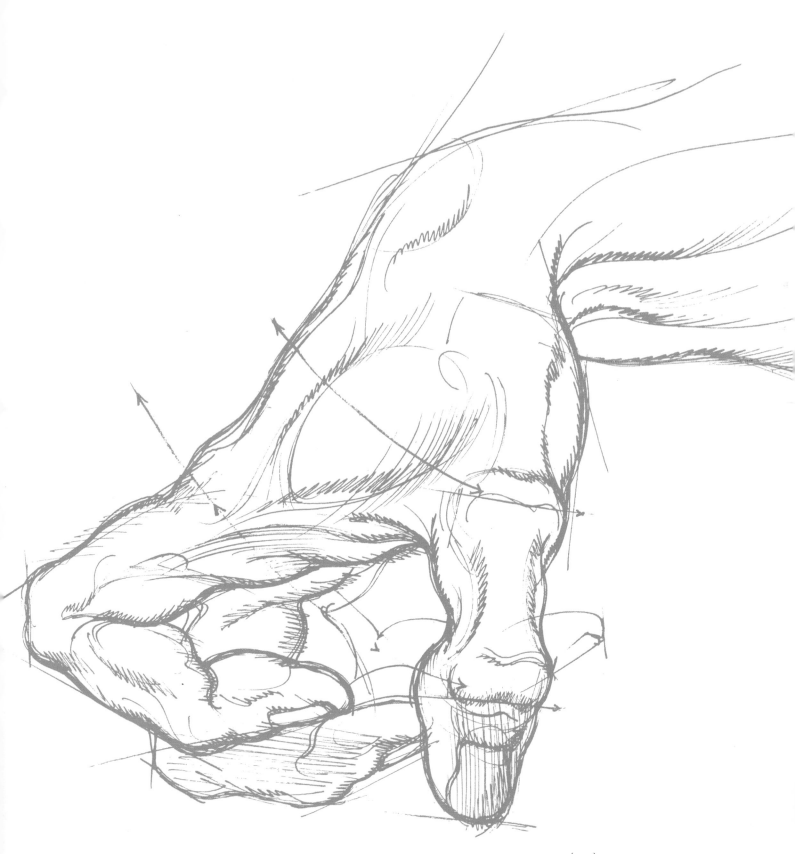

ACTIVITY OF THE HAND The hand may be said to have three kinds of activity: *rhythm,* developed from a relationship of the parts in structure and form; *action,* developed from the capability of the hand to operate in a specific manner; and *movement,* developed from the *visual* pattern of behavior in the action of the hand.

> *RHYTHM* (1) From a side position looking across the top of the hand, the palm and fingers have a *wavelike* rhythm. The wave rhythm can be observed on the entire length of the forearm, rising over the wrist, dropping down the palm, rising over the finger, down again, and up the lift of the fingertip. The undersurface of arm and hand follows this wave motion exactly. Frequently, the difficulty in drawing the hand lies in the rigidity of fingers and palm. When the hand appears mechanical and lifeless, the wave rhythm will restore the living quality of the hand in drawing. (2) A second rhythm effect of the hand is the arched or *domed rhythm* of the palm of the hand. The palm is never flat. Thus, the fingers lie across the curved dome of the palm; the high point is equal to the middle finger and curves away on both sides to the thumb and little finger. This arch can be observed easily from a fingertip view into the palm. Note how low the thumb appears from this view. (3) Looking down on the top, or dorsal, view of the hand, the fingers look like spokes of a wheel radiating from the hub in the top of the wrist. Seen this way, the longest, middle,

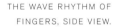

THE WAVE RHYTHM OF FINGERS, SIDE VIEW.

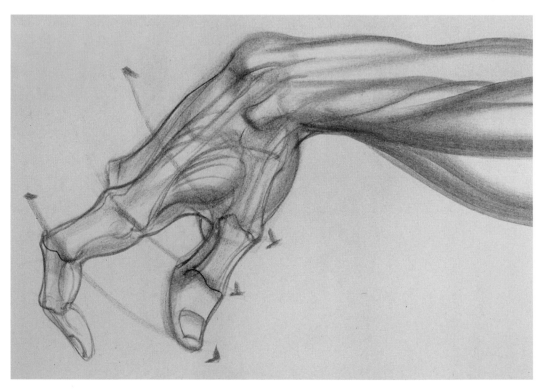

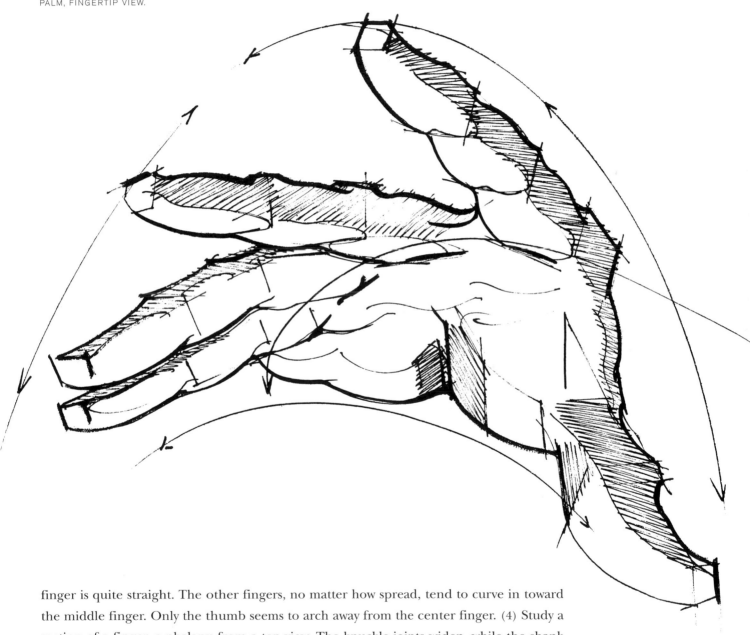

finger is quite straight. The other fingers, no matter how spread, tend to curve in toward the middle finger. Only the thumb seems to arch away from the center finger. (4) Study a section of a finger, a phalanx from a top view. The knuckle joints widen, while the shank between narrows. Thus, from this view, a symmetrical rhythm of widening and narrowing on all fingers can be observed. The thumb shows the effect most clearly.

THE SYMMETRICAL
RHYTHM: WIDENING
AND NARROWING
OF BONE FORMS.

FINGERS TEND TO
CURVE IN TOWARD THE
LONG MIDDLE FINGER.

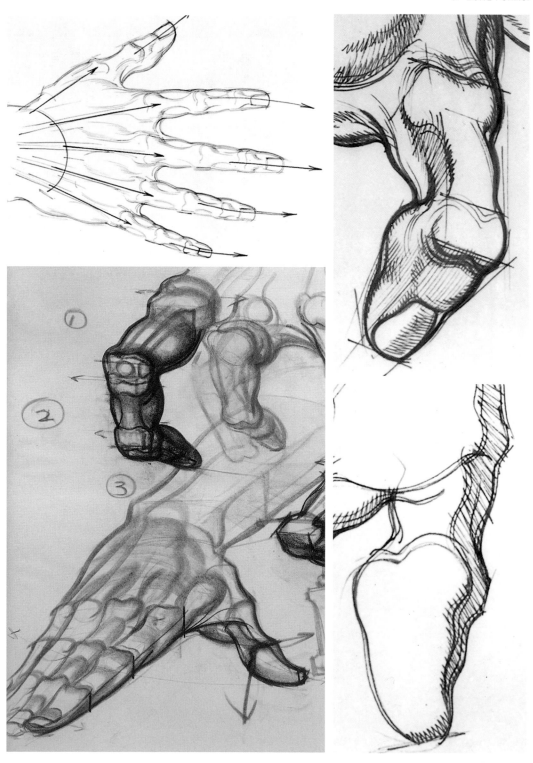

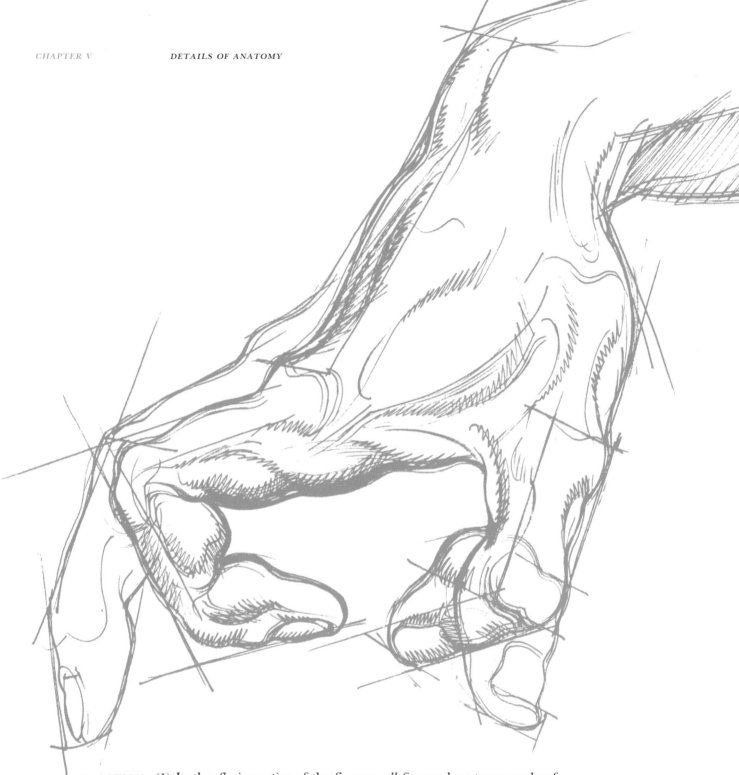

> *ACTION* (1) In the *flexing action* of the fingers, *all fingers* close to an angle of ninety degrees, or a right-angle bend at the knuckles. In closing a fist, each finger closes the joints to the ninety-degree square corner position. (2) The wrist in flexion can be bent to a ninety-degree angle. This is not quite true, however, if the fist is closed. (3) In clenching the fist, the last three fingers of the hand close into the hollow triangle of the palm. The index finger closes into the thumb. Thus, the index finger in a fist is always more forward than the closure of the other three fingers. (4) In closing and unclosing the hand,

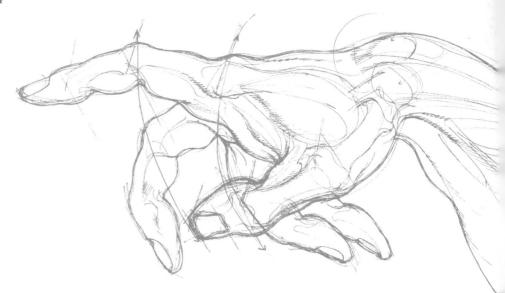

the little finger *folds first*. The others follow in order, to the thumb, which is the last to close. In unclosing, the order is reversed; the thumb unfolds first, the little finger last. (5) The thumb, from a closed position against the forefinger, swings outward to a ninety-degree angle with the palm. An extension of the angle in drawing may appear quite abnormal. (6) The thumb, in opposition to the palm, crosses in its extreme position to the little finger. Beyond this line it cannot go.

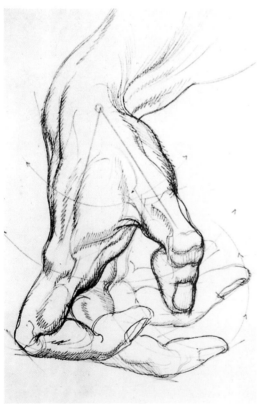

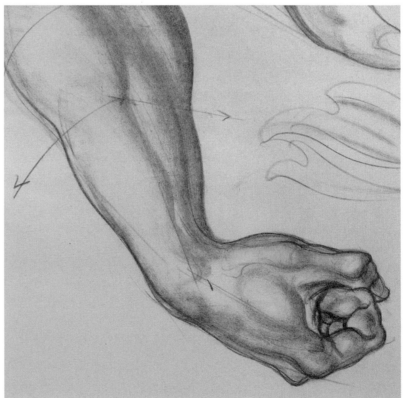

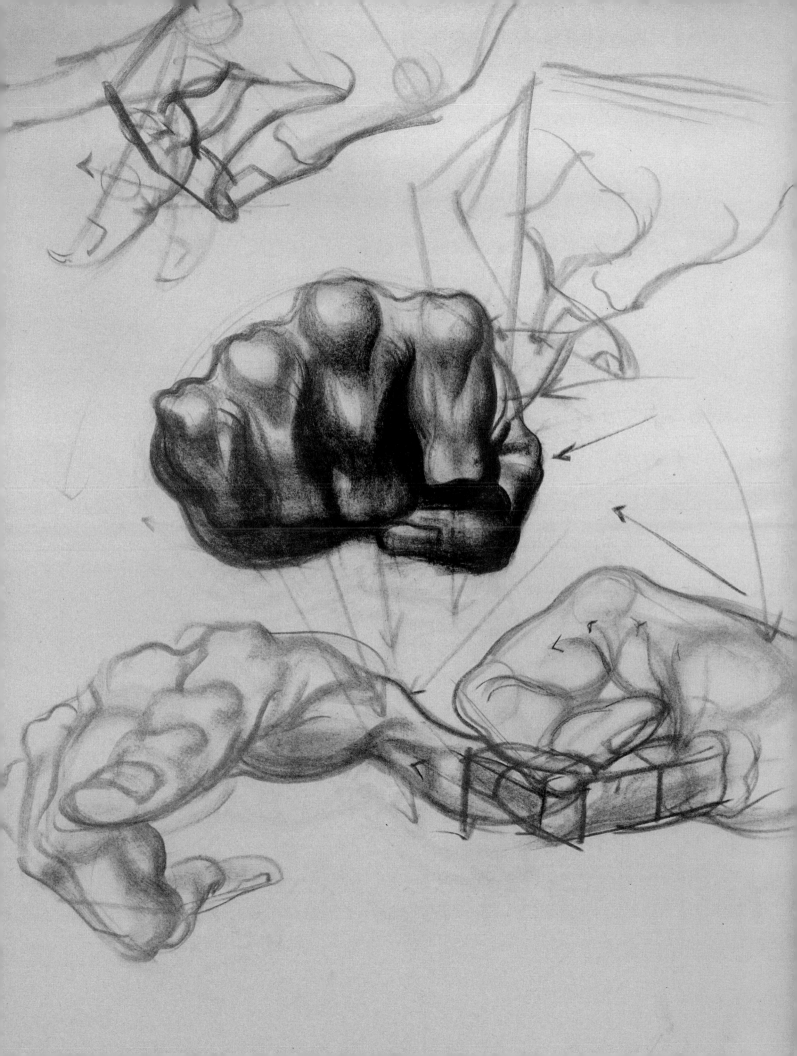

THE ORDER OF
CLOSING THE FINGERS.

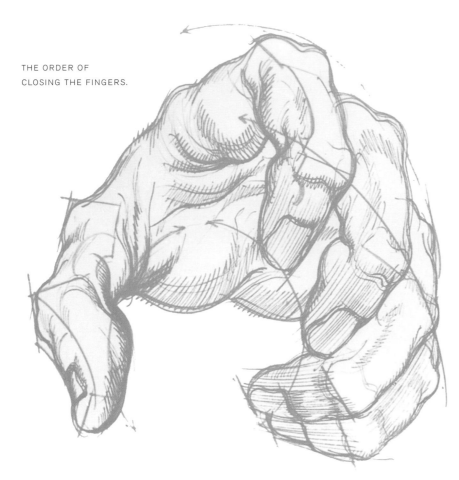

1. FLEXOR CARPI ULNARIS
2. TENDON—EXTENSOR CARPI ULNARIS
3. ULNAR HEAD
4. TENDON—PALMARIS LONGUS
5. TRIQUETRUM BONE
6. PISIFORM BONE
7. ABDUCTOR DIGITI QUINTI
8. PALMARIS BREVIS
9. FLEXOR DIGITI QUINTI BREVIS
10. TENDONS—FLEXOR DIGITORUM SUBLIMIS
11. OPPONENS DIGITI QUINTI
12. PROXIMAL PHALANX (I)
13. MEDIAN PHALANX (II)
14. TERMINAL PHALANX (III)
15. TENDONS—FLEXOR DIGITORUM SUBLIMIS
16. TENDON—ABDUCTOR POLLICIS LONGUS
17. FLEXOR CARPI RADIALIS
18. OPPONENS POLLICIS
19. ABDUCTOR POLLICIS BREVIS
20. PALMAR APONEUROSIS
21. FLEXOR POLLICIS BREVIS
22. TENDON—FLEXOR POLLICIS LONGUS
23. ADDUCTOR POLLICIS
24. INTEROSSEUS
25. LUMBRICALS
26. FINGER PADS

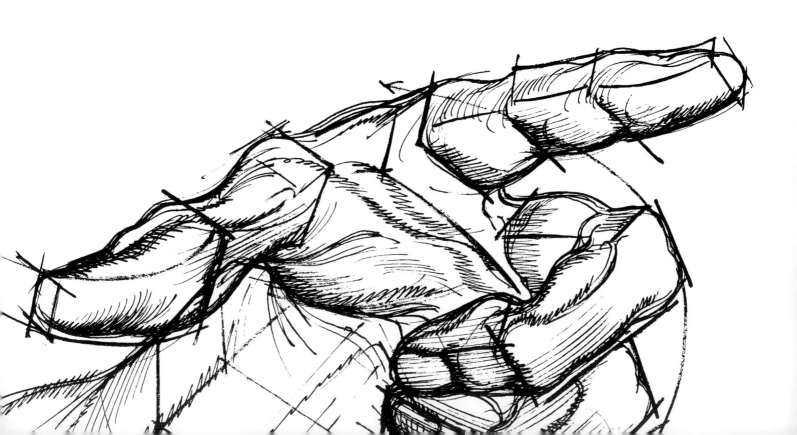

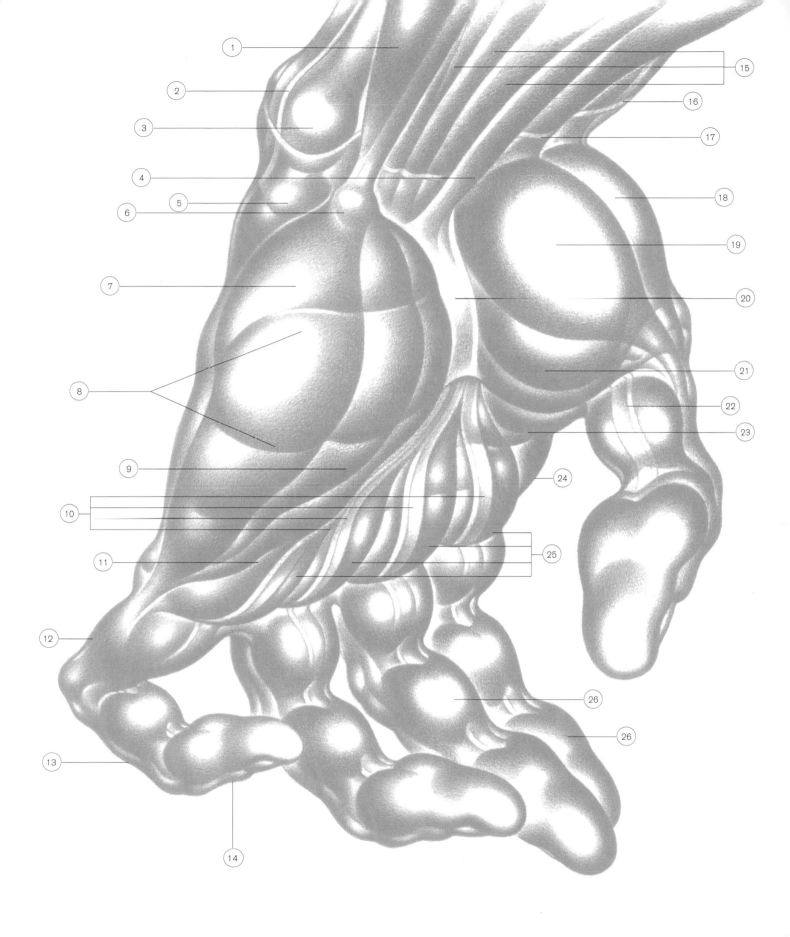

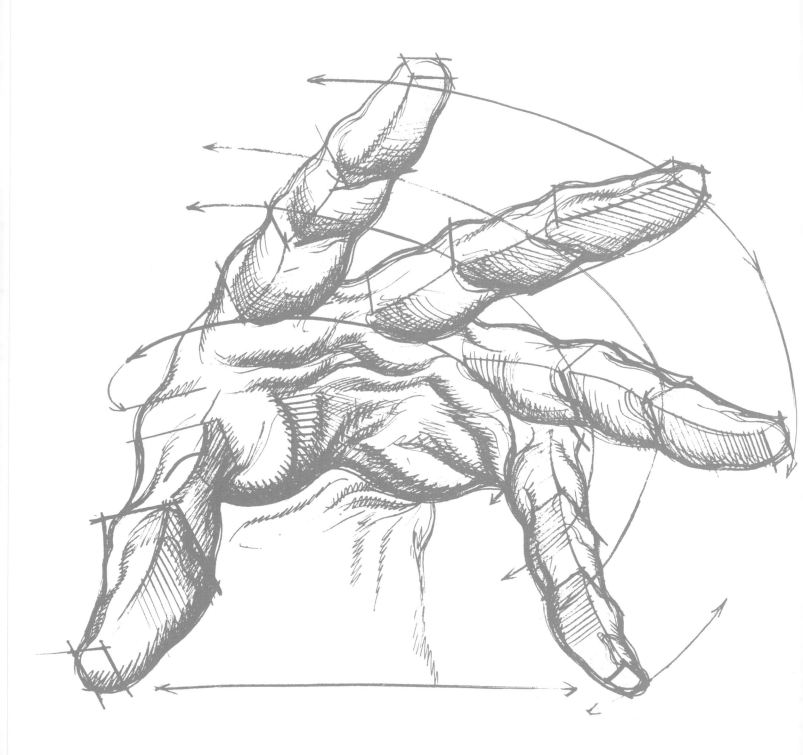

(c) To place the hand correctly on the arm, the hand will be seen to thrust *away* from the body, while the arm moves *toward* the body. This tendency of thrust is equivalent to the stance of feet pointing away from the body line. It is similar to the position of toes in animals. This idea is especially important in deep foreshortening of the hand and arm.

(d) In relating hand and arm together, observe how the inside contour of the index finger passes through the palm to the *inside contour* of the forearm. The view looking on top of the palm is easy enough to understand. However, try looking into the hand from the fingertips. To draw this view may be troublesome. Relating hand and arm is simplified if the contour check is used.

(e) Another check line is the little finger contour lining up with the outer contour of the arm. Here, the ulnar head in the wrist is directly in line with the little finger knuckle of the palm. They are equal in line and height. Thus, thickness of palm and arm and placement of the top bones are accounted for in difficult views.

(f) To place the thumb in the palm, notice how the index finger and thumb line come together high up in the wrist, where the arm joins the palm. This angle relationship should be used whenever the thumb presents a placement problem in drawing.

(g) Fingers are webbed *below* the knuckles of the palm, on the undersurface of the hand. Top surface form will thus override the lower webbed base.

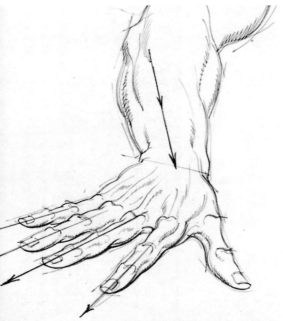
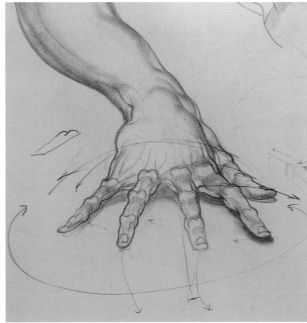

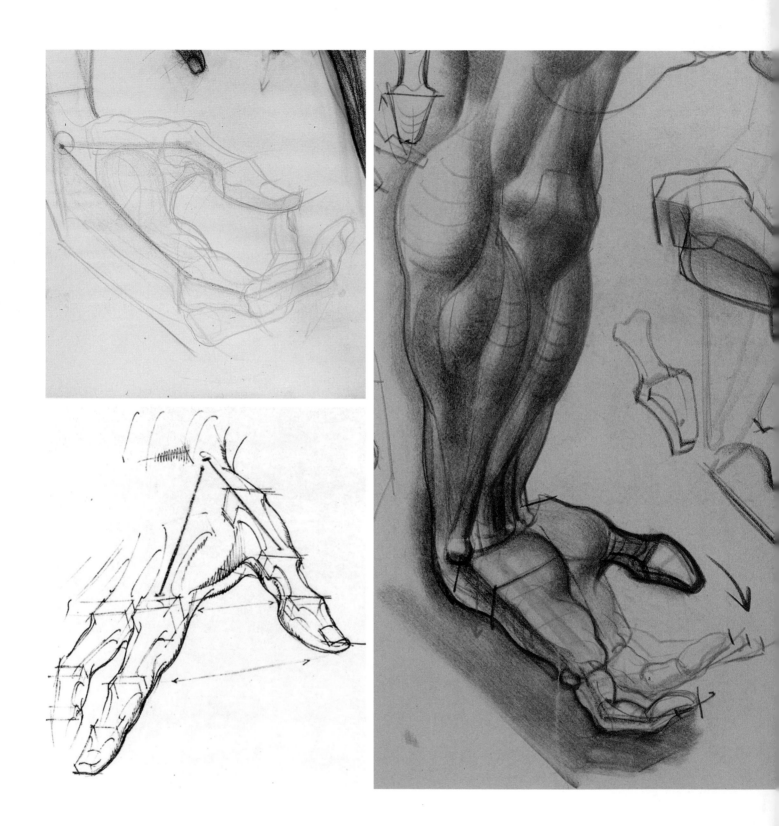

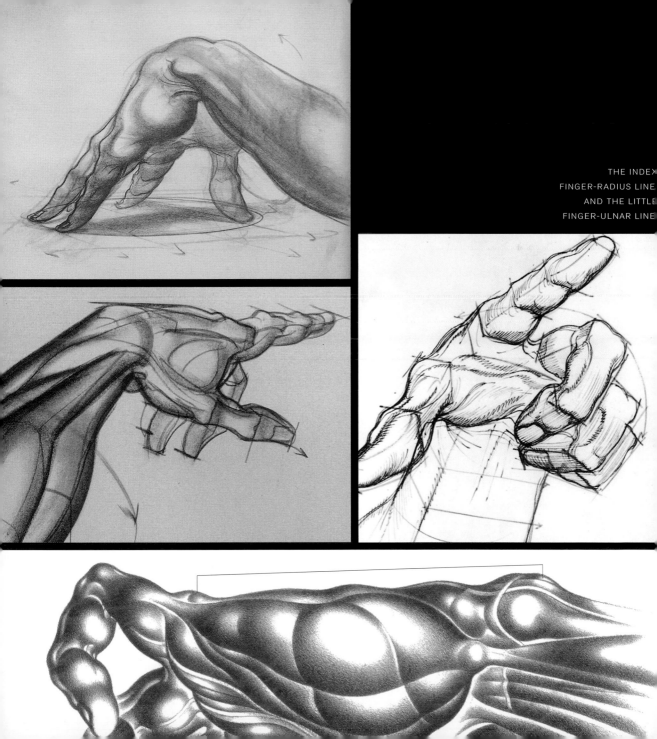

THE LEG

THE UPPER LEG MASSES The upper leg presents a roundly formed tapered cylinder, somewhat flat on the inner leg area, but markedly broad at the trochanter and compressed toward the knee. The upper leg, front view, consists of five major muscle masses and two minor masses. The leg, for clarification, originates high in the pelvic girdle at the iliac crest. Thus, the front upper leg masses are: gluteus medius, filling the space between the iliac crest and the trochanter; the powerful side mass below the trochanter, vastus externus, sending its tendon to the kneecap; rectus femoris, the long middle column descending vertically from the anterior pelvis across the patella to the tibia; the vastus internus, starting on the middle inside area of the leg and turning lower, to form a common tendon with rectus femoris and vastus externus; and the adductor and pectineus group, high inside the leg, moving into the pelvis at the groin line. The two smaller masses, tensor fascia and sartorius, both originating on the high anterior point of the pelvis, divide right and left. Tensor swings outside to an attachment just below the trochanter, while sartorius, the longest muscle in the body, winds down the inside leg channel beside rectus and vastus internus, around the knee to the inside upper tibia.

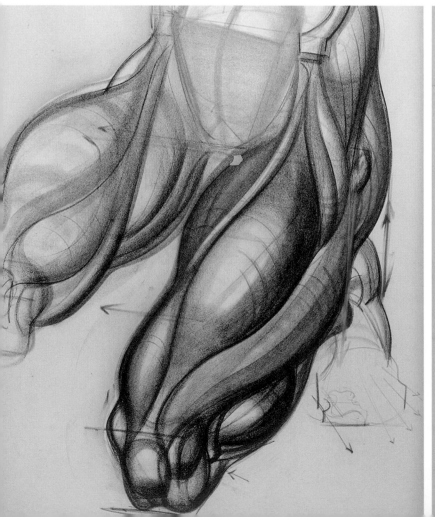
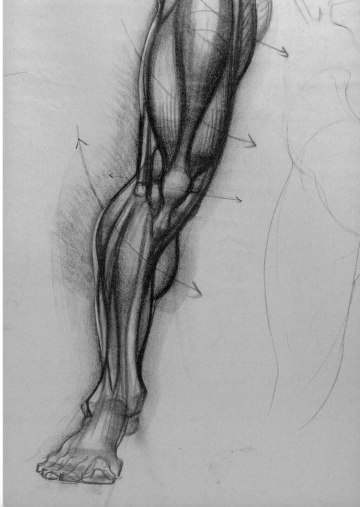

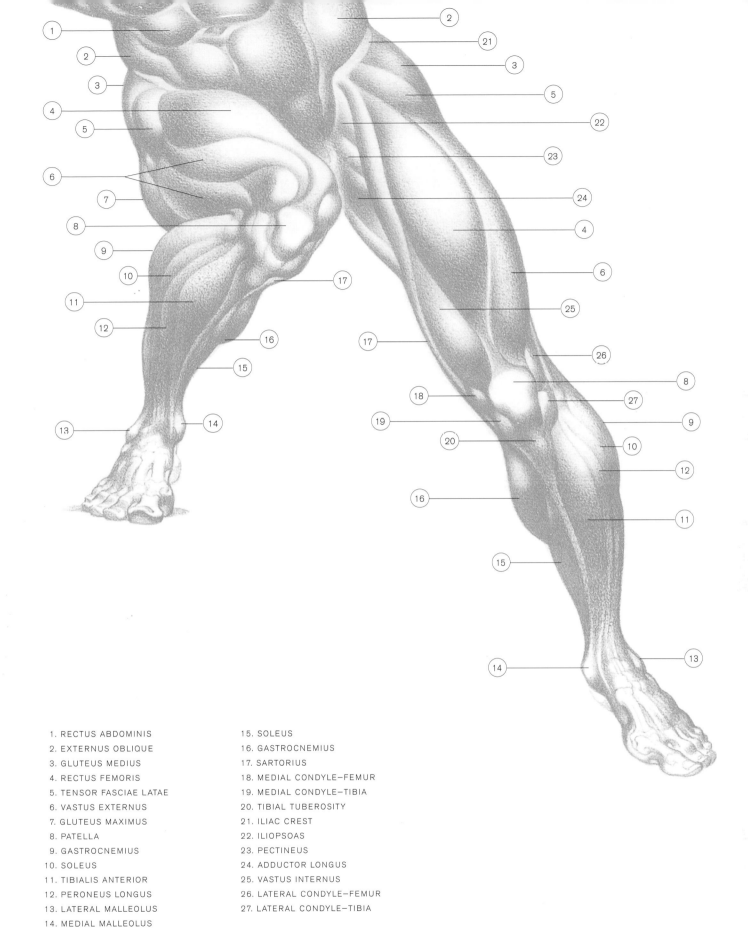

1. RECTUS ABDOMINIS
2. EXTERNUS OBLIQUE
3. GLUTEUS MEDIUS
4. RECTUS FEMORIS
5. TENSOR FASCIAE LATAE
6. VASTUS EXTERNUS
7. GLUTEUS MAXIMUS
8. PATELLA
9. GASTROCNEMIUS
10. SOLEUS
11. TIBIALIS ANTERIOR
12. PERONEUS LONGUS
13. LATERAL MALLEOLUS
14. MEDIAL MALLEOLUS

15. SOLEUS
16. GASTROCNEMIUS
17. SARTORIUS
18. MEDIAL CONDYLE—FEMUR
19. MEDIAL CONDYLE—TIBIA
20. TIBIAL TUBEROSITY
21. ILIAC CREST
22. ILIOPSOAS
23. PECTINEUS
24. ADDUCTOR LONGUS
25. VASTUS INTERNUS
26. LATERAL CONDYLE—FEMUR
27. LATERAL CONDYLE—TIBIA

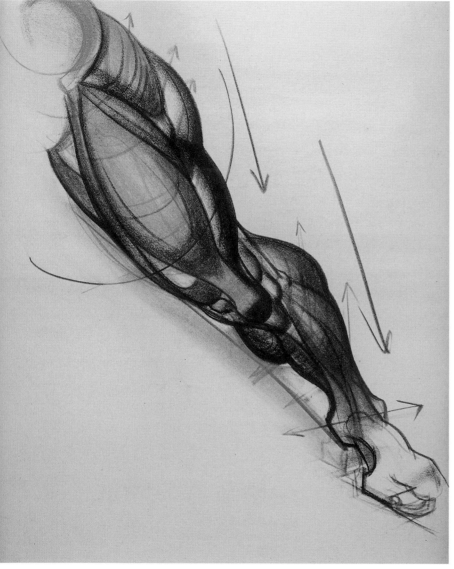

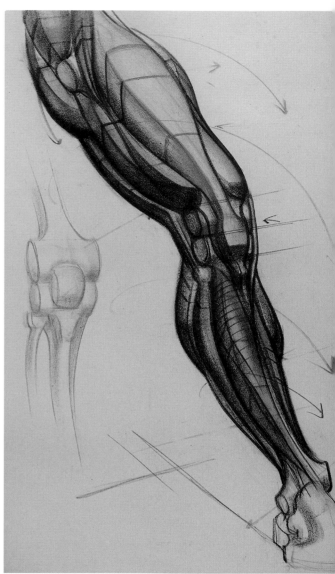

THE OUTER LEG MASSES
PRESENT MARKEDLY
COMPRESSED
OR TAPERED FORMS.

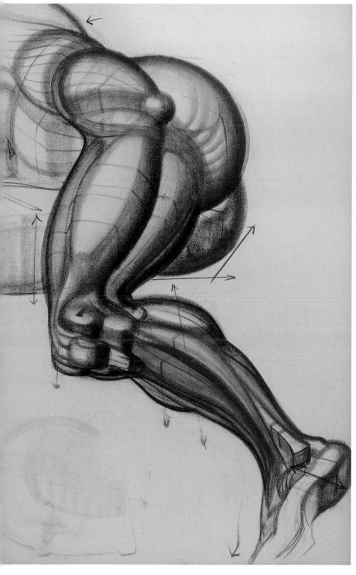

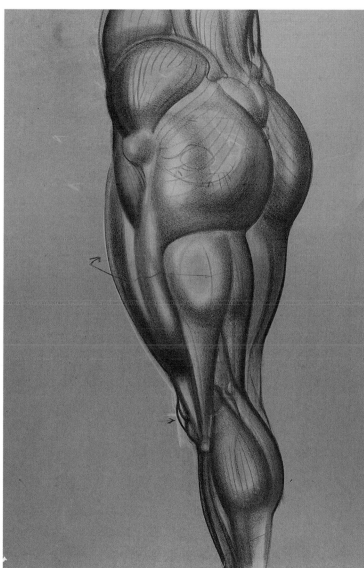

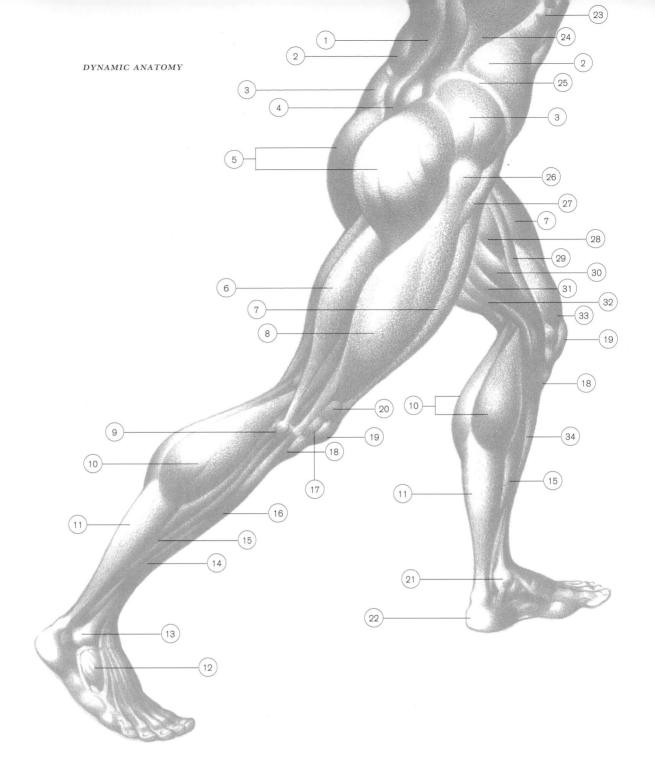

1. SACROSPINALIS
2. EXTERNUS OBLIQUE
3. GLUTEUS MEDIUS
4. SACRUM
5. GLUTEUS MAXIMUS
6. BICEPS FEMORIS
7. RECTUS FEMORIS
8. VASTUS EXTERNUS
9. FIBULA HEAD
10. GASTROCNEMIUS
11. TENDON ACHILLES
12. EXTENSOR DIGITORUM BREVIS
13. LATERAL MALLEOLUS
14. PERONEUS LONGUS
15. SOLEUS
16. TIBIALIS ANTERIOR
17. LATERAL CONDYLE—TIBIA
18. TIBIAL TUBEROSITY
19. PATELLA
20. LATERAL CONDYLE—FEMUR
21. MEDIAL MALLEOLUS
22. CALCANEUM
23. SERRATUS ANTERIOR
24. LATISSIMUS DORSI
25. ILIAC CREST
26. GREAT TROCHANTER
27. TENSOR FASCIAE LATAE
28. ADDUCTOR LONGUS
29. SARTORIUS
30. GRACILIS
31. SEMIMEMBRANOSUS
32. SEMITENDINOSUS
33. VASTUS INTERNUS
34. TIBIA

1. GLUTEUS MEDIUS
2. SACRUM
3. GREAT TROCHANTER
4. TENSOR FASCIAE LATAE
5. GLUTEUS MAXIMUS
6. VASTUS EXTERNUS
7. BICEPS FEMORIS
8. SEMITENDINOSUS
9. SEMIMEMBRANOSUS
10. GRACILIS
11. POPLITEAL FOSSA
12. FIBULA HEAD
13. GASTROCNEMIUS
14. SOLEUS
15. TENDON ACHILLES
16. PERONEUS LONGUS
17. LATERAL MALLEOLUS
18. CALCANEUM
19. BURSA

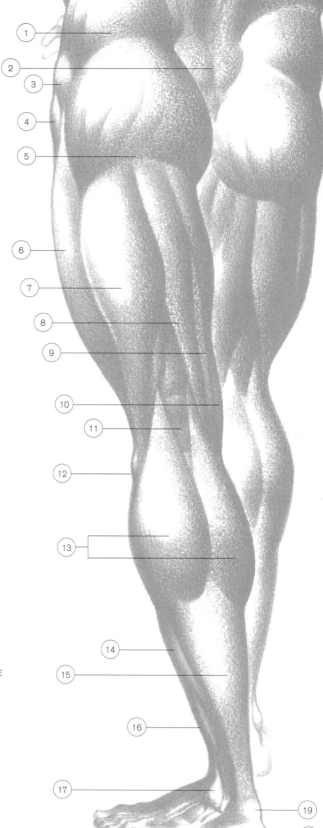

In rear view, the leg consists of five large masses: the two pelvic masses, gluteus medius and maximus, described earlier as the butterfly forms locked in the hip and lower spine; the middle complex of hamstring muscles, the outer biceps femoris, moving from under the buttock down to the fibula head of the outside lower leg, and the inner hamstring group, semitendinosus, semimembranosus, and gracilis, descending to the inside tibia below the knee; then vastus internus, appearing slightly at the lower inside leg behind the hamstring tendons; and finally, vastus externus, now seen partially at the broad outer contour of the back leg.

THE HIGH-LOW
BUTTOCK LINE OF
THE SUPPORTING
LEG AND THE
RELAXED LEG.

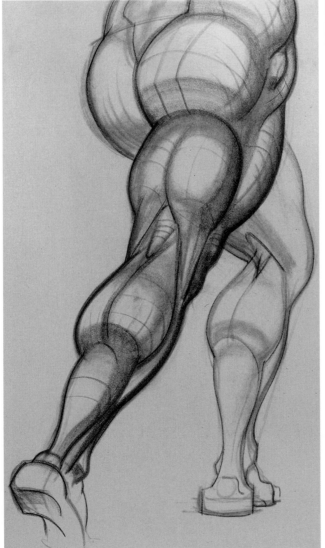
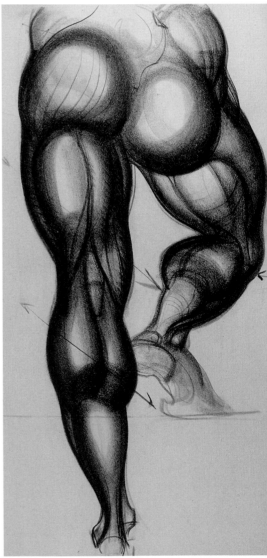

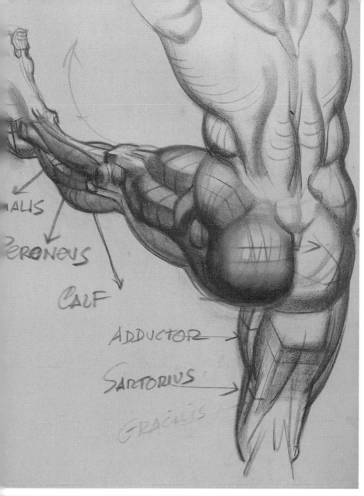

IALIS

PERONEUS

CALF

ADDUCTOR

SARTORIUS

GRACILIS

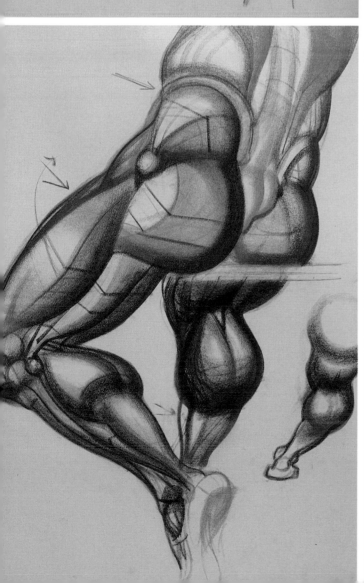

THE GREAT
TROCHANTER
PROTRUSION ALWAYS
LIES IN THE SIDE
PLANE OF THE LEG.

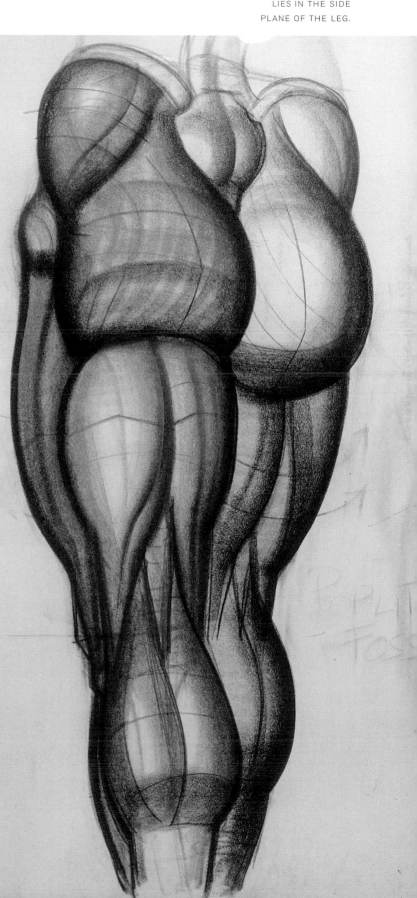

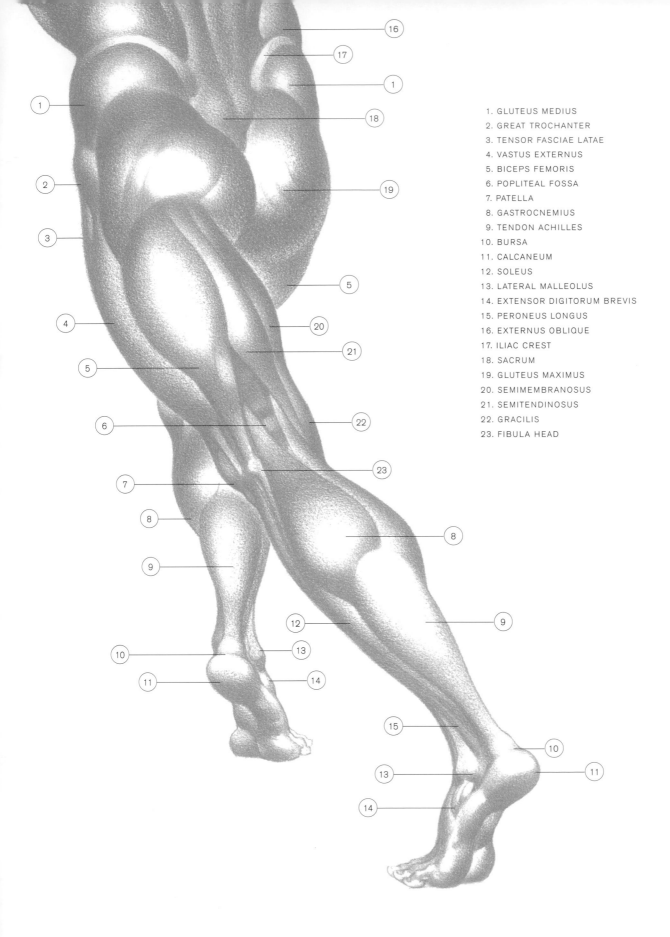

1. GLUTEUS MEDIUS
2. GREAT TROCHANTER
3. TENSOR FASCIAE LATAE
4. VASTUS EXTERNUS
5. BICEPS FEMORIS
6. POPLITEAL FOSSA
7. PATELLA
8. GASTROCNEMIUS
9. TENDON ACHILLES
10. BURSA
11. CALCANEUM
12. SOLEUS
13. LATERAL MALLEOLUS
14. EXTENSOR DIGITORUM BREVIS
15. PERONEUS LONGUS
16. EXTERNUS OBLIQUE
17. ILIAC CREST
18. SACRUM
19. GLUTEUS MAXIMUS
20. SEMIMEMBRANOSUS
21. SEMITENDINOSUS
22. GRACILIS
23. FIBULA HEAD

{194}

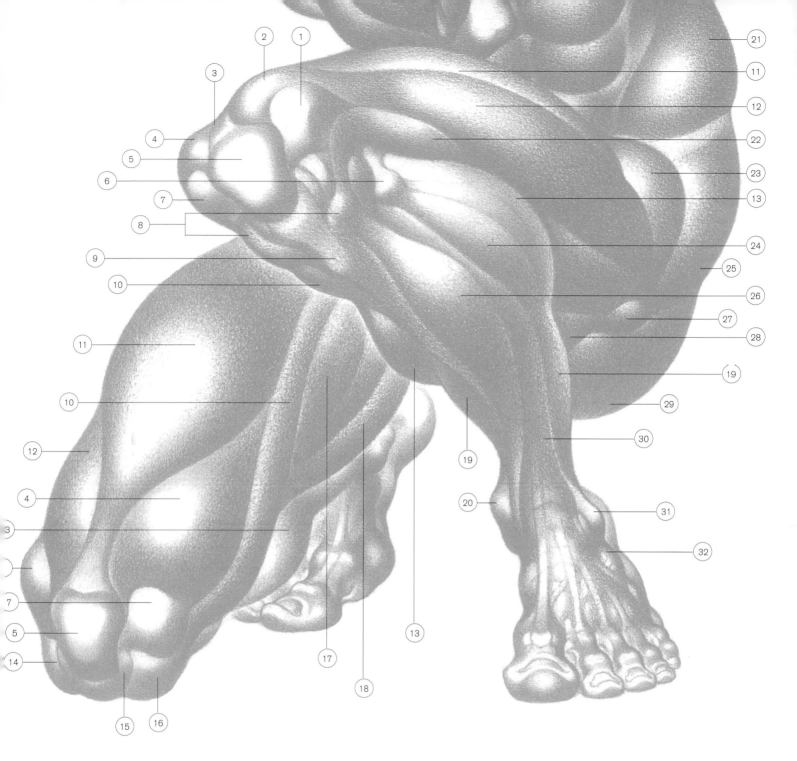

1. LATERAL CONDYLE–FEMUR
2. TENDON–VASTUS EXTERNUS
3. TENDON–RECTUS FEMORIS
4. VASTUS INTERNUS
5. PATELLA
6. FIBULA HEAD
7. MEDIAL CONDYLE–FEMUR
8. MEDIAL AND LATERAL CONDYLES–TIBIA
9. TIBIAL TUBEROSITY
10. SARTORIUS
11. RECTUS FEMORIS

12. VASTUS EXTERNUS
13. GASTROCNEMIUS
14. LATERAL CONDYLE–TIBIA
15. PATELLAR FAT
16. MEDIAL CONDYLE–TIBIA
17. ADDUCTOR LONGUS
18. GRACILIS
19. SOLEUS
20. MEDIAL MALLEOLUS
21. EXTERNUS OBLIQUE
22. BICEPS FEMORIS

23. TENSOR FASCIAE LATAE
24. PERONEUS LONGUS
25. GLUTEUS MEDIUS
26. TIBIALIS ANTERIOR
27. GREAT TROCHANTER
28. BICEPS FEMORIS
29. GLUTEUS MAXIMUS
30. EXTENSOR DIGITORUM
31. LATERAL MALLEOLUS
32. EXTENSOR DIGITORUM BREVIS

THE LOWER LEG MASSES The tapered mass of the lower leg generally has a club-like appearance, bulged and wide at the calf and quickly compressed toward the ankle. The frontal area is rather flat compared to the great bulge of the rear area.

The lower leg, front view, consists of six long muscle forms: inside the tibia, or shinbone, the soleus muscle appears briefly and moves downward behind the inner ankle bone into the heel; to the back of the soleus, the inner gastrocnemius, or calf muscle, bulges from the mid-leg and passes upward to the femur condyle behind the knee; the long central muscle, tibialis anterior, starts at the high outer condyle of the tibia and drops toward the ankle to the instep of the foot; at the side edge of tibialis, peroneus moves down the leg and passes behind the outer ankle bone into the base of the foot; however, between

THE LOWER LEG CURVES DECISIVELY INWARD ON THE TIBIA BONE LINE.

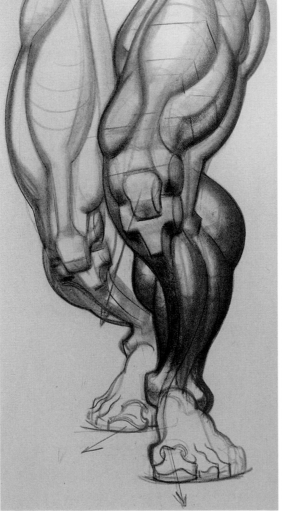
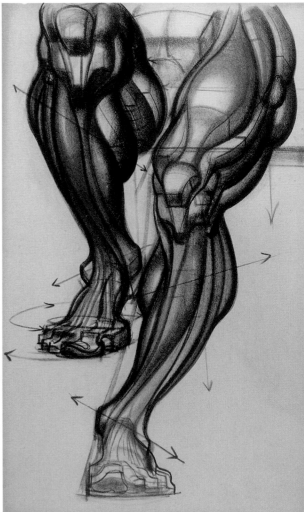

tibialis and peroneus, a slot opens on the middle leg, and the large extensor group widens to send its tendons over the arch of the foot to the toes; now soleus reappears slightly outside peroneus; last, the outer gastrocnemius thrusts out from the mid-leg and rises high behind the knee to the outer condyle of the femur.

In rear view the lower leg presents five masses, three large and two smaller ones. The large masses are the two great heads of the calf muscles, divided centrally and locked into the condyles of the femur base; they descend to the midpoint of the lower leg, where they join their common tendon, the achilles, a mass by itself that drops to the bursa of the calcaneum, or heel bone. The two smaller masses are the soleus muscle, inner and outer, emerging from the sides of the calf muscles and passing inside the tendon to the heel.

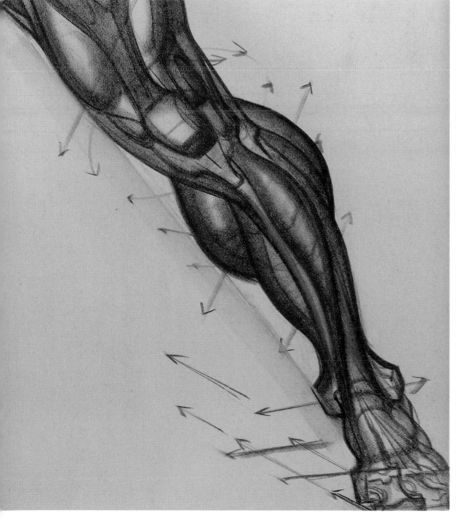
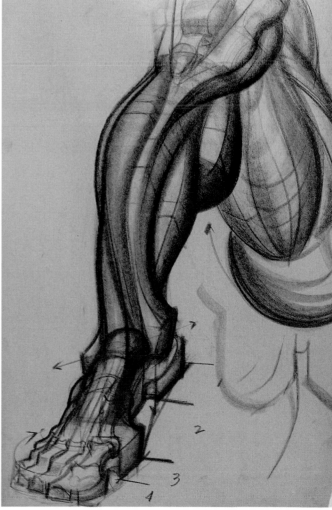

A special note must be made of the hollow area behind the knee, the popliteal fossa, where the hamstring tendons widen to permit the calf tendons to attach to the femur. This fossa is somewhat depressed even when covered by muscle and membranous tissue. The quadrilateral hollow permits the leg to bend in deep squatting positions.

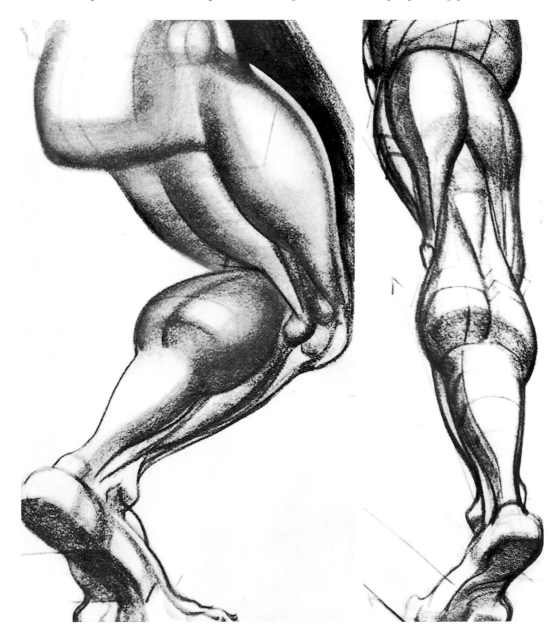

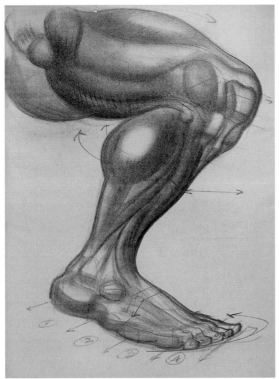

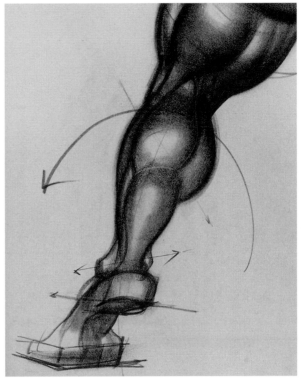

IN THE STANCE OF
THE FEET, THE FOOT
LINE POINTS OUTWARD
FROM THE LEG LINE.

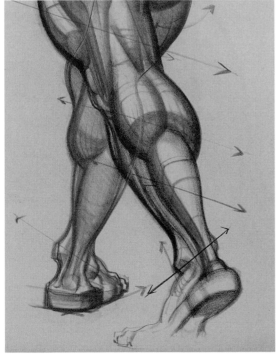

THE KNEE AND ANKLE (a) The bone formation of the knee consists of seven prominences: six symmetrical protrusions and one offset protrusion. The large prominences of the femur base and the tibia head form the large box of the knee with their condyles set out at the four corners. In the center of the group of four, the patella, or kneecap, thrusts forward. Below the box, in the tibia, a smaller projection rises, the tibial tuberosity. Thus, a system of six bone forms appears, in a double triangular pattern, one under the other. To the lower outside position of the tibia, the seventh projection, the fibula head, develops in line with the tibial tuberosity.

(b) The ankle is a locked structure of the lower tibia and fibula and presents the appearance of a large wrench. The ankle is the powerful gripping head that holds the foot secure. The great bony projections are the inner malleolus of the tibia and the outer malleolus of the fibula. The inner ankle lies higher than the outer, thus presenting a fifteen-degree drop from the inside bone to the outside bone. The relationship *never* changes.

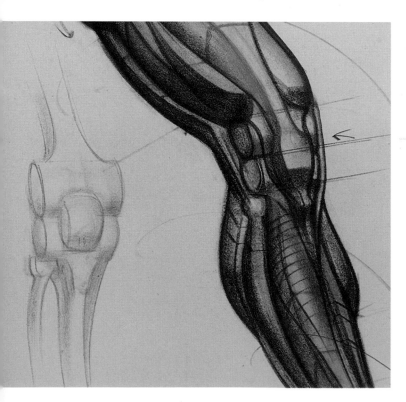
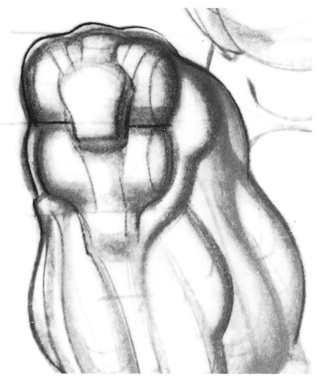

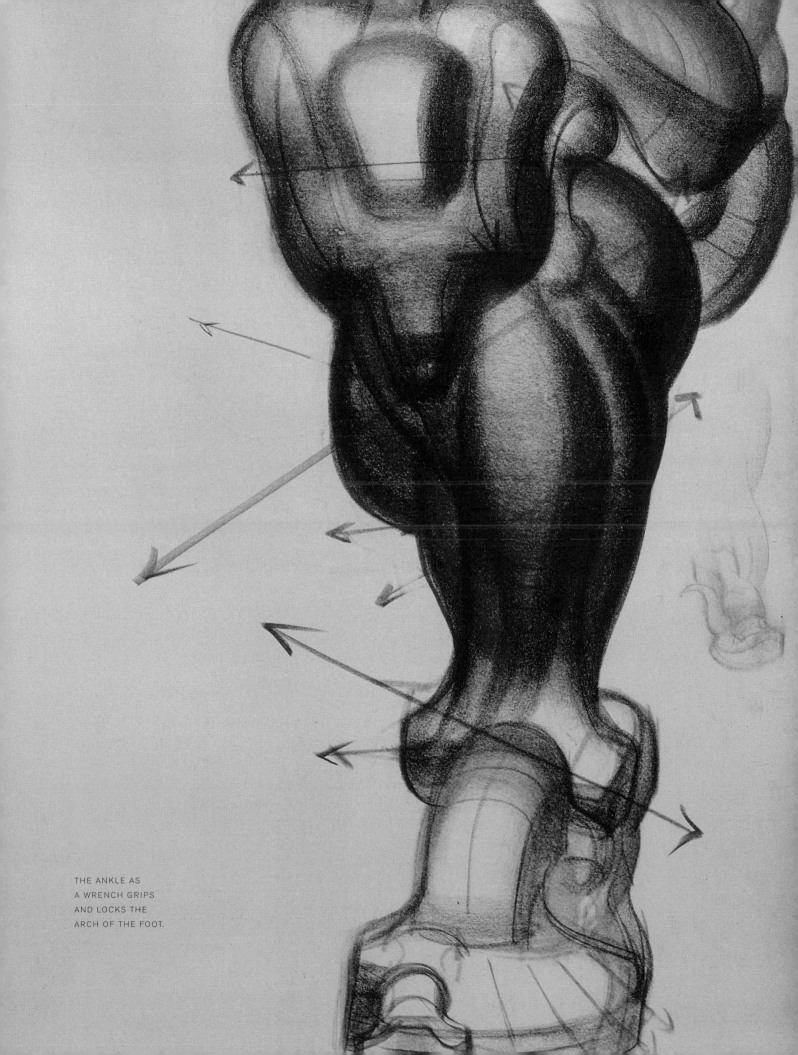

THE ANKLE AS
A WRENCH GRIPS
AND LOCKS THE
ARCH OF THE FOOT.

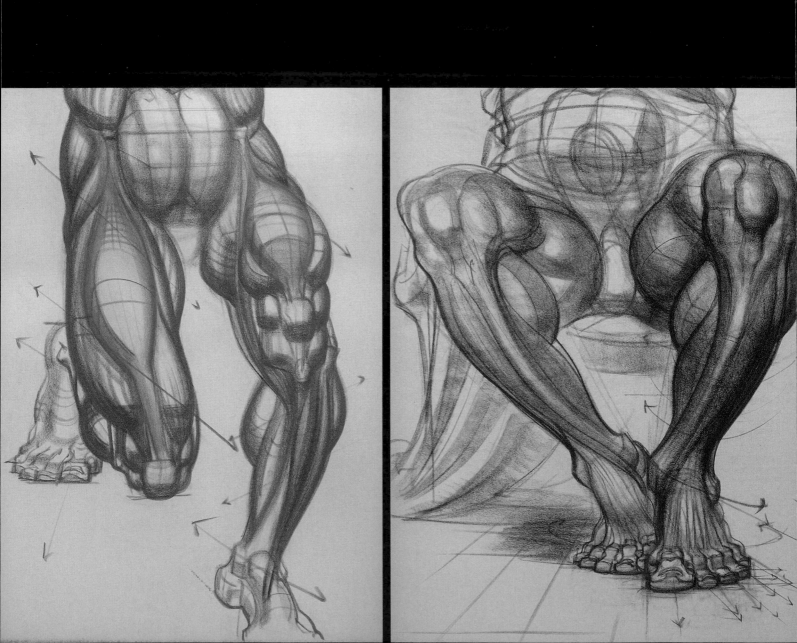

MEASUREMENTS The upper leg, from trochanter to kneecap, is two heads in length. The lower leg, from kneecap to foot, is also two heads in length. The height of the foot from the inside anklebone is one-fourth of a head in length. Thus, in all, the entire leg is four and one-quarter heads long. The inside contour of the upper leg mass divides at the midpoint where the adductor meets the sartorius and vastus internus. The inside contour of the lower leg also divides at the mid-position, separating the calf bulge from the soleus muscle. The buttock enters the femur in the rear upper leg one-half a head below the trochanter and coccyx line.

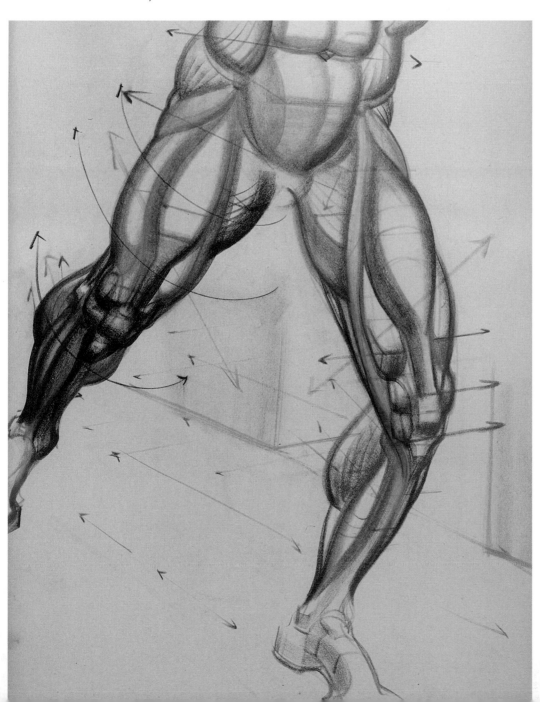

POINTS TO REMEMBER IN DRAWING (a) The visual shape of the entire front view of the leg looks like an elongated, tapered B. The flat line of the B lies on the inside leg as a control line for the contours of forms that touch it. They push toward it and recede, yet almost never override the line, even in deep, foreshortened views of the front or back leg. The outer B identifies the tapered compressions to the knee and ankle on the contour line.

(b) The visual shape of the leg seen in side view is an elongated S line. The upper curve identifies the rectus, or thigh bulge, to the front, while the lower curve identifies the pouch of the calf muscle to the rear. In drawing the leg in side view, laying in the visual S first will produce a quick, natural result.

(c) The major bone of the lower leg is the tibia. It conditions the direction of the entire lower mass. In front view, it always appears to curve inward to the body line from the knee to the ankle. To straighten this line would make the leg look like a piece of pipe, unnatural and grotesque.

(d) Study all the muscle masses of the outside leg contour with respect to the masses of the inside leg contour. The outside masses are higher across a corresponding group of the inside contour. The line of relationship drops from the high outside forms to the lower inside forms along the entire length of the leg. Observe the position of the calf masses outside and inside. See the positions of vastus externus and internus. They follow the pattern of angled descent, as do all the others. This pattern continues until the ankle is reached, and here the angle relationship is reversed on the bones. The drawing must show these interrelationships no matter how well the anatomy is defined.

(e) A great bow, like that of an archer, appears as a visual pattern of movement down the entire front of the leg. It can be seen to start at the hip front, move along the sartorial channel, swing around the inside of the knee, and curve on the tibia channel to the ankle. This line will help form the major inside contour of the leg, and will aid in muscle placement.

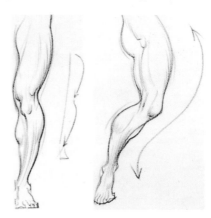

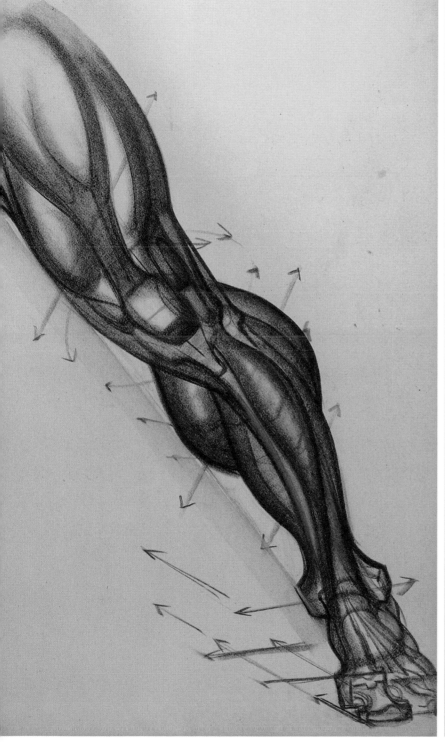

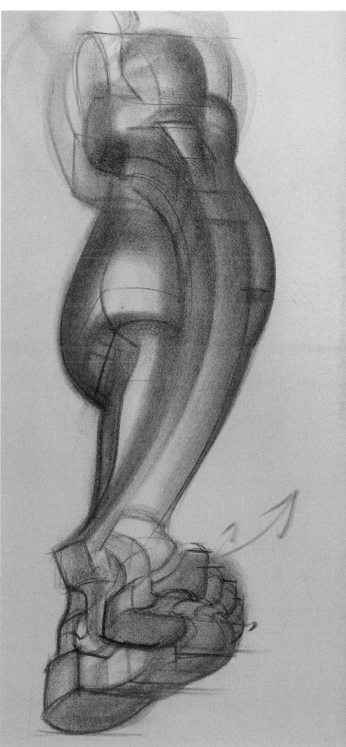

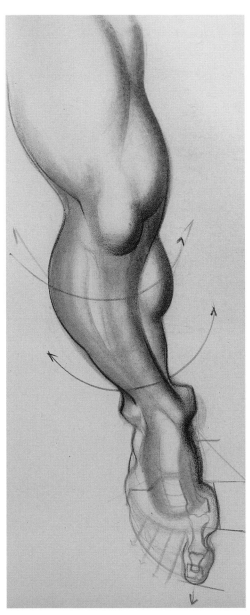

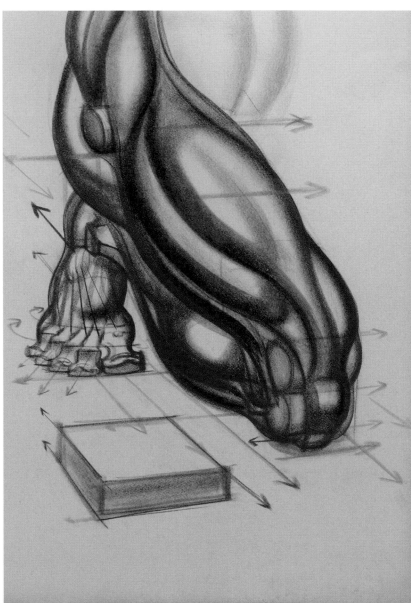

THE BOW LINE
OF THE LEG, THE SARTORIUS-
TIBIA CHANNEL.

THE TROCHANTER-ANKLE
VERTICAL RELATIONSHIP
IN THE DEEP SQUATTING
POSITION OF THE LEG.

(f) When the leg bends to a deep squatting position, the trochanter and outer anklebone lie one under the other. The heel is pressed against the buttock, and the base-line of the foot can be seen to curve onto the curve of the buttock line. In deep views of the leg in this position, these checkpoints will establish correct placement of the lengths of the leg. Now, observe carefully: As the leg opens, first slightly, then wider, the equal lengths of upper and lower leg form a series of isosceles triangles—that is, equal-sided triangles—when the trochanter and anklebones are connected with a line. This device will establish correctly the lengths of the leg in any position in drawing. The device can be used for the arm as well.

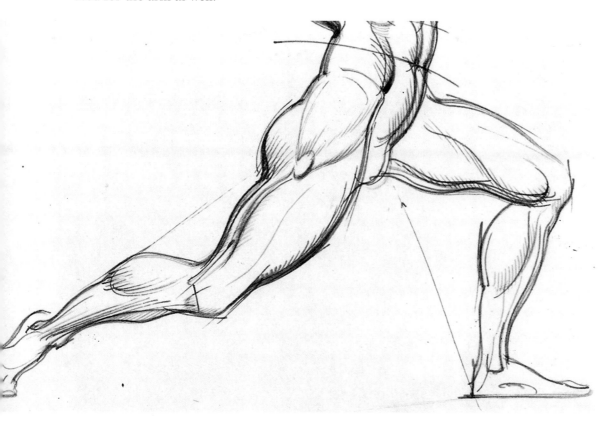

THE ISOSCELES
TRIANGULATION OF THE
LEGS IN MOVEMENT.

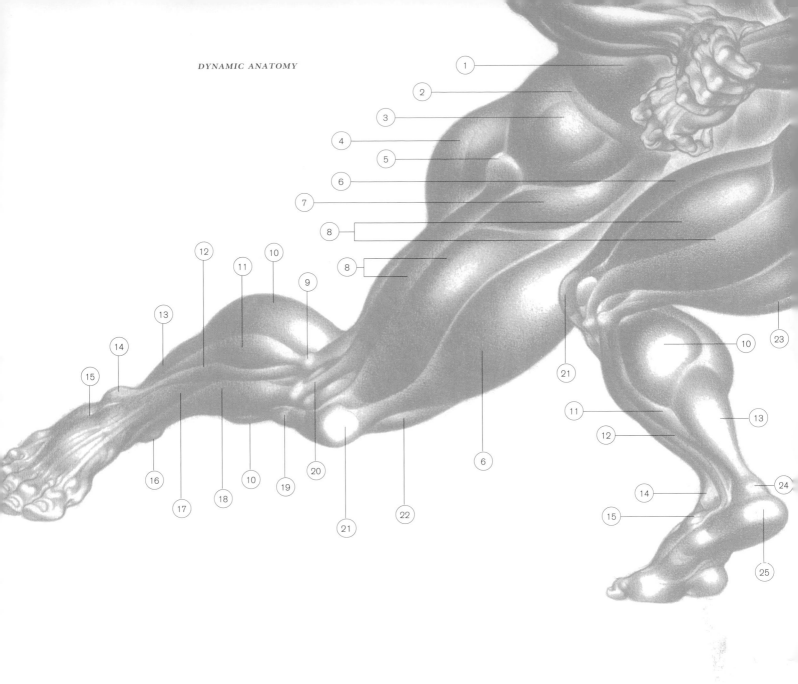

1. EXTERNUS OBLIQUE
2. ILIAC CREST
3. GLUTEUS MEDIUS
4. GLUTEUS MAXIMUS
5. GREAT TROCHANTER
6. RECTUS FEMORIS
7. TENSOR FASCIAE LATAE
8. VASTUS EXTERNUS
9. FIBULA HEAD
10. GASTROCNEMIUS
11. SOLEUS
12. PERONEUS LONGUS
13. TENDON ACHILLES

14. LATERAL MALLEOLUS
15. EXTENSOR DIGITORUM BREVIS
16. MEDIAL MALLEOLUS
17. EXTENSOR DIGITORUM
18. TIBIALIS ANTERIOR
19. TIBIAL TUBEROSITY
20. ILIOTIBIAL BAND
21. PATELLA
22. VASTUS INTERNUS
23. BICEPS FEMORIS
24. BURSA
25. CALCANEUM

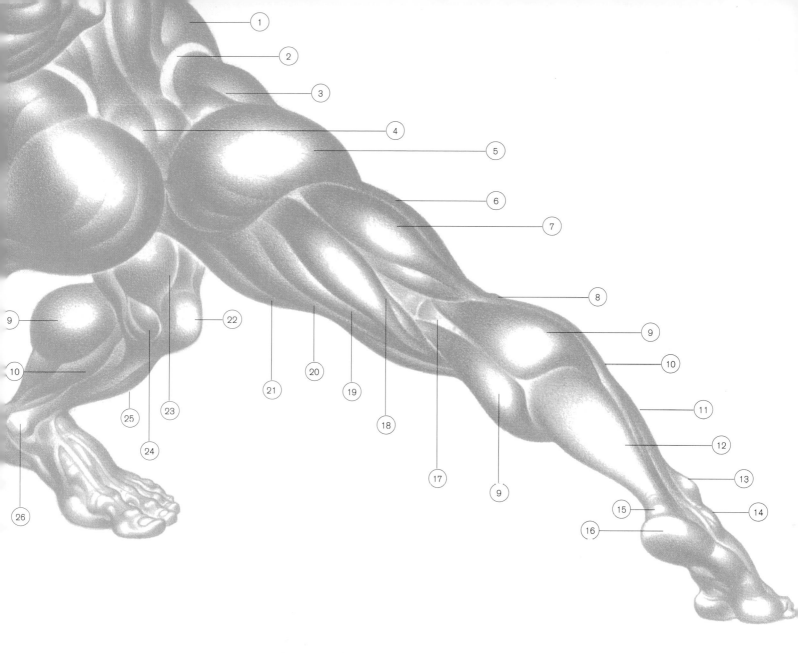

1. EXTERNUS OBLIQUE
2. ILIAC CREST
3. GLUTEUS MEDIUS
4. SACRUM
5. GLUTEUS MAXIMUS
6. VASTUS EXTERNUS
7. BICEPS FEMORIS
8. FIBULA HEAD
9. GASTROCNEMIUS
10. SOLEUS
11. PERONEUS LONGUS
12. TENDON ACHILLES
13. LATERAL MALLEOLUS

14. EXTENSOR DIGITORUM BREVIS
15. BURSA
16. CALCANEUM
17. POPLITEAL FOSSA
18. SEMITENDINOSUS
19. SEMIMEMBRANOSUS
20. GRACILIS
21. ADDUCTOR LONGUS
22. PATELLA
23. VASTUS INTERNUS
24. MEDIAL CONDYLE–FEMUR
25. TIBIALIS ANTERIOR
26. MEDIAL MALLEOLUS

THE FOOT

THE MASSES OF THE FOOT There are three major masses in the foot: the heel platform; the arch; and the front platform, the sole, which is divided in half to form the front and middle soles of the foot. The heel and middle sole provide a pedestal base for the column of the figure, while the arch acts as a spring device to absorb pressure shock to the body. The front sole of the toes acts as a gripping and pushing device in walking and running.

The top of the foot is quite hard and bony, with the arch distinctly extruded from the base. The outer form on the sole of the foot contacts the ground surface along the entire length from heel to toes. The inner foot touches the surface mainly at the toe and heel, with the instep arch off the ground. Thus, with the feet together, an elliptical pediment is formed, with a hollow center area to support the body column.

The sole of the foot, padded and cushioned, consists of four generalized masses: the calcaneum, or heel; the outer ridge of padded muscle, the abductors, from heel to the little toe; the large, cushioned mass of lumbricals and short flexors grouped behind the four toes; and the large, padded bulge behind the hallux, or big toe. The instep is high and cushioned, and under its surface, the long abductor group spans the length of the foot from the big toe to the heel.

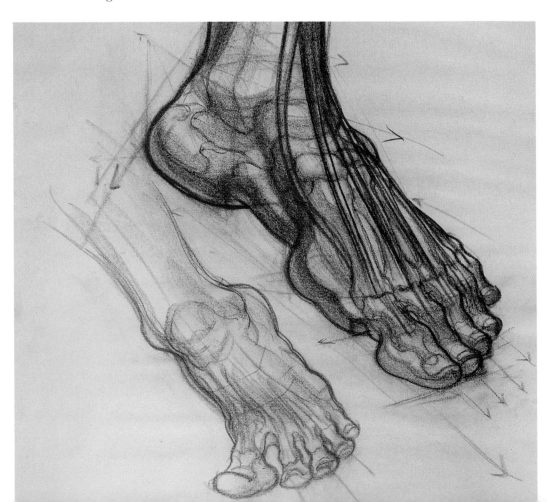

CARVING THE ARCH AND
INSTEP ESTABLISHES
THE VERTICAL AND HORIZONTAL
PLANES OF THE FOOT.

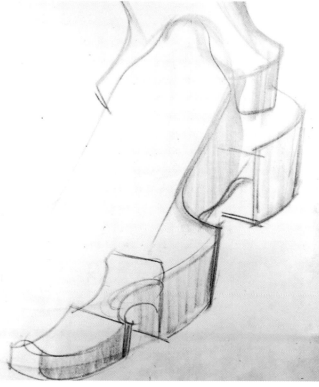

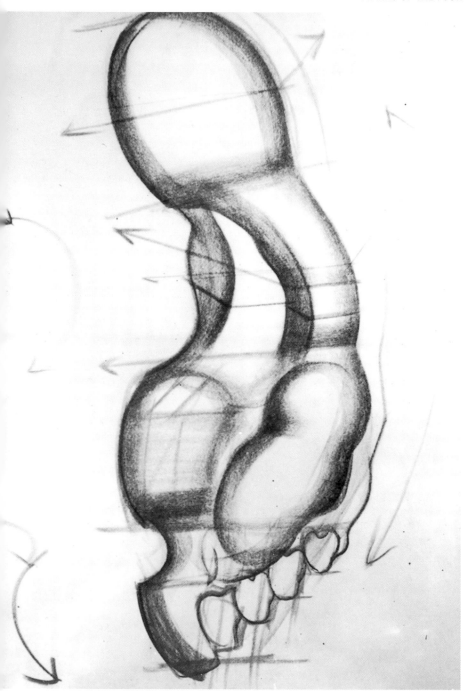

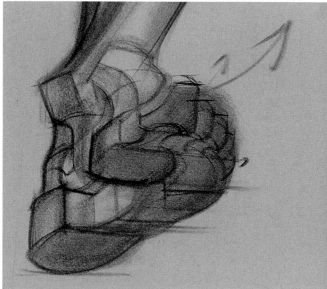

The locked arch in the wrench of the ankle consists of the tarsal bones. The major bone here is the talus, a saddle of bone protruding from the wrench, which starts the arch over which the ramp of extensor tendons descend to the toes.

A small muscle mass located on the outer side of the arch, just in front of the ankle-bone, may be observed. This is the small extensor muscle group, virtually the only muscle mass visible on the top of the foot.

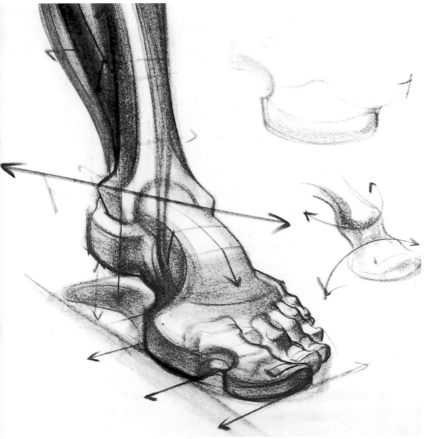

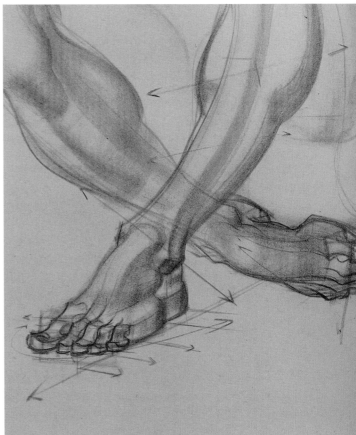

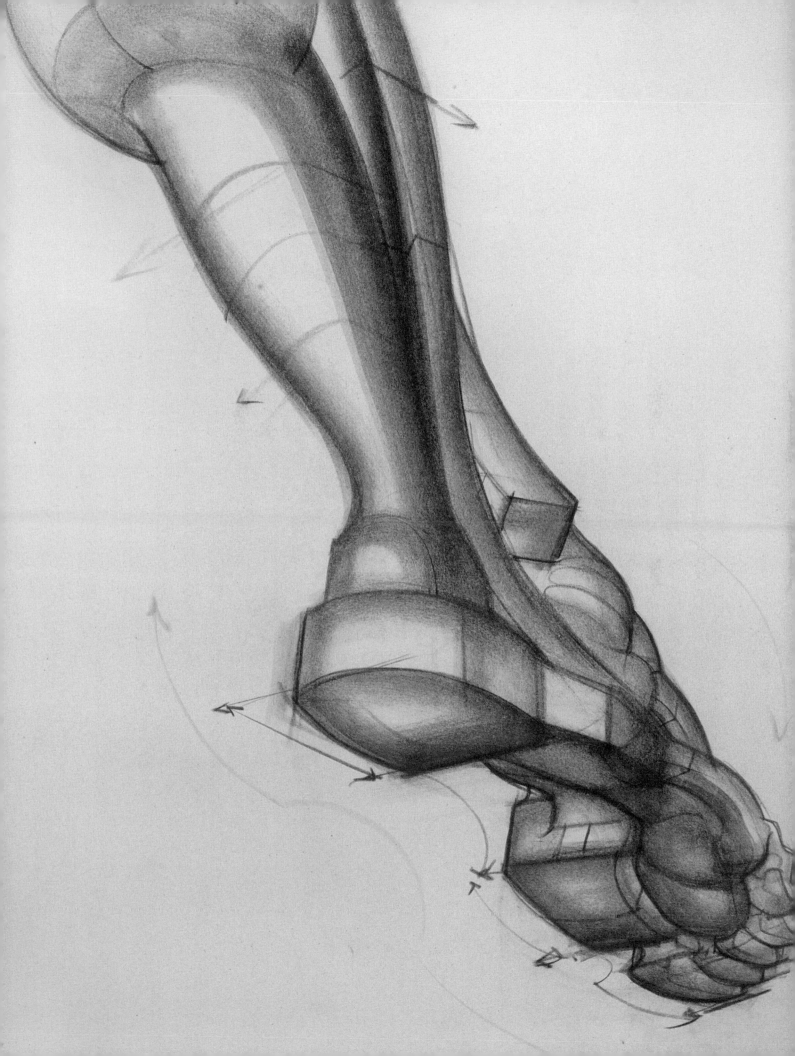

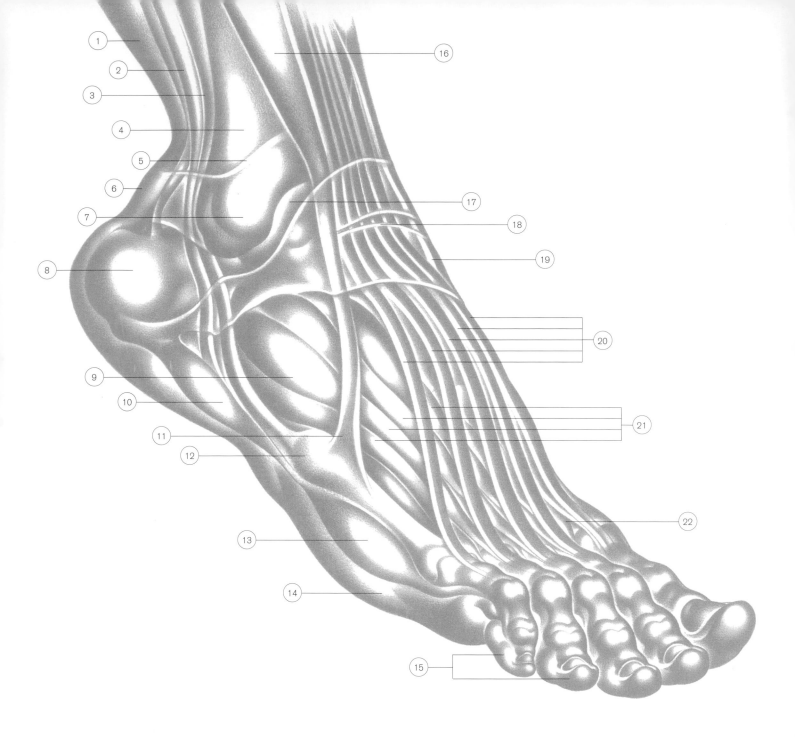

1. TENDON ACHILLES
2. PERONEUS BREVIS
3. PERONEUS LONGUS
4. FIBULA BONE
5. TRANSVERSE LIGAMENT
6. BURSA
7. LATERAL MALLEOLUS
8. CALCANEUM
9. EXTENSOR DIGITORUM BREVIS
10. ABDUCTOR DIGITI QUINTI
11. TENDON—PERONEUS TERTIUS

12. FIFTH METATARSAL
13. ABDUCTOR DIGITI QUINTI
14. SOLE PAD
15. TOE PADS
16. PERONEUS TERTIUS
17. TALUS TARSAL BONE
18. CRUCIATE LIGAMENT
19. TENDON—TIBIALIS ANTERIOR
20. TENDONS—EXTENSOR DIGITORUM
21. TENDONS—EXTENSOR DIGITORUM BREVIS
22. INTEROSSEUS

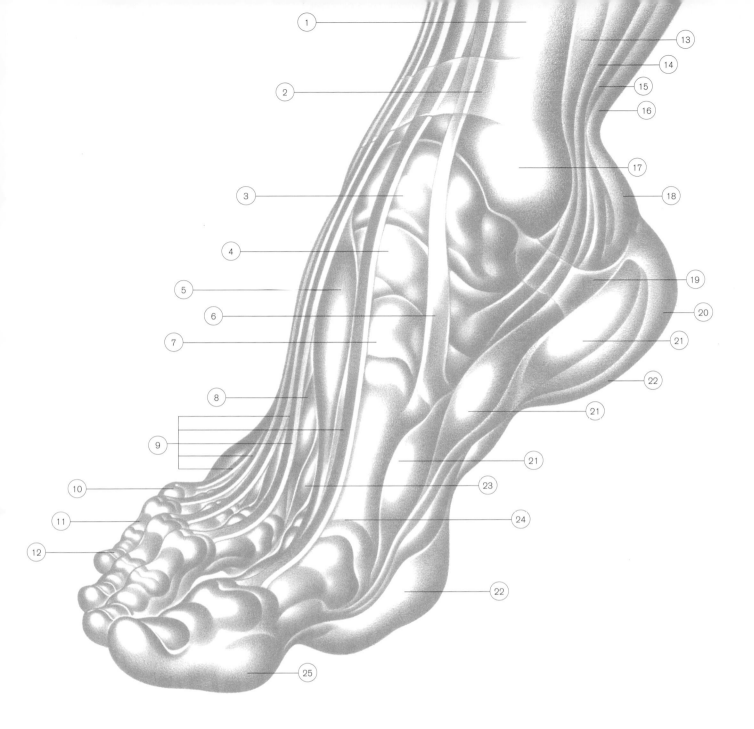

1. TIBIA BONE
2. TRANSVERSE LIGAMENT
3. TALUS TARSAL BONE
4. NAVICULAR TARSAL BONE
5. EXTENSOR HALLUCIS BREVIS
6. TENDON–TIBIALIS ANTERIOR
7. CUNEIFORM TARSAL BONE (I)
8. INTEROSSEUS
9. TENDONS–EXTENSOR DIGITORUM
10. PROXIMAL PHALANX (I)
11. MEDIAN PHALANX (II)
12. TERMINAL PHALANX (III)
13. FLEXOR DIGITORUM LONGUS

14. FLEXOR HALLUCIS LONGUS
15. SOLEUS
16. TENDON ACHILLES
17. MEDIAL MALLEOLUS
18. BURSA
19. LACINIATE LIGAMENT
20. CALCANEUM
21. ABDUCTOR HALLUCIS
22. SOLE PAD
23. INTEROSSEUS
24. FIRST METATARSAL
25. TOE PAD

MEASUREMENTS The length of the foot is the length of the *forearm*. In another context, it is one and one-third heads in length. The width of the foot, from the big toe to the little toe, is half a head.

The length of the foot divides into four equal sections: (a) the heel, from back to front; (b) the instep; (c) the ball of the big toe; (d) the big toe (both phalanges).

The ankle joins the foot at a vertical point over the front of the heel. Its height at the inner anklebone is equal to the length of the heel, or one-fourth the length of the foot. The smallest toe, on the outside of the foot, *ends* at the line drawn across the beginning of the big toe.

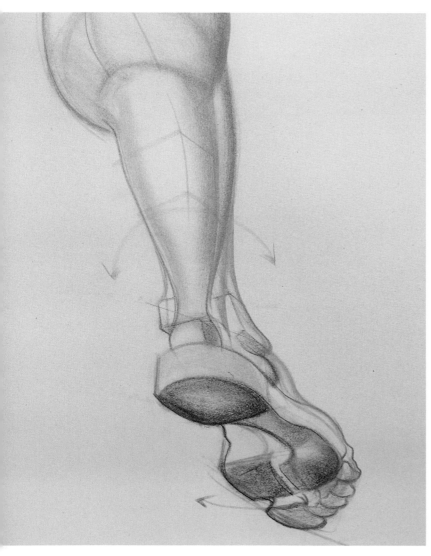

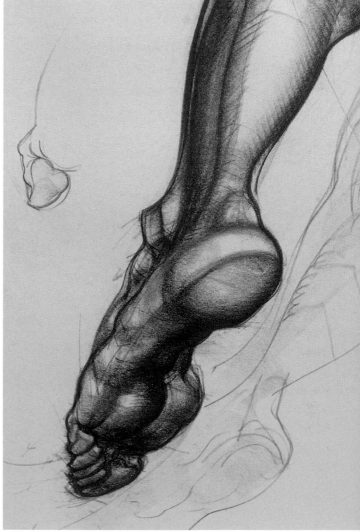

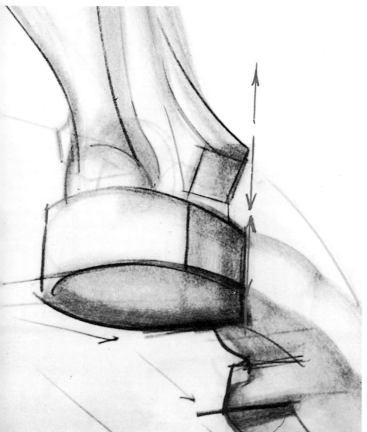

THE HEEL POSITION
BEGINS ON A
LINE DIRECTLY BELOW
THE ANKLEBONE.

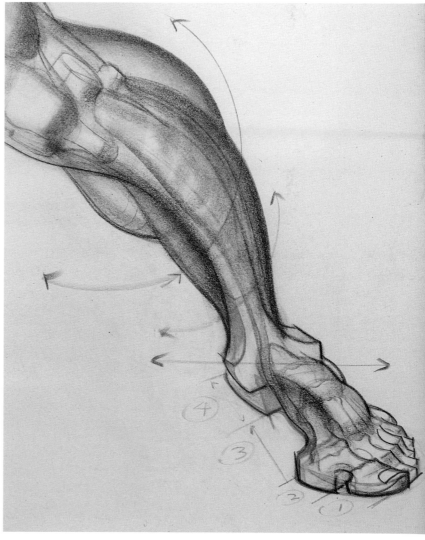

POINTS TO REMEMBER IN DRAWING (a) The *stance of the feet* almost invariably points off the center body line. As the legs thrust inward to the center, the foot reverses the direction and points outward. With the heels together, the toes point out to form a fifty-degree angle; at the extreme position, they may form a ninety-degree angle.

(b) In drawing the foot, remember to *carve the arch and the instep* immediately. This will locate major forms of the foot for later refinement.

(c) The top of the foot forms a long ski slope from arch to toes. Place this line first to define the rhythm movement of the top surface.

(d) To define the bottom surface easily, lay in a simple *footprint* first. Refinement and development of forms will follow quickly.

(e) The heel bone has a broad knob above it. This is the bursa, which creates the dual form of the heel contour.

(f) The small toes of the foot have a different rhythm movement from the big toe. The big toe tends to swing up in an upthrust movement, while the smaller toes tend to press and grip the ground surface. Note the middle sections of the small toes. The dropped, almost vertical plane here contrasts sharply with the upward movement of the big toe.

(g) The foot is much like a hand; it is modified to give support to the body, as the hand is modified to act as a tool. The basic forms, however, are quite similar, and the identities of one should help the understanding of the other.

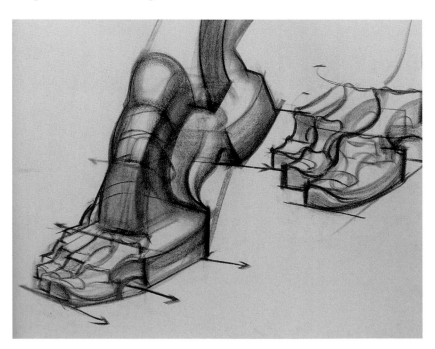

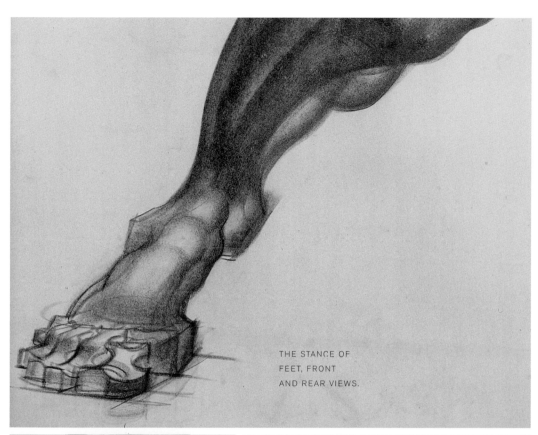

THE STANCE OF
FEET, FRONT
AND REAR VIEWS.

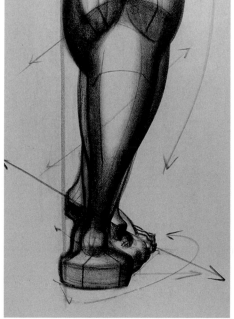

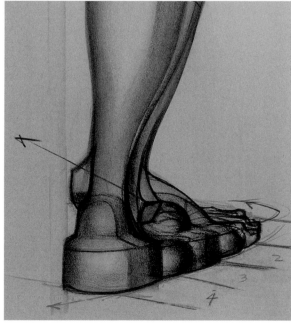

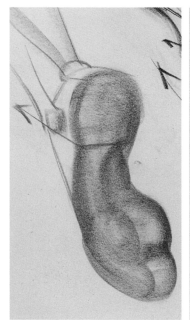

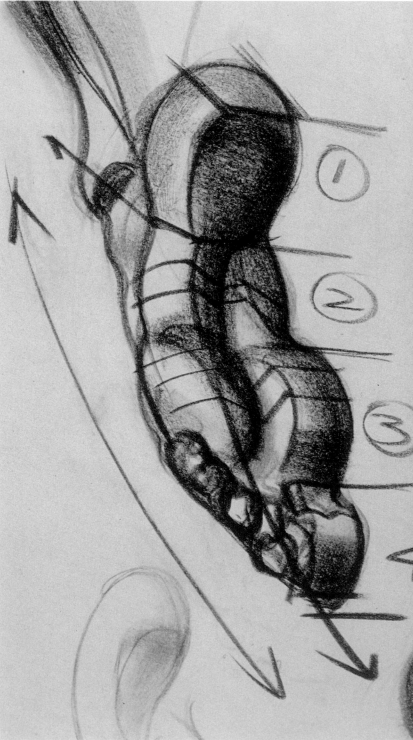

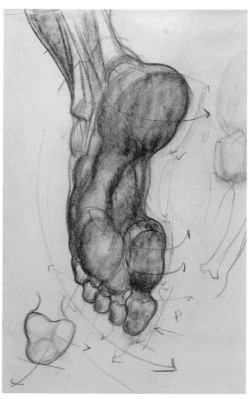

THE UPWARD
THRUST OF THE
BIG TOE, AND
THE DROPPED
MIDDLE SECTIONS
OF THE SMALL TOES.

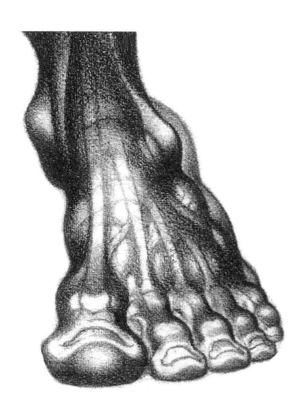

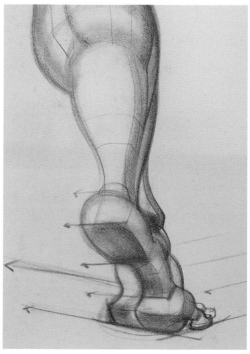

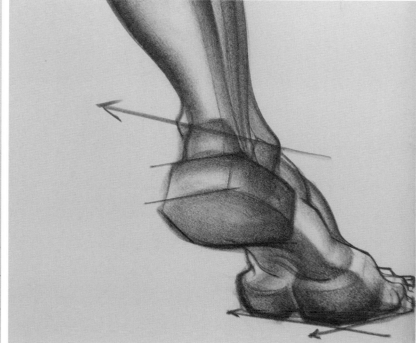

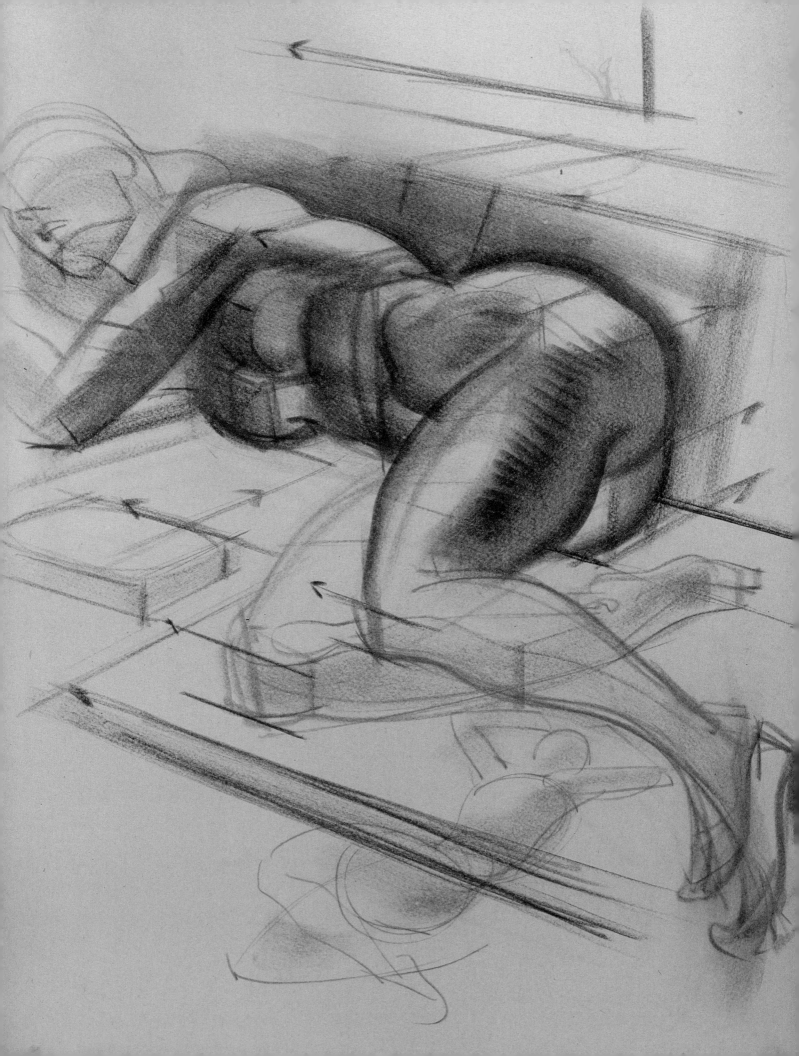

VI.

NINE PRINCIPLES OF FORESHORTENING

IN THESE OBSERVATIONS on the figure in foreshortening, it must be noted at the outset that the principles set down here are not meant to be seen as rigid formulations, nor are they meant to be used in an inflexible manner. They are to be interpreted as broadly as possible within the context of a given style or convention of drawing. They may be enlarged upon, modified, or discarded as the artist desires. Their reason for inclusion here is analytical and descriptive only. They are aids toward developing an understanding of form and to reinforce the artist's command of the depth of space in the picture.

Artists throughout history have sought ways to make the flat working surface intrude and extrude, advance and recede. The illusionistic principles of light and shade to produce form, linear visual perspective, and figure foreshortening have been great discoveries toward the solutions of depth on the two-dimensional surface. The human apparatus of vision, the eye, cannot see depth. The third dimension is a perception factor of experience judgment, developed through physical contact and body movement in the objective world of reality. If we could see depth as a three-dimensional reality, it would be possible to view the top, bottom, side, and back of an object *simultaneously*, as a hand experiences depth when it holds a ball in its grasp. If the eye could do this, no photograph, ordinary or stereoscopic, no drawing, however well modeled, could make us believe the existence of flat surface form—as the hand does not believe it when it reaches out to touch photographic form. Thus, in drawing the figure, the artist who desires a translation of a depth idea, whether he leans to the traditional or modern, from da Vinci to Picasso, should equip himself with tried and fundamental disciplines of depth illusion before he seeks to exaggerate, distort, or invent new perceptions of the real. The nine principles are offered in this light: to enhance clarity of observation in the artistic perception of depth toward making valid judgments of form.

OVERLAPPING SHAPES TO ACHIEVE RECESSION AND ADVANCEMENT OF FORM Forms will appear to advance or recede in space regardless of size or shape if the contour of one form is clearly intercepted or overlapped by another. Experience and a commonsense understanding of near and far relationships will produce the illusion of spatial position. However, observe that when contours of forms are tangent, i.e., when their outlines are not overlapped but merely continue the contour line, the result will be a confusion of the depth of space. Neither form, the front or rear, will appear to advance or recede.

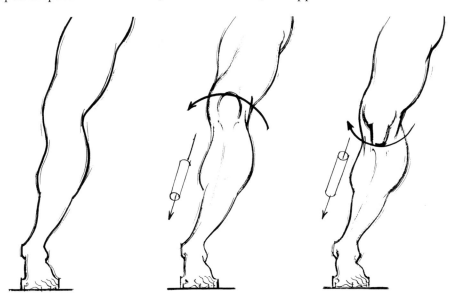

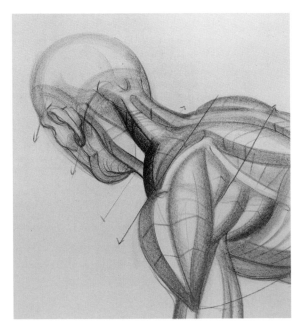

PRINCIPLE 2

CYLINDRICAL FORMS BECOME CIRCULAR IN FORESHORTENING In the fore-shortening of generally cylindrical body forms, the *width* of a form will remain *constant* as its *length shortens* in depth. Therefore, as a leg or arm is seen on end or in deep space, the effect produced is a circular shape around the width of the form as the cylinder length disappears.

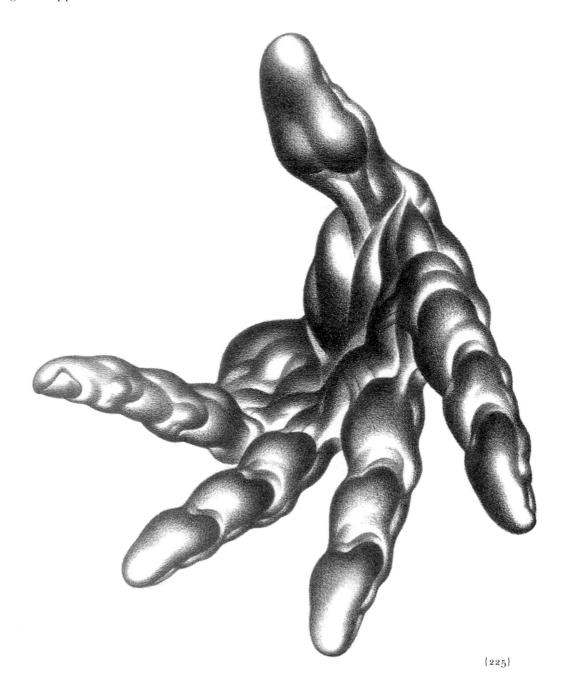

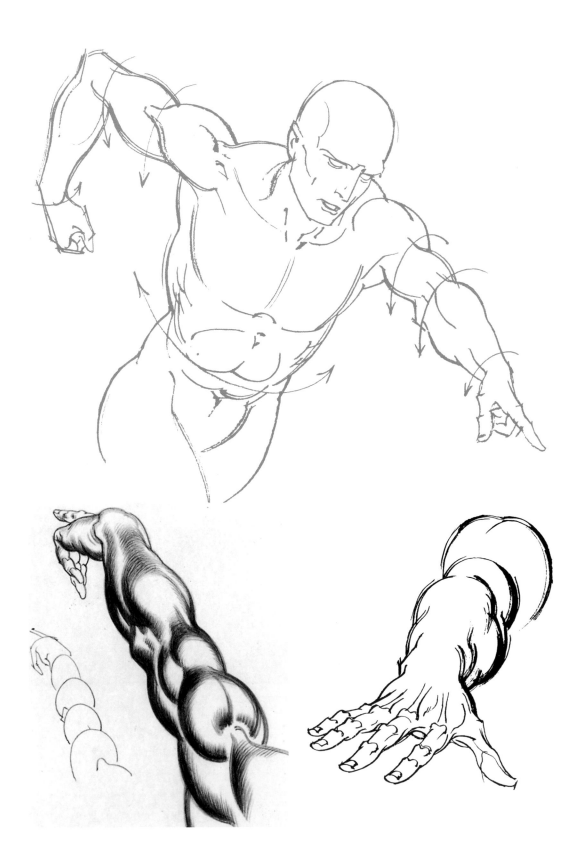

PRINCIPLE 3

POSITIONING THE JOINTS AT DETERMINED LENGTHS BEFORE FILLING IN
THE FORMS BETWEEN THEM To achieve extreme views of depth in body forms such as
legs and arms moving directly in or out of the flat surface, the positions of the joints—hip,
knee, ankle, shoulder, elbow, wrist—should be set down *first* at the required lengths. The
forms may then be filled in between the joints without distorting the view or stretching out
the given form beyond its normal appearance in the drawing.

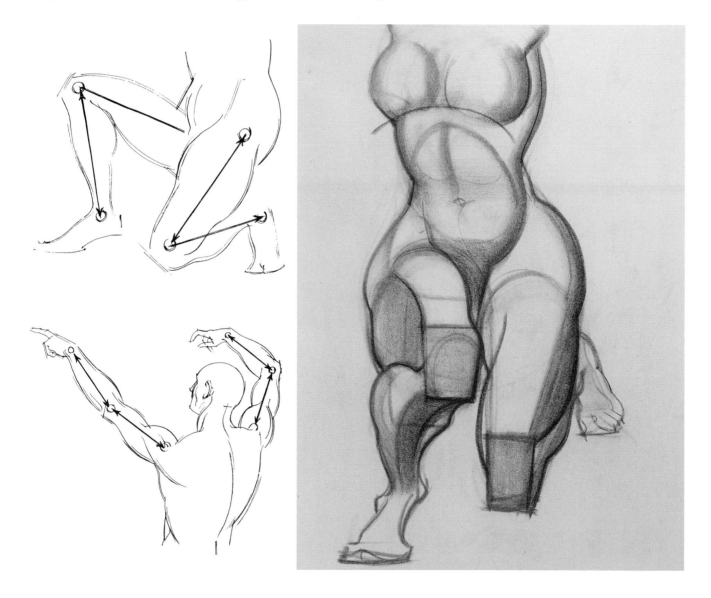

PRINCIPLE 4

SHARP COMPRESSION OF TAPERED FORMS TO ACHIEVE DEEP FORESHORT-
ENING When forms are seen on end in deep space, the change in *contour* from one form
to another will be sudden and abrupt. The effect produced will be a ballooning out of large
form and quick tapering or wedging toward small form. The outline, moving with a sharp
compression of form over the shortened length, will produce the illusion of great depth.

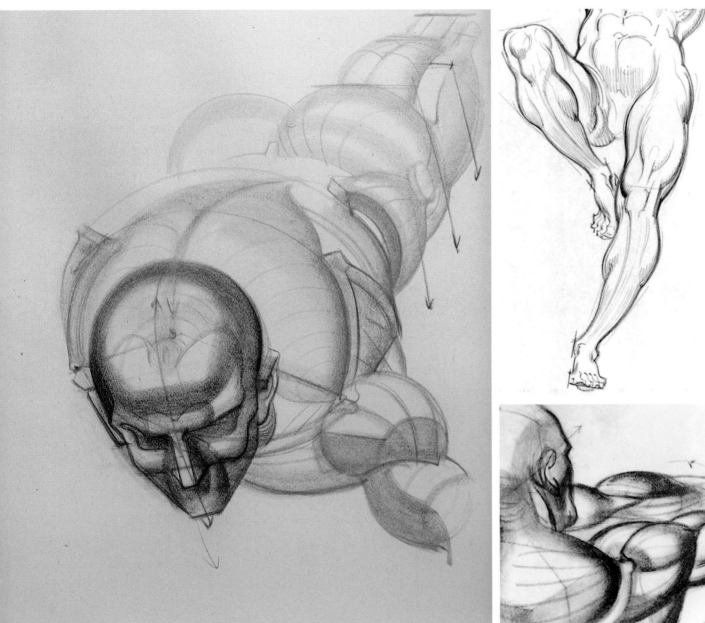

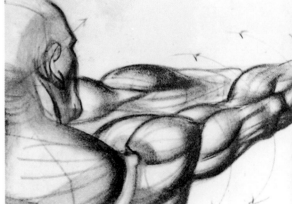

PRINCIPLE 5

USING ARBITRARY VALUES ON RECEDING PLANES Forms that are *shaded* tend to produce a recession in depth of plane. When forms move away from the eye, shade or value on the receding area will heighten the effect of depth. On rounded surfaces, barreling or turning the stroke enhances the artist's ability to project the spherical compression of tapered forms.

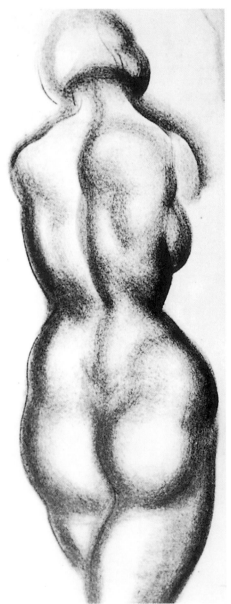
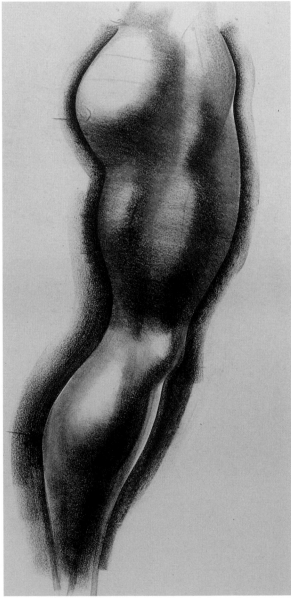

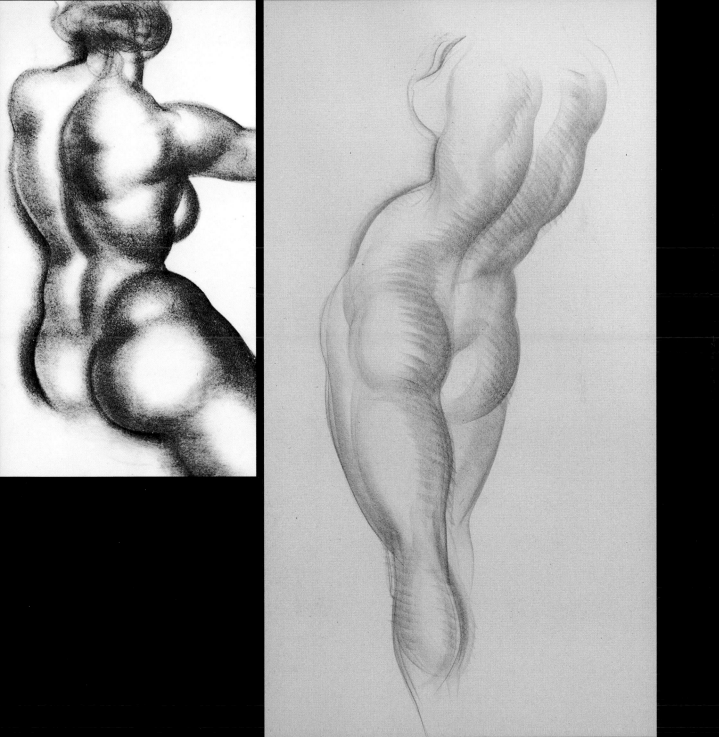

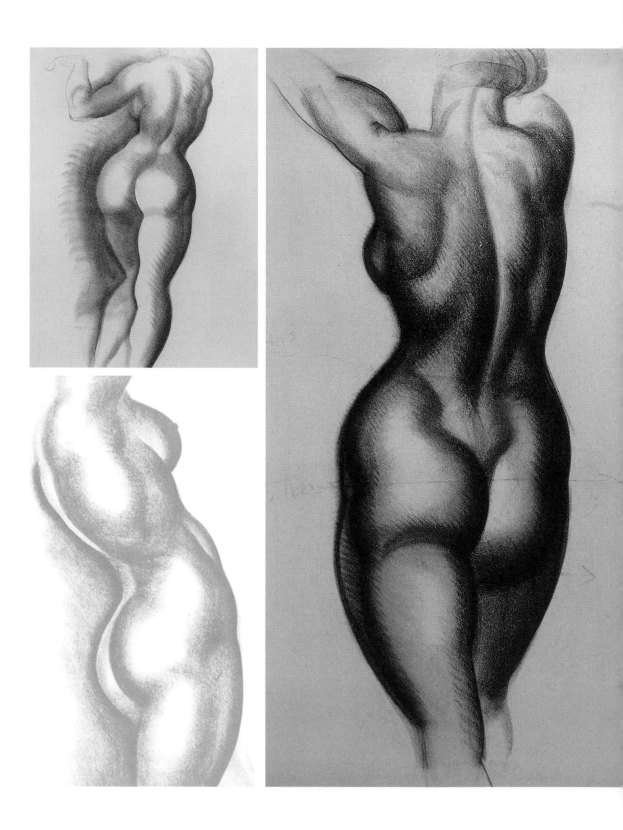

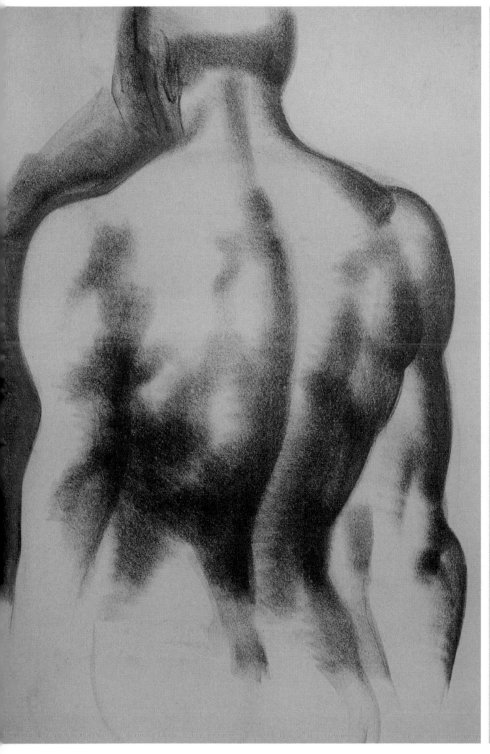

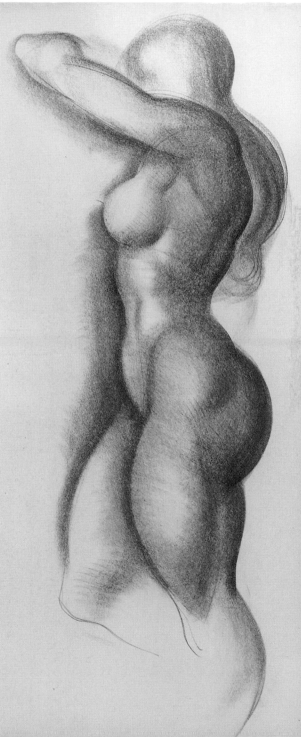

PRINCIPLE 6

USING PERSPECTIVE ELLIPSES IN FORESHORTENING, WITH A JOINT AS A PIVOT To maintain a proportionate length of a member, whatever its position in depth, a perspective circle or ellipse may be set up using the joint as a pivot, or center of movement. Thus, in an arm, from whichever viewing position the ellipse is seen, the measurements may be taken from the shoulder—the pivot—to the midway point, the elbow, and thence to the outer rim of the circle, the hand position. In this sense the arm length is a *radius of a circle,* however the circle may appear to be seen in a depth of space. The arm length, when placed at any position of a radius in the perspective circle, i.e., the length from shoulder to hand, will achieve a variety of positions. The series as a whole will produce a windmilling effect. This principle may be applied to a leg, though with limited results.

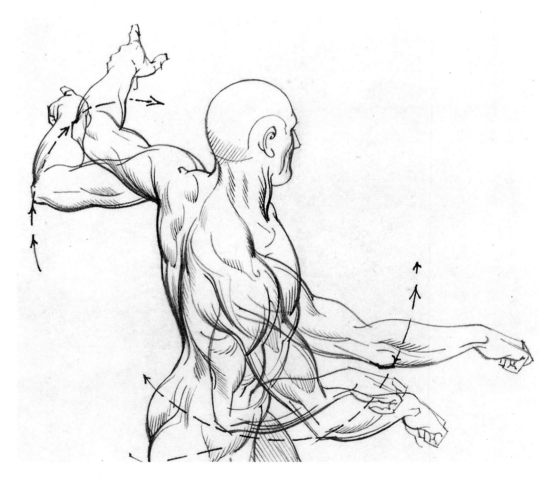

PRINCIPLE 7

PROJECTING THE SIDE VIEW OF THE FIGURE TO ACHIEVE THE FORE-
SHORTENED FIGURE When the problem of visualizing the figure in deep space cannot
be resolved, *a side view,* or easily understood profile of head or body, should be drawn in
first. Tipping the figure forward or backward will produce a view from *above* or *below,*
respectively. Once the side view key drawing has been developed, projection lines drawn
horizontally out to a drawing alongside the first will give the key positions of important
parts of the body in *exactly* the same positions in the depth of space. Filling in form details
afterward will present no problem once the proportionate positions are found.

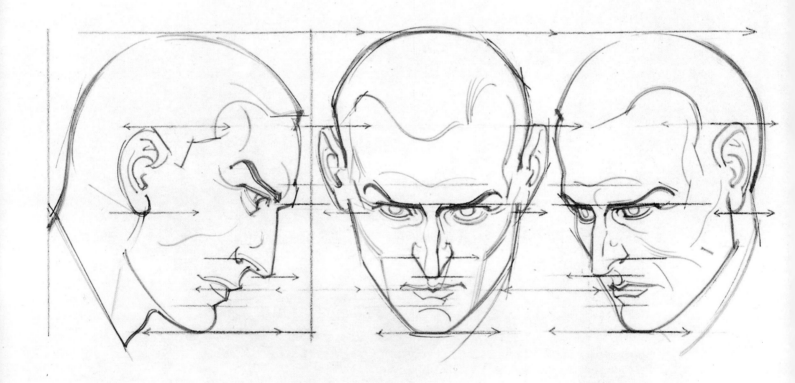

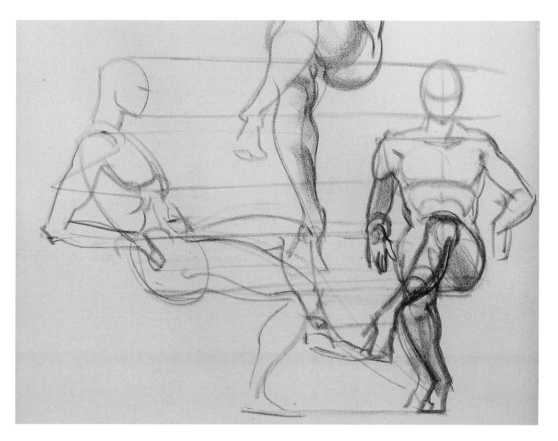

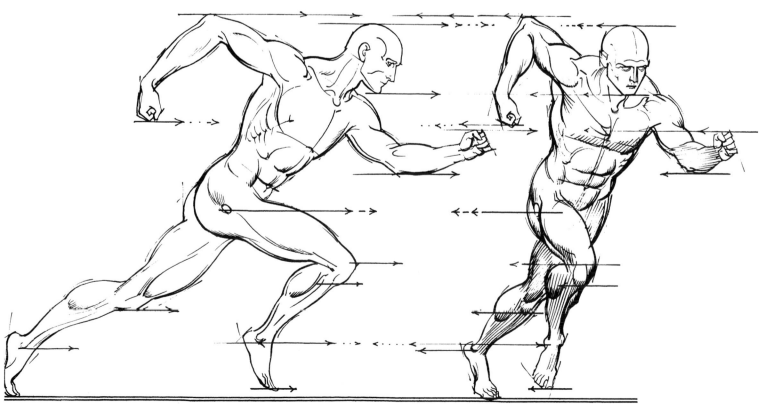

PRINCIPLE 8

TRACKING PERSPECTIVE TO HOLD CORRECT PROPORTIONS IN DEEP VIEWS OF THE FIGURE When the figure has been sketched in as a visual comprehensive, body forms may then be blocked in simple surfaces using a system of parallel perspective lines to hold the positions of planes correctly. If the figure is seen from a height, whether standing or moving, the placement of the feet as they walk or arms as they move may be related to the ground plane without difficulty when the perspective system is applied to track the members as seen in depth. An entire ground plane with objects may be added from the original perspective of the figure. Thus, the figure drawn in first will lend its perspective to an entire pictorial development in correct relationship throughout.

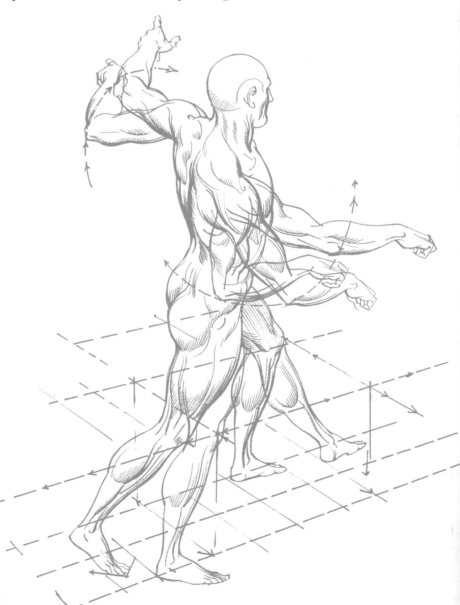

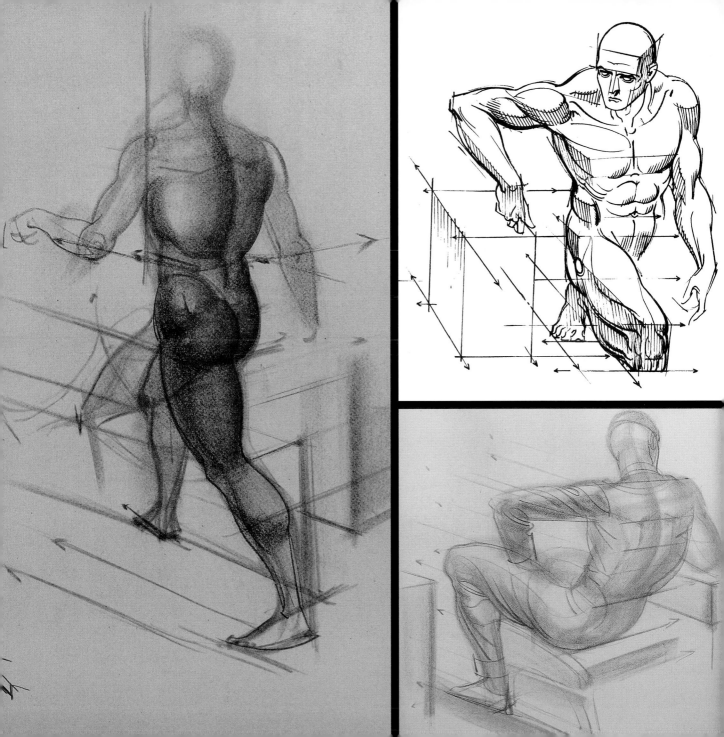

INTERLACING THE JOINT TO THE ADVANCING MEMBER When parts of the body bend (fingers, arms, legs), two forms are presented moving in opposite directions: the *advancing* member and the *receding* member. The joint in between—an elbow, knee, or knuckle—must be placed or drawn interlaced upon the *advancing* member. Violation of the premise usually results in a complete confusion of movement, and the direction of the member will appear to move in reverse.

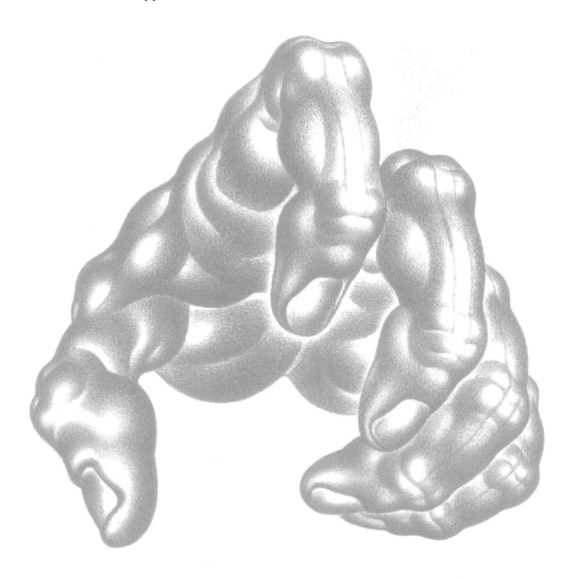

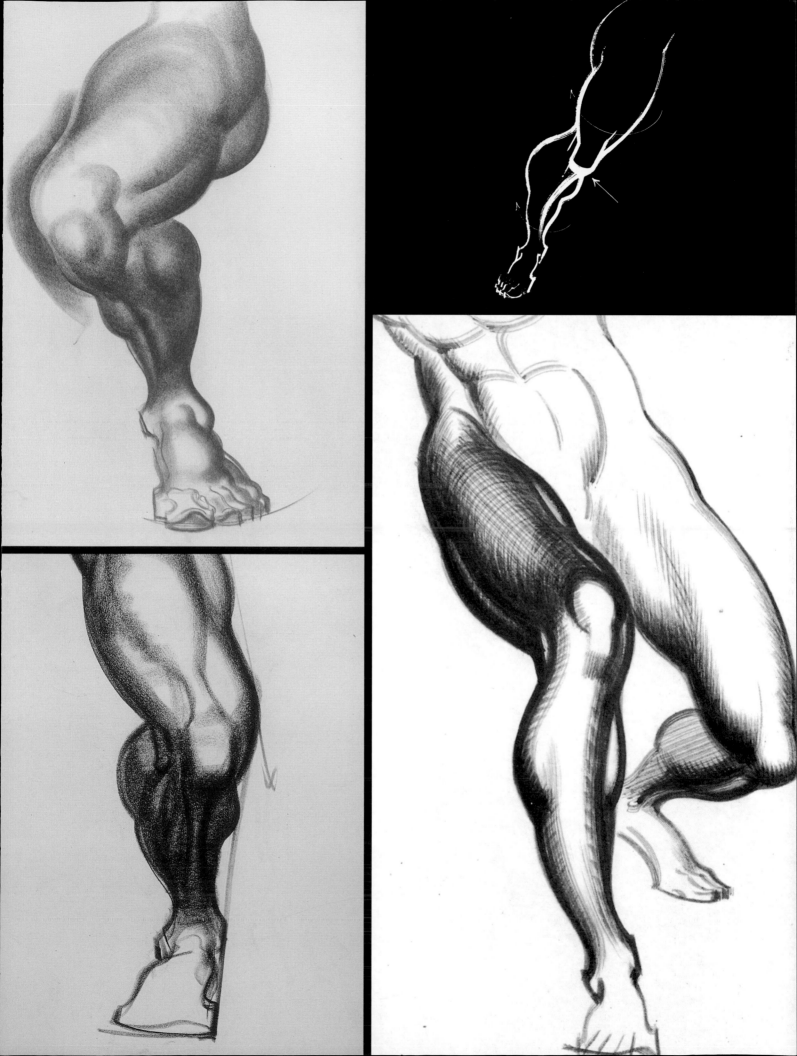

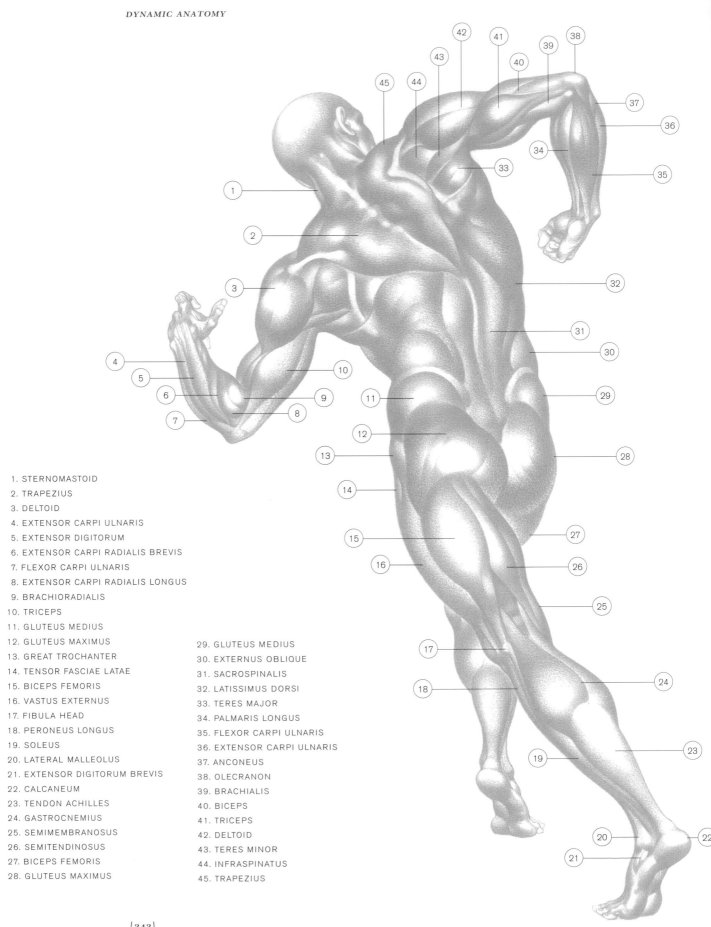

1. STERNOMASTOID
2. TRAPEZIUS
3. DELTOID
4. EXTENSOR CARPI ULNARIS
5. EXTENSOR DIGITORUM
6. EXTENSOR CARPI RADIALIS BREVIS
7. FLEXOR CARPI ULNARIS
8. EXTENSOR CARPI RADIALIS LONGUS
9. BRACHIORADIALIS
10. TRICEPS
11. GLUTEUS MEDIUS
12. GLUTEUS MAXIMUS
13. GREAT TROCHANTER
14. TENSOR FASCIAE LATAE
15. BICEPS FEMORIS
16. VASTUS EXTERNUS
17. FIBULA HEAD
18. PERONEUS LONGUS
19. SOLEUS
20. LATERAL MALLEOLUS
21. EXTENSOR DIGITORUM BREVIS
22. CALCANEUM
23. TENDON ACHILLES
24. GASTROCNEMIUS
25. SEMIMEMBRANOSUS
26. SEMITENDINOSUS
27. BICEPS FEMORIS
28. GLUTEUS MAXIMUS

29. GLUTEUS MEDIUS
30. EXTERNUS OBLIQUE
31. SACROSPINALIS
32. LATISSIMUS DORSI
33. TERES MAJOR
34. PALMARIS LONGUS
35. FLEXOR CARPI ULNARIS
36. EXTENSOR CARPI ULNARIS
37. ANCONEUS
38. OLECRANON
39. BRACHIALIS
40. BICEPS
41. TRICEPS
42. DELTOID
43. TERES MINOR
44. INFRASPINATUS
45. TRAPEZIUS

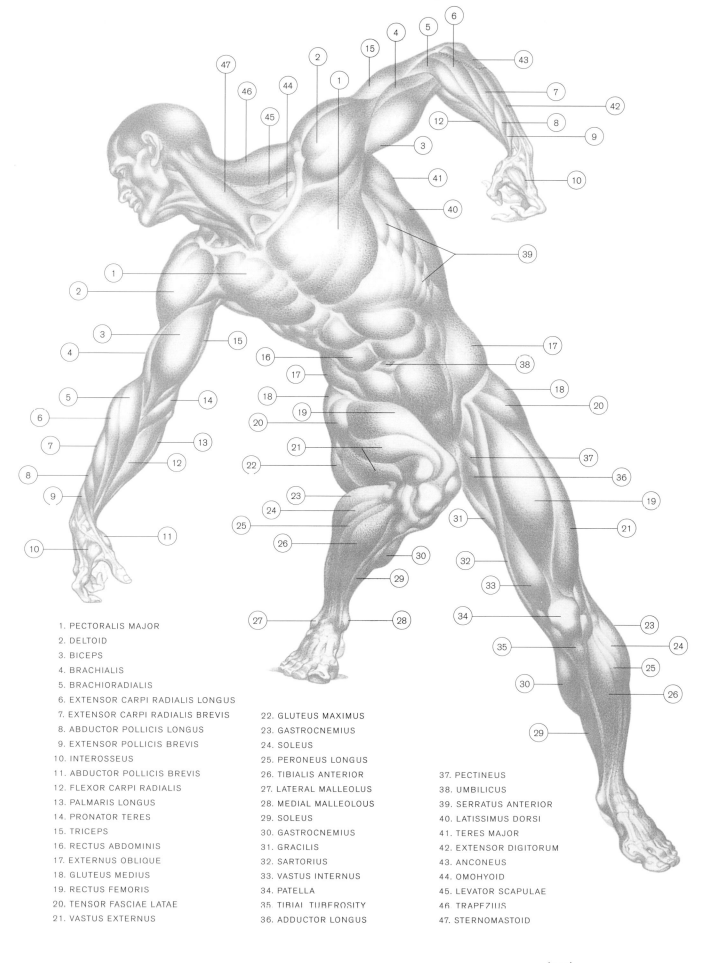

1. PECTORALIS MAJOR
2. DELTOID
3. BICEPS
4. BRACHIALIS
5. BRACHIORADIALIS
6. EXTENSOR CARPI RADIALIS LONGUS
7. EXTENSOR CARPI RADIALIS BREVIS
8. ABDUCTOR POLLICIS LONGUS
9. EXTENSOR POLLICIS BREVIS
10. INTEROSSEUS
11. ABDUCTOR POLLICIS BREVIS
12. FLEXOR CARPI RADIALIS
13. PALMARIS LONGUS
14. PRONATOR TERES
15. TRICEPS
16. RECTUS ABDOMINIS
17. EXTERNUS OBLIQUE
18. GLUTEUS MEDIUS
19. RECTUS FEMORIS
20. TENSOR FASCIAE LATAE
21. VASTUS EXTERNUS

22. GLUTEUS MAXIMUS
23. GASTROCNEMIUS
24. SOLEUS
25. PERONEUS LONGUS
26. TIBIALIS ANTERIOR
27. LATERAL MALLEOLUS
28. MEDIAL MALLEOLOUS
29. SOLEUS
30. GASTROCNEMIUS
31. GRACILIS
32. SARTORIUS
33. VASTUS INTERNUS
34. PATELLA
35. TIBIAL TUBEROSITY
36. ADDUCTOR LONGUS

37. PECTINEUS
38. UMBILICUS
39. SERRATUS ANTERIOR
40. LATISSIMUS DORSI
41. TERES MAJOR
42. EXTENSOR DIGITORUM
43. ANCONEUS
44. OMOHYOID
45. LEVATOR SCAPULAE
46. TRAPEZIUS
47. STERNOMASTOID

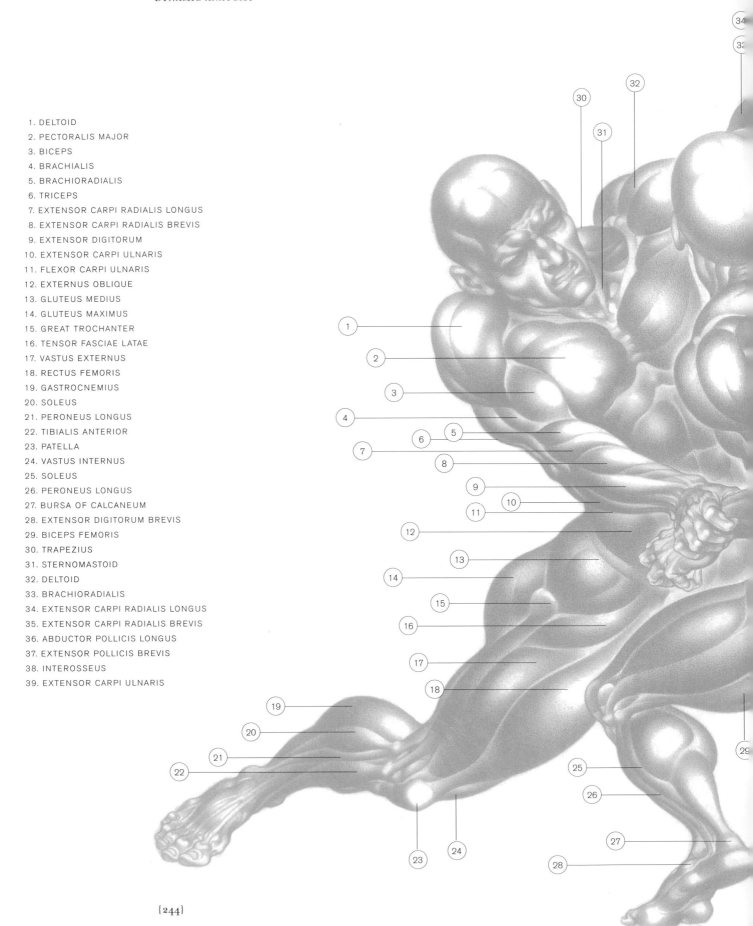

1. DELTOID
2. PECTORALIS MAJOR
3. BICEPS
4. BRACHIALIS
5. BRACHIORADIALIS
6. TRICEPS
7. EXTENSOR CARPI RADIALIS LONGUS
8. EXTENSOR CARPI RADIALIS BREVIS
9. EXTENSOR DIGITORUM
10. EXTENSOR CARPI ULNARIS
11. FLEXOR CARPI ULNARIS
12. EXTERNUS OBLIQUE
13. GLUTEUS MEDIUS
14. GLUTEUS MAXIMUS
15. GREAT TROCHANTER
16. TENSOR FASCIAE LATAE
17. VASTUS EXTERNUS
18. RECTUS FEMORIS
19. GASTROCNEMIUS
20. SOLEUS
21. PERONEUS LONGUS
22. TIBIALIS ANTERIOR
23. PATELLA
24. VASTUS INTERNUS
25. SOLEUS
26. PERONEUS LONGUS
27. BURSA OF CALCANEUM
28. EXTENSOR DIGITORUM BREVIS
29. BICEPS FEMORIS
30. TRAPEZIUS
31. STERNOMASTOID
32. DELTOID
33. BRACHIORADIALIS
34. EXTENSOR CARPI RADIALIS LONGUS
35. EXTENSOR CARPI RADIALIS BREVIS
36. ABDUCTOR POLLICIS LONGUS
37. EXTENSOR POLLICIS BREVIS
38. INTEROSSEUS
39. EXTENSOR CARPI ULNARIS

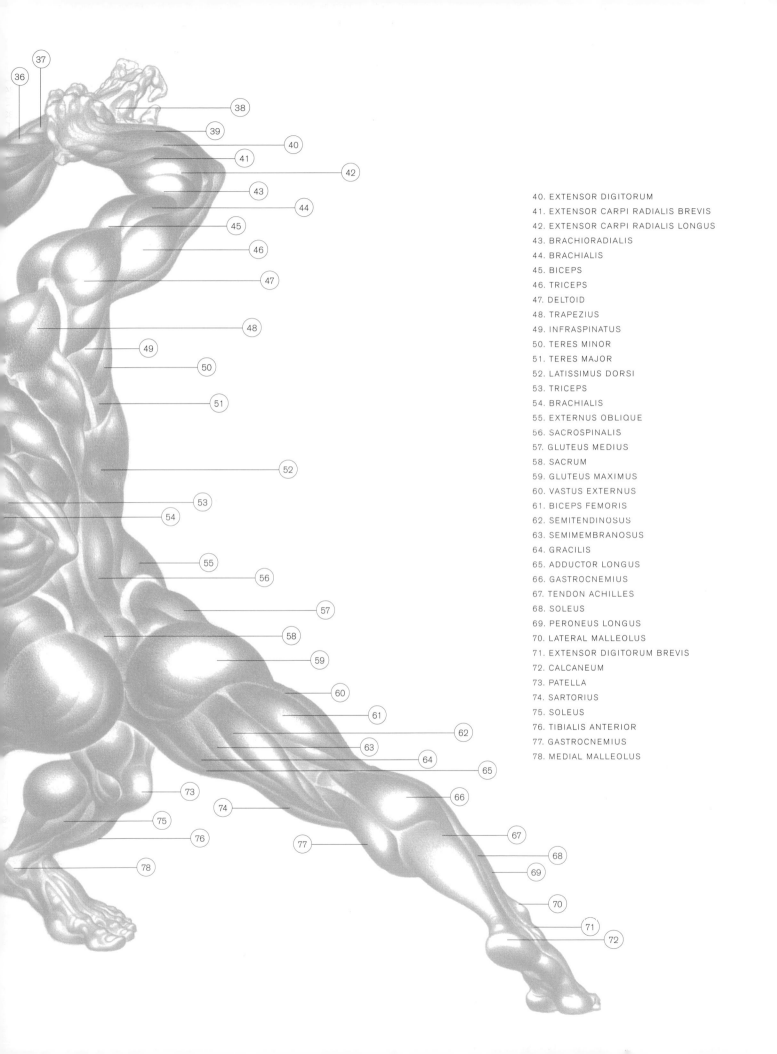

40. EXTENSOR DIGITORUM
41. EXTENSOR CARPI RADIALIS BREVIS
42. EXTENSOR CARPI RADIALIS LONGUS
43. BRACHIORADIALIS
44. BRACHIALIS
45. BICEPS
46. TRICEPS
47. DELTOID
48. TRAPEZIUS
49. INFRASPINATUS
50. TERES MINOR
51. TERES MAJOR
52. LATISSIMUS DORSI
53. TRICEPS
54. BRACHIALIS
55. EXTERNUS OBLIQUE
56. SACROSPINALIS
57. GLUTEUS MEDIUS
58. SACRUM
59. GLUTEUS MAXIMUS
60. VASTUS EXTERNUS
61. BICEPS FEMORIS
62. SEMITENDINOSUS
63. SEMIMEMBRANOSUS
64. GRACILIS
65. ADDUCTOR LONGUS
66. GASTROCNEMIUS
67. TENDON ACHILLES
68. SOLEUS
69. PERONEUS LONGUS
70. LATERAL MALLEOLUS
71. EXTENSOR DIGITORUM BREVIS
72. CALCANEUM
73. PATELLA
74. SARTORIUS
75. SOLEUS
76. TIBIALIS ANTERIOR
77. GASTROCNEMIUS
78. MEDIAL MALLEOLUS

1. EXTENSOR CARPI ULNARIS
2. EXTENSOR POLLICIS BREVIS
3. ABDUCTOR POLLICIS LONGUS
4. EXTENSOR CARPI RADIALIS BREVIS
5. EXTENSOR DIGITORUM
6. DELTOID
7. BICEPS
8. EXTENSOR CARPI RADIALIS LONGUS
9. LATERAL FEMORAL CONDYLE
10. PATELLA
11. FIBULA HEAD
12. MEDIAL FEMORAL CONDYLE
13. TIBIAL TUBEROSITY
14. SARTORIUS
15. GASTROCNEMIUS
16. ADDUCTOR LONGUS
17. GRACILIS
18. RECTUS FEMORIS
19. VASTUS EXTERNUS
20. VASTUS INTERNUS
21. GASTROCNEMIUS
22. LATERAL FEMORAL CONDYLE
23. MEDIAL FEMORAL CONDYLE
24. PATELLA
25. LATERAL TIBIAL CONDYLE
26. MEDIAL TIBIAL CONDYLE
27. TRAPEZIUS
28. OMOHYOID
29. DELTOID
30. TRICEPS—LONG HEAD
31. TRICEPS—LATERAL HEAD
32. BICEPS

33. BRACHIALIS
34. OLECRANON
35. BRACHIORADIALIS
36. EXTENSOR CARPI RADIALIS LONGUS
37. EXTENSOR CARPI RADIALIS BREVIS
38. EXTENSOR DIGITORUM
39. FLEXOR CARPI ULNARIS
40. TERES MAJOR
41. STERNOMASTOID
42. PECTORALIS MAJOR
43. LATISSIMUS DORSI
44. SERRATUS ANTERIOR
45. FLEXOR CARPI ULNARIS
46. ANCONEUS
47. RECTUS ABDOMINIS
48. OLECRANON
49. RECTUS FEMORIS
50. EXTERNUS OBLIQUE
51. VASTUS EXTERNUS
52. TENSOR FASCIAE LATAE
53. GASTROCNEMIUS
54. GLUTEUS MEDIUS
55. SOLEUS
56. TIBIALIS ANTERIOR
57. GREAT TROCHANTER
58. GLUTEUS MAXIMUS
59. SOLEUS
60. EXTENSOR DIGITORUM LONGUS
61. MEDIAL MALLEOLUS
62. LATERAL MALLEOLUS
63. EXTENSOR DIGITORUM BREVIS

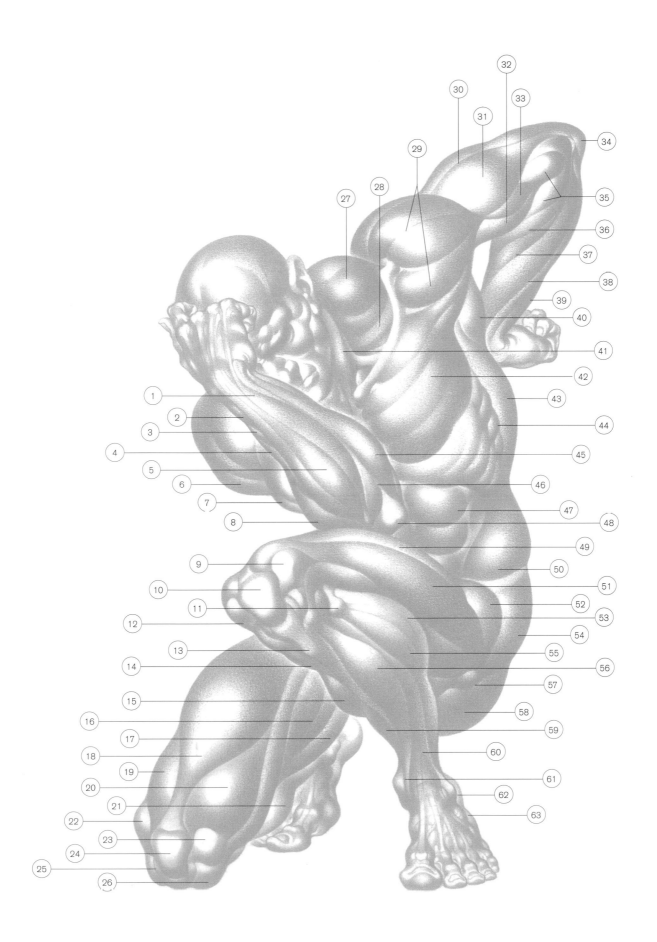

BIBLIOGRAPHY

(Editor's note: All book sources listed here are cited from the original 1958 edition of *Dynamic Anatomy*, with a few editorial corrections. Subsequent editions and printings of these titles may still be available. For further guidance, consult your local public library system or the Library of Congress.)

Arnheim, Rudolph. *Art and Visual Perception.* Berkeley and Los Angeles: University of California Press, 1954.

Barr, Alfred H. Jr., ed. *Masters of Modern Art.* New York: Museum of Modern Art, 1954.

————. *What Is Modern Painting?* New York: Museum of Modern Art, 1943.

Beck, William S. *Modern Science and the Nature of Life.* New York: Harcourt Brace, 1957.

Boas, Franz. *Primitive Art.* New York: Dover, 1955.

Boeck, Wilhelm, and Jaime Sabartes. *Pablo Picasso.* New York: Harry N. Abrams, 1955.

Brash, J. C., and E. B. Jamieson. *Cunningham's Textbook of Anatomy.* London: Oxford University Press, 1943.

Bridgman, George B. *The Human Machine.* Pelham, N.Y.: Bridgman Publishers, 1939.

Cheney, Sheldon. *The Story of Modern Art.* New York: Viking, 1951.

Clark, Kenneth. *The Nude.* New York: Pantheon, 1956.

Couch, Herbert Newell, and Russel M. Geer. *Classical Civilization.* New York: Prentice-Hall, 1940.

Frankel, Charles. *The Case for Modern Man.* New York: Harper and Brothers, 1956.

Fremantle, Anne, et al., eds. *The Great Ages of Western Philosophy.* Boston: Houghton-Mifflin, 1957.

Goldscheider, Ludwig. *Michelangelo Drawings.* London: Phaidon, 1951.

Hall, A. R. *The Scientific Revolution, 1500–1800.* Boston: Beacon Press, 1956.

Hatton, Richard G. *Figure Drawing.* London: Chapman and Hall, 1949.

Hauser, Arnold. *The Social History of Art.* New York: Knopf, 1952

Hekler, Anton. *Greek and Roman Portraits.* London: William Heinemann, 1912.

Hogben, Lancelot. *From Cave Painting to Comic Strip.* New York: Chanticleer Press, 1949.

Howells, William. *Back of History.* New York: Doubleday, 1957.

Hoyle, Fred. *The Nature of the Universe.* New York: Harper and Brothers, 1950.

Kasner, Edward, and James Newman. *Mathematics and the Imagination.* New York: Simon and Schuster, 1940.

Massachusetts Institute of Technology Committee for the Study of the Visual Arts, 1952–54. *Art Education for Scientist and Engineer.* Cambridge, Mass.: Committee Report, 1957.

Meer, Frederik van der. *Atlas of Western Civilization.* English version by T. A. Birrell. Amsterdam: Elsevier, 1956.

Myers, Bernard S. *Art and Civilization.* New York: McGraw-Hill, 1957.

National Geographic Society. *Everyday Life in Ancient Times.* Washington, D.C.: National Geographic, 1953.

——. *Indians of the Americas.* Washington, D.C.: National Geographic, 1955.

Raynal, Maurice. *History of Modern Painting.* Geneva: Skira, 1949.

——. *Modern Painting.* Geneva: Skira, 1956.

Read, Herbert. *The Philosophy of Modern Art.* New York: Meridian Books, 1955.

Rewald, John. *The History of Impressionism.* New York: Museum of Modern Art, 1946.

Robinson, James H. *The Mind in the Making.* New York and London: Harper and Brothers, 1921.

Sachs, Paul J. *Modern Prints & Drawings.* New York: Knopf, 1954.

Saunders, J. B. de C. M., and Charles D. O'Malley. *Illustrations from the Works of Andreas Vesalius of Brussels.* Cleveland: World Publishing Company, 1950.

Schider, Fritz. *An Atlas of Anatomy for Artists.* New York: Dover, 1947.

Segy, Ladislas. *African Sculpture Speaks.* New York: A. A. Wyn, 1952.

Shahn, Ben. *The Shape of Content.* Cambridge, Mass.: Harvard University Press, 1957.

Sherrington, Sir Charles. *Man on His Nature.* Garden City, N.Y.: Doubleday, 1953.

Singer, Charles. *The Evolution of Anatomy.* New York: Knopf, 1925.

Taylor, Francis Henry. *Fifty Centuries of Art.* New York: Harper and Brothers, 1954.

Tylor, Edward Burnett. *Primitive Culture.* New York: Brentano's, 1924.

Vanderpoel, John H. *The Human Figure.* Chicago: Inland Printer Company, 1919.

Venturi, Lionello. *Italian Painting.* Geneva: Skira, 1950.

Visser, H. F. E. *Asiatic Art.* New York and Amsterdam: Seven Arts Book Society, 1952.

Waddington, C. H. *The Scientific Attitude.* London: Pelican, 1948.

Weber, Alfred. *History of Philosophy.* Translated by Frank Thilly. With "Philosophy Since 1860" by Ralph Barton Perry. New York and Chicago: Charles Scribner's Sons, 1925.

Wells, H. G. *The Outline of History.* New York: Macmillan, 1921.

Weltfish, Gene. *The Origins of Art.* Indianapolis: Bobbs-Merrill, 1953.

Whitehead, Alfred North. *Science and the Modern World.* Lowell Lectures, 1925. New York: Macmillan, 1947.

Wölfflin, Heinrich. *Principles of Art History.* New York: Dover, 1932.

YOUR KNOWLEDGE AND LEARNING MORE ABOUT THE LIFE, WORK, AND TEACHING METHODS OF BURNE HOGARTH?

For a wide variety of materials to enhance your enjoyment of *Dynamic Anatomy* and other titles in the Burne Hogarth™ dynamic drawing™ art instruction series, please visit www.burnehogarth.com, or send an e-mail to info@burnehogarth.com.

WE LOOK FORWARD TO HEARING FROM YOU!